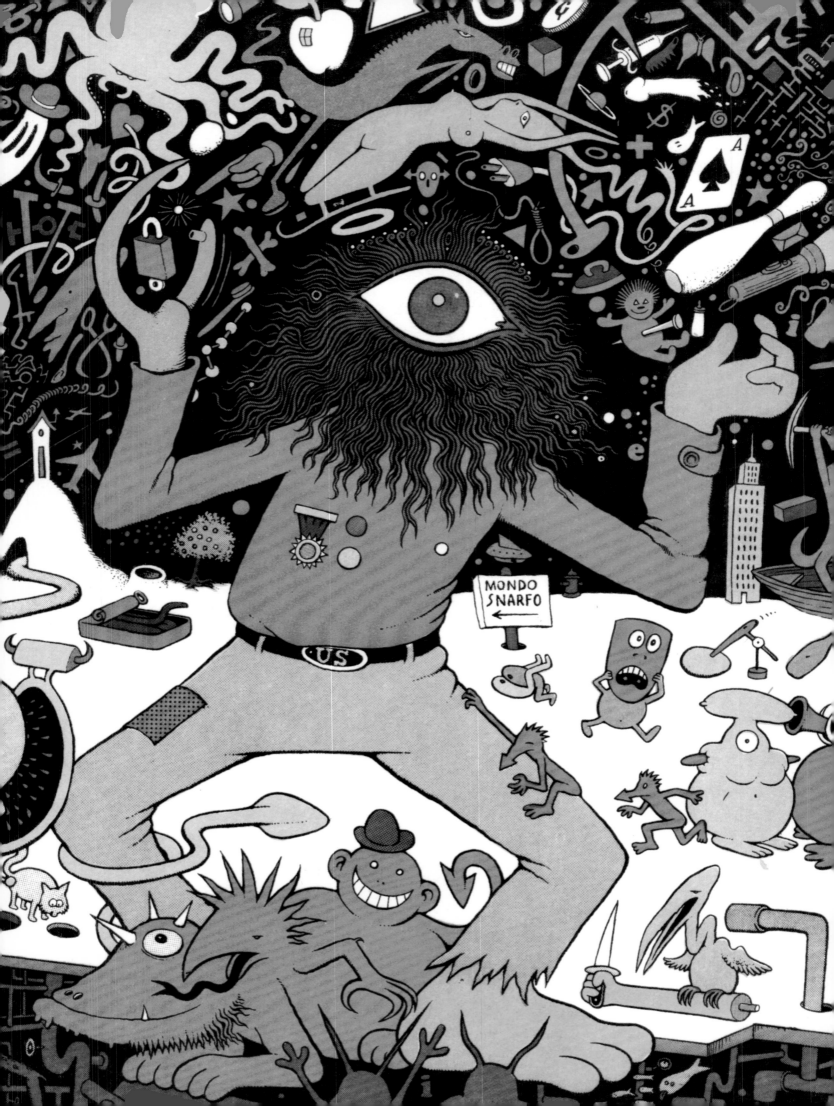

THE ODDLY COMPELLING ART OF DENIS KITCHEN

INTRODUCTION BY NEIL GAIMAN

PUBLISHED BY MIKE RICHARDSON

DESIGNED BY JOHN LIND

ESSAY BY CHARLES BROWNSTEIN

WITH CAPTIONS WRITTEN BY DENIS KITCHEN

DARK HORSE BOOKS

EDITORS: JOHN LIND & DIANA SCHUTZ
ASSISTANT EDITOR: BRENDAN WRIGHT
DIGITAL PRODUCTION: CHRIS HORN

Library of Congress Cataloging-in-Publication Data

Kitchen, Denis, 1946-
 The oddly compelling art of Denis Kitchen / introduction by Neil Gaiman ; edited by
Diana Schutz ; co-edited and designed by John Lind ; essay by Charles Brownstein ; with
captions written by the artist. -- 1st ed.
 p. cm.
 Includes bibliographical references and index.
 ISBN 978-1-59582-360-1
 1. Kitchen, Denis, 1946---Themes, motives. I. Schutz, Diana. II. Brownstein, Charles.
III. Title.
 N6537.K535A4 2010
 741.5'973--dc22

 2009047612

THE ODDLY COMPELLING ART OF DENIS KITCHEN

Published by Dark Horse Books
A division of Dark Horse Comics, Inc.
10956 SE Main Street
Milwaukie, Oregon 97222

darkhorse.com
deniskitchen.com

First edition: June 2010
ISBN: 978-1-59582-360-1

10 9 8 7 6 5 4 3 2 1

Printed by Midas Printing International, Ltd., Huizhou, China.

THIS BOOK IS DEDICATED TO WILL AND HARVEY.

And to the memory of two siblings who are also no longer with me: my late sister
Doreen, who dearly loved comix; and my late brother Jim, who was once my
closest confidant.

ACKNOWLEDGMENTS

A somewhat thinner version of this *Oddly Compelling Art* collection was first
announced in late 1988 to coincide with the twentieth anniversary of two career
milestones: my first comic book, *Mom's Homemade Comics*, and the founding of
Kitchen Sink Press. But I had my hands full in 1989 and decided to sacrifice my
most self-indulgent project. It remained on the back burner till a decision, in 1998,
to publish it during Kitchen Sink Press's thirtieth anniversary. But at the start of
1999, KSP went under. The book, somehow fittingly, was finally assembled during
the fortieth anniversary.

Executive Editor Diana Schutz first approached me about a monograph not long
after the demise of Kitchen Sink Press. A few years of fits and starts passed, but
Diana remained tenacious about pushing me on stage. I am very grateful for her
enthusiasm, astute editorial oversight, that infectious laugh, and faith in the project.

As co-editor and designer, John Lind slogged through my flat files, digital files,
film negs, and photo archives, slicing and dicing with a fierce but intelligent scalpel.
Some of my personal favorites hit the cutting room floor, but John brought an
objective eye to this task that I could not. The book looks amazing due to his
multiple skills, dedication, and decisive input throughout the long process.

It's hard to call fifteen-year comics industry veteran Charles Brownstein a wunder-
kind now that he has finally turned thirty, but he was certainly still a wunderkind
when he started pressing me to focus on this project. Charles's inventory of my
art jump-started the book, and his great career-spanning essay puts everything in
perspective. I am deeply thankful for his longtime support.

Thanks go to Mike Richardson, who for many years was a friendly publishing rival.
In recent years I've helped assemble various books for Dark Horse, but with *Oddly
Compelling* he finally has a book that will outsell *Sin City* and *Star Wars*. And I
especially thank my close friend Mike Martens, DH's Vice President of Business
Development, for guaranteeing such sales.

Thanks to the invariably smooth Neil Gaiman for his kind introduction; and to the
sage R. Crumb for his blurb.

Appreciation to Assistant Editor Brendan Wright and assistants Madeline Gobbo
and Daniel Chabon for their transcription of lengthy interview tapes; to Chris
Horn for scanning the bulk of the art (Zip-A-Tone not making that an easy task); to
Ellen Lind for conscientious copyediting of my captions during the writing phase;
to Bryant Paul Johnson for coloring "Turgid Toad" on page 120; to Eric Sack for
providing photographs of a few of my originals from his fabulous comix art collec-
tion; to Dave Dumas at Pivot Media for expertly photographing a few originals and
objects; and to my wonderful wife Stacey for scanning everything else (and for the
smile that still makes me melt).

And though not directly involved in this book, a high tip of my Sinkers softball
cap to the late, great Dave Schreiner and to colleagues Peter Poplaski and Jamie
Riehle. The personal loyalty, dedication, and high professional standards of these
true friends—my real brothers—helped make those long years in the comix mill a
genuine pleasure.

COVER: **Detail from "Square Publisher"** | 1995
HALF TITLE PAGE: *Self-Portrait as Quarter Moon* | 2007
TITLE SPREAD: **Detail from** *Major Arcana* **album cover** | 1975
CONTENTS PAGE: *Three-Piece Band* | 1994
PAGE 198: **Steve Krupp** | 1990
PAGE 200: *Steve Krupp Travels On* | 1987
BACK COVER: **Detail from** *Bugle* **no. 316 cover** | 1978

CONTENTS

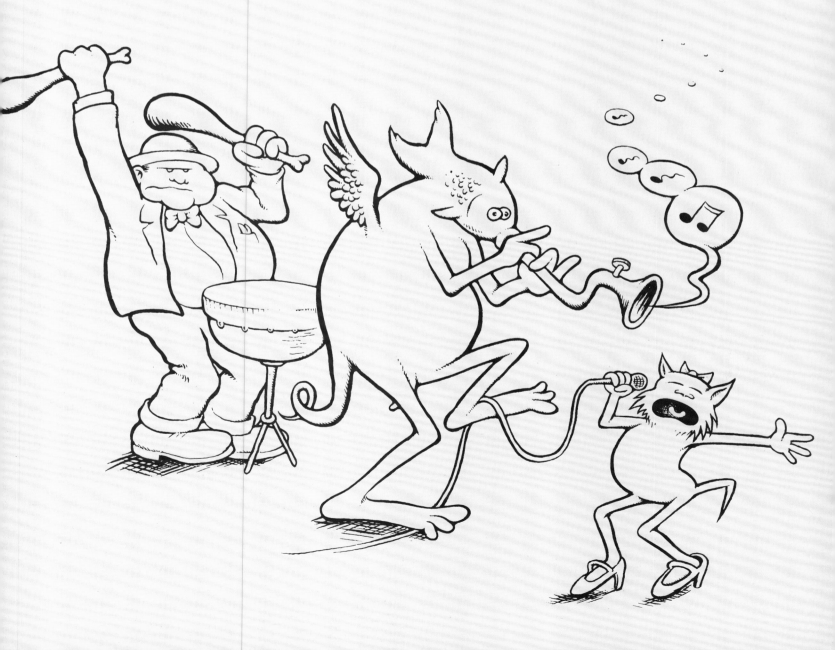

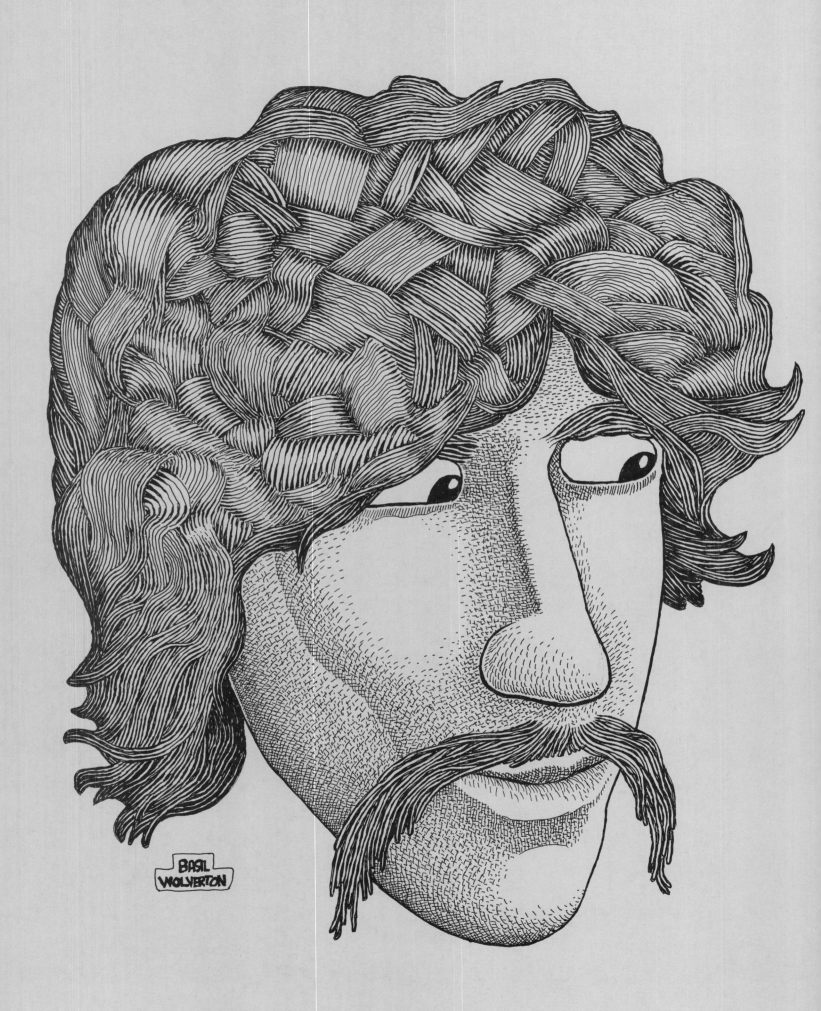

DENIS KITCHEN
THE AWFUL TRUTH

ONE.

The thing about Denis Kitchen is this: he's a snappy dresser. Do not underestimate this. Not one bit. It's the key to everything.

TWO.

I knew that Denis Kitchen existed and was an underground artist when I was about fourteen years old, because Plus Books in West Croydon, which masked its dealings in secondhand pornography by selling secondhand comics and magazines and SF, and which would have been the best place in the world if it weren't for the middle-aged men in long raincoats giving me and my schoolboy friends resentful, or embarrassed, looks before asking if there were any less-soiled copies of "All Nude Bodybuilders" behind the counter, had two copies of something called *Comix Book* up on the wall for sale, and I bought both of them.

It was a very odd magazine. It was published by Marvel Comics—Stan Lee even presented it—and was just like the underground comics I bought, except for being, well, slightly milder. Less sex, less drugs, less crazed taking-it-to-the-edge, but it was still the strangest thing I'd ever seen published under the Marvel brand. Denis Kitchen drew the cover to the second issue (I think it was the second), which meant that I knew from the start how Denis Kitchen drew things. And I knew he was an editor.

By the time I was seventeen, I had Gone Off comics. I wasn't going to read them anymore. They had started cutting pages. The artists I liked had stopped drawing, the writers I liked weren't writing. There was one exception: Will Eisner, whose work, both old and new, I had loved. So I bought the reprints of Will Eisner's *The Spirit*, published by a company called Kitchen Sink.

Somewhere in one of those Kitchen Sink *Spirit* magazines was a jam page, where Denis drew himself and Will drew himself, and I suddenly realized that this was the same guy from those strange Marvel-But-Not-Marvel not-actually-undergrounds I'd read.

I did not know that I would ever meet him.
I knew nothing then about how he dressed.

THREE.

I backed into comics in the late 1980s and saw Denis Kitchen from afar at a Dallas Fantasy Convention, in about 1989. He was the publisher of Kitchen Sink comics, a highly reputable independent publishing house, based in Wisconsin. He was also extremely tall. Not freakishly tall. Certainly not sideshow tall. But tall.

Also, he was the only person with a moustache I had encountered in comics up until that time who was not either 1) trying to look like an artist, 2) trying to look like an adult, or 3) Sergio Aragonés.

I did not talk to him then.

FOUR.

I did not really talk to Denis until I had moved to the U.S., to fairly near his old stomping grounds, whereupon Kitchen Sink Publishing bought Northampton Publisher Tundra (the word on the street was that Tundra had paid Kitchen Sink to buy Tundra), and Denis and Kitchen Sink moved to Northampton and took over the Tundra offices. It was the kind of odd commercial move that the history of comics ought to be littered with. Tundra had a book of mine, *Violent Cases*. So, the next time Denis and I were at a convention together, I plucked up my courage (I was less intimidated by publishers at this point, even tall ones) and went over and talked about the new edition of the book we were planning, shot from the original art.

I discovered that Denis was really smart, and sane and easy to talk to. He asked sensible questions. He seemed to be enjoying the publishing process.

And he was astonishingly well-dressed.

You may know nothing of comics. You may know nothing of the conventions of comics—either the ones that the people who make and read comics are meant to abide by or the ones where they go and meet and talk and buy comics and get signatures and stand in lines—but in neither of these are people renowned for sartorial elegance. Or even sartorial competence. The unofficial uniform is a T-shirt and jeans. The snappy dressers are the ones who bring three clean T-shirts to a three-day convention.

We are geeks, and nerds. We are shy and awkward. Some of us have managed to emerge from the pupa stage, and have transformed ourselves by some effort of will into social butterflies, but it is skin deep. Scratch us, and we will babble about a long-forgotten Superhero comic.

OPPOSITE: Portrait of Denis Kitchen by Basil Wolverton | 1974
I'd been a big fan of Basil Wolverton since first seeing his work in the early *MAD* comics and, later, his outrageous winning entry (among tens of thousands) in Al Capp's Lena the Hyena contest in 1946, the year I was born. I hired Basil in 1974 to contribute to *Comix Book*, then, on impulse, commissioned him to draw this caricature of me, based on photo references. Sadly, this was one of Wolverton's very last drawings. Less than two weeks after delivering this portrait he had a stroke, ending his career. He died in 1978.

Denis Kitchen wasn't that. He was urbane. He wore the clothes as if he knew how. As if he had been born wearing them.

FIVE.

I watched Denis rebuild Kitchen Sink from the ashes of Tundra. We became friends. I was becoming more interested and passionate about the work and existence of the Comic Book Legal Defense Fund, the First Amendment organization Denis chaired. I began to give readings to raise money for them. I stayed at Denis's house. I met his wife, Stacey, who is beautiful and smart. During the nineties I made the acquaintance of a whole slew of Denis Kitchens: Kitchen the publisher, Kitchen the candy magnate, Kitchen the former publisher, Kitchen the raconteur, Kitchen the wise and sober President of the Board of Directors of the Comic Book Legal Defense Fund, Kitchen the associate of Will Eisner, Kitchen the art dealer . . .

I was certain I had the measure of the man. That there was nothing about Denis Kitchen that would come as a surprise.

SIX.

We were on a ship.

The Comic Book Legal Defense Fund had organized a Cruise in the spring of 2000. Dozens of members of the public had paid real money to travel on a ship with a generous handful of comics luminaries. Will Eisner was there. So were the Hernandez Bros. and Adrian Tomine and Neal Adams and Frank Miller and Matt Wagner and Jill Thompson and a horde of others.

I was gathering drawings for friends back in England. I had drawings by everyone I could think of. All the famous artists there.

Then there was Denis Kitchen. He used to draw, didn't he? I asked him for a drawing. He demurred, said something about not drawing any longer. I pointed out it was for the CBLDF, to entice my friends to come on the Cruise the following year, and a reluctant Denis told me he would give me a drawing the following day.

In the morning, Denis passed me a drawing. It was a Denis Kitchen Seagull.

And it was, in every way, a Denis Kitchen drawing. It was amazing.

I had Please Come On The Next Cruise drawings by half the greats in comics (including a Jaime Hernandez drawing of Maggie and Hopey cuddling up to Benny Hill), but the Denis Kitchen drawing was the only one I contemplated simply not giving away. I could have kept it. It's not like anyone except me would have known.

I gave it to my friend.

That was the only CBLDF cruise there was. But I had learned something, something I had forgotten for half my life: Denis Kitchen is an artist. Now I'd discovered it, I couldn't forget it again. The smart clothes were really some kind of strange disguise. Underneath, however he denied it, there was someone who drew . . .

SEVEN.

Years have passed. Denis semi-retired from publishing, and semi-retired from the CBLDF, he became the father of Alexa Kitchen, the youngest comics instructor I've yet encountered, and works harder than ever.

I was in Northampton, Massachusetts, last week, for the first time in many years, and called the Kitchen phone number. Stacey Kitchen answered.

"I'm writing an introduction," I told her. "Mostly it seems to be about what an amazingly snappy dresser Denis is."

"Ah," said Stacey, confidentially. "That was me."

EIGHT.

There's an alternate world in which Denis Kitchen was a prolific underground artist. One of the ones who changed the way we saw the world, like Crumb. In which Kitchen Sink didn't happen, or barely. He would have worn jeans, and only changed his T-shirts whenever he handed in an art assignment. The book you're holding would have come out when it was first announced, and would have been the first of many volumes of collected Denis Kitchen art, of course, and Denis would have carried home the Eisner and Harvey awards for things he had written and drawn, not just edited or published . . .

Of course, the face of comics today would be different. The underground might never have met the overground, and the cross-fertilization that led to the comix-rich world of today would never have occurred in the way that it did, for a start. The second act of Will Eisner's career might never have happened as it did. The world of comics would have been infinitely poorer without Denis Kitchen in all his incarnations.

I like the world we live in now: the one with the smartly dressed Denis Kitchen in it. But still . . . sometimes I remember a drawing of a seagull, and I wonder. And now I have this book to make me wonder just a little bit more.

—NEIL GAIMAN
November 2009

Bestselling author Neil Gaiman has long been one of the top writers in modern comics, as well as writing books for readers of all ages. He is listed in the *Dictionary of Literary Biography* as one of the top ten living postmodern writers, and is a prolific creator of works of prose, poetry, film, journalism, comics, song lyrics, and drama.

OPPOSITE: **The Artist as a Snappy Dresser** | 2010
Aside from my wife, Stacey, I seek sartorial advice from my trusty staff.

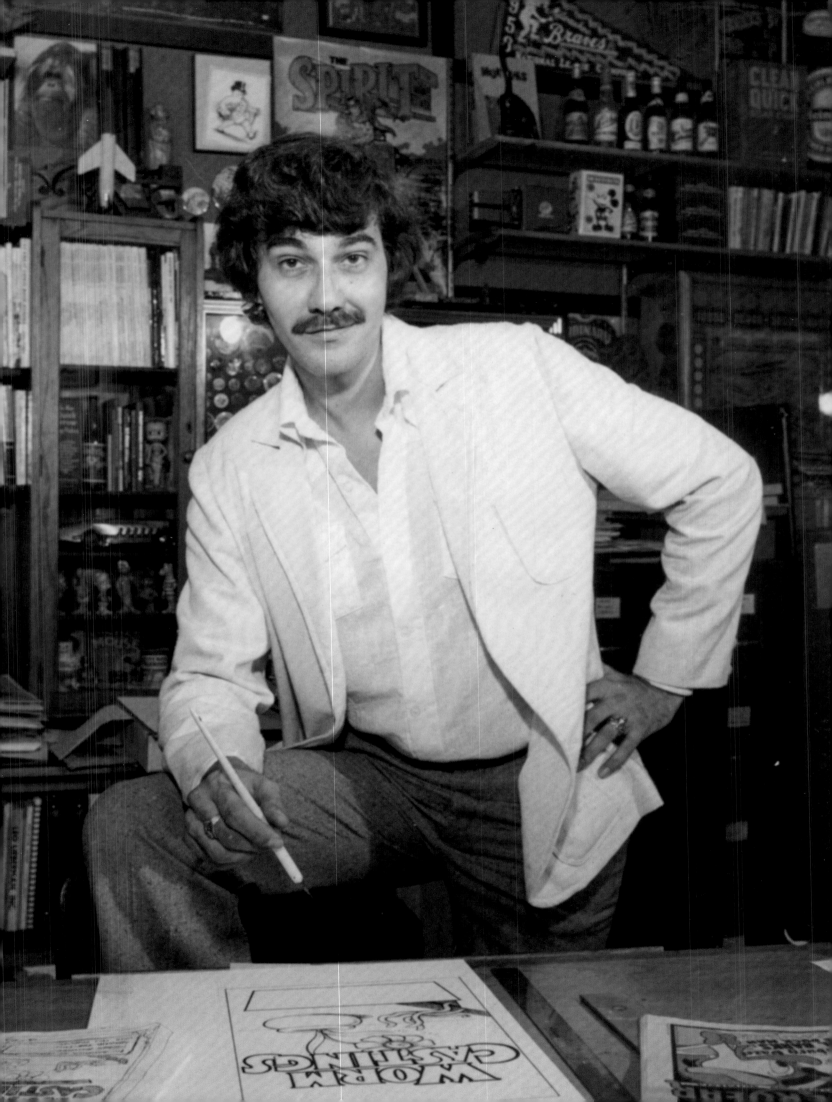

Who is Denis Kitchen?

SNAPSHOTS FROM AN ODDLY COMPELLING LIFE

The book you're holding is forty years in the making, and twenty years in the procrastinating. It was first solicited under this title for publication in 1989, to commemorate two landmarks in Denis Kitchen's professional life: the twentieth anniversary of his publishing company, Kitchen Sink Press, and the publication of his first full-length entry as a cartoonist, *Mom's Homemade Comics* #1. To understand why this book has taken so long to reach you, not to mention why so many of us are glad for its arrival, you need to understand a bit about the thorny and convoluted answer to the seemingly simple question posed in the title of this essay.

If asked who Denis Kitchen was at the time this book was first solicited, most savvy comics readers would have identified him as a publisher or as founder of the Comic Book Legal Defense Fund, but could have been forgiven if they weren't aware of his infrequent cartooning output. At a time when the comics market was thoroughly dominated by the cheaply produced periodical-format comic book (and predominantly superhero comics at that), Kitchen Sink established a reputation for genre diversity, outstanding production values, investment in new formats (including what we now call the graphic novel), and an even-handed commitment to preserving the best work of comics masters while at the same time encouraging top-flight work by new and established authors. In the year this book was first planned for release, Kitchen Sink published work by Doug Allen, Charles Burns, Ernie Bushmiller, Al Capp, Daniel Clowes, Milton Caniff, Joe Coleman, Richard Corben, Robert Crumb, Howard Cruse, Julie Doucet, Dupuis & Berberian, Will Eisner, Rand Holmes, Jack Jackson, Joe Matt, Moebius, Mark Newgarden, Harvey Pekar, Spain Rodriguez, Steve Rude, Mark Schultz, Richard Sala, Don Simpson, Dave Stevens, and Basil Wolverton, to name a mere sampling.

Today, comics-savvy readers holding this book can be forgiven for being unaware not just of Kitchen's cartooning, but of his years, too, as a leading boutique publisher of comics and graphic novels. After all, more than a decade has passed since KSP closed its doors, and a lot of other publishers and imprints have picked up where that press left off. Since then, Kitchen has directed his energies to being a serious behind-the-scenes player in a variety of capacities. So, if you were asked now who Denis Kitchen is, you'd be right to answer that he's an important agent, art dealer, author, book packager, curator, historian, specialty publisher, and specialty online retailer. But those are just his day jobs! You'd also be right if, having met him at a convention or book signing, you claimed that he's the proud father of tween author Alexa Kitchen, whom he dubbed "The World's Youngest Professional Cartoonist" and whose most recent graphic novel was published in 2009 by Disney/Hyperion. If you got to speak to him about his other passions, you might answer that he's an avid collector of a wide variety of ephemera—or that sometimes, and usually under duress, he puts pen to paper and is a cartoonist.

The Oddly Compelling Art of Denis Kitchen represents the first definitive survey of Kitchen's short but memorable art career. It includes examples of his work from his earliest juvenile endeavors to the infrequently produced, highly accomplished contemporary illustrations he now creates in his spare time. The largest concentration of work spans a period of roughly ten years, from the first strips that were drawn for *Mom's* #1 in 1968 to the publication of the surrealist short story "Major Arcana" in 1978's anthology *Mondo Snarfo*, which Kitchen edited. This period shows Kitchen's art following two paths: that of a cartoonist participating in the underground comix movement and that of an illustrator whose principal work was made for local editorial and commercial clients. Kitchen himself has provided detailed captions contextualizing the illustrations reproduced throughout this book from the whole of his artistic career. As such, this essay focuses not on individual pieces or their merits, but instead provides a brief biographical overview, emphasizing the life circumstances that informed Kitchen's art career and the events of the decade that produced his largest artistic output. That decade found Kitchen defining for himself the question of who he is, leaving the drawings he created in that time as snapshots from a singular and oddly compelling life.

BEGINNINGS: 1946–1969

Denis Lee Kitchen was born on August 27, 1946, the first child of Margaretha Margert and recently discharged World War II veteran Benjamin Kitchen. His early years were spent in poverty-stricken communities in the Texas Panhandle and southeastern Wisconsin, where, for the first seven of those years, he was an only child.

"We lived in Caledonia, on the outskirts of Milwaukee's southernmost suburbs, in a community of prefabricated homes we used to call Cracker Jack boxes, because they all looked the same: very small and primitive," Kitchen recalls of his Wisconsin neighborhood. "It was very blue-collar. That's all I knew. My father was a factory worker. He never made much money his entire life. When I was twelve, I remember seeing what is now a W-2 statement with his year's earnings. The reason I remember is because that year he had earned $4,999, and I said, 'Oh, wow! One more dollar, Dad, and you would have made $5,000!' He was very embarrassed that I saw it, and I remember him yelling at me, 'It's none of your business!'"

Nosing about his father's papers was part of Kitchen's overall inquisitive youth. "I was just intensely curious about

COME TO AUSTRALIA ABOARD A LUXURIOUS

stuff," he remarks. "I wouldn't say I was a loner as a kid, but I spent a lot of time reading and drawing."

Comics ignited those passions long before Kitchen started school, and are the subject of one of his earliest memories. "I had a babysitter when I was probably six or seven in Mukwonago, Wisconsin. She lived in a farmhouse, and she must have had older children, because along one wall in the basement they had these *enormous* stacks of comics. Each stack was higher than me, and there must have been half a dozen of them! She used to joke with my mother that I was the easiest kid in the world to sit for, because she'd just set me up in the basement and several hours later call me back up!

"One day when my mother picked me up, the babysitter said, 'Denis loves these comics so much; why don't you take one of these stacks with you?' My mother asked me, 'Would you like that?' I remember looking at my mom and feeling kind of guilty because these weren't mine—they belonged to other kids. Apparently my mother, in teaching me manners, must have somehow caused me to say, to my eternal regret, 'No, Mrs. Whatever.' It was a lost opportunity, and I've regretted it every day since. But what I knew from then on was that I wanted my *own* stacks!"

That early desire inspired the young Kitchen to use his weekly fifty-cent allowance to begin amassing a comics collection while also developing a fully rendered fantasy world. "Back then, a comic book was a dime, and a box of modeling clay was a dime, and those were the two things I spent my money on," he explains. Before the birth of younger siblings, an existing spare room in the house served as Kitchen's playroom, which "consisted of a table and a chair and an ever-expanding amount of clay. And I built a complex world on the tabletop," he says. "I spent hours and hours and hours building this clay world, creating armies of clay men with tanks and planes, having them clash, and then starting all over again.

"When I wasn't playing with clay, I was reading comic books and trading with other kids in the neighborhood. I remember early on having apparently more diverse tastes than the other boys, at least, in the neighborhood. They were only interested in *Superman* and *Batman* types of comics. I liked those, but I also loved *Little Lulu* and *Uncle Scrooge* and some of the more eccentric ones. I used that to my advantage, because I could trade one *Superman* and get at least two, three, or four *Lulu*s or *Scrooge*s, because they were considered, I presume, comics aimed at girls or something. I didn't care. They were all great."

Second grade drawing | 1953
This drawing was presumably the result of an assignment to make a travel poster. About this time I started to create illustrated stories for classmates.

Kitchen's sensibility as a careful collector was born when his mother, like so many others of the era, threw out a stack of his comic books during a cleaning session. "I got extremely indignant," Kitchen says. "I was a well-behaved kid. I confronted her about it, and she told me if the comics were lying around my room, she'd toss 'em. So I compromised. I promised to keep them in a nice, neat pile on my shelf, but in exchange, she couldn't throw them away. She agreed, and that was my first lesson, I think, in preserving and organizing objects."

By the time he started school, Kitchen channeled his interest in comics and world-building to his social advantage by illustrating stories to entertain his classmates. "The earliest drawings I still have go back to first and second grade, and I had, certainly, a primitive style," Kitchen says. "The earliest one I saved is called 'Captain Sauerkraut,' and it's about pirates. It's laughably crude, but I remember it made my classmates laugh. I had a teacher, Ms. Mayhew, I think in second grade, who noticed the kids tittering in the back. She said, 'What's the commotion back there?' and somebody answered, 'Oh, we're reading Denis's story.' So she looked at me and said, 'Well, if you're so proud of your story, why don't you come up and read it to the whole class?' I froze for a moment, then took it, stood up front, held up the pictures, and read it to the class. I got enough giggling and what I interpreted as approval that I didn't see it as an embarrassment or punishment at all. For whatever reason, Ms. Mayhew began encouraging that. So, rather than have me pass the stuff around class and be disruptive, she would periodically allow me to do my own show-and-tell with words and pictures. That kind of encouragement feeds an ego early on, and I think that was a crucial stage in terms of my acceptance, both by peers and authority. And, slowly, my stuff got a little more sophisticated."

Kitchen's grade school years continued to be consumed with comics and drawing, which he used as a sort of social currency. When snubbed by a group of boys who'd started a club in which he wasn't included, Kitchen began his own rival gang, the Sharks, that offered his hand-drawn membership cards. Eventually the kids who'd snubbed him came around asking to be part of his club to get their own cards. "That left an impression on me," he recalls. "It showed me that by using images, I had the power to influence my peers."

By the cusp of adolescence, Kitchen had acquired traits and passions that he would continue to develop for the rest of his life. A passion for comics, a collector's sensibility, and an interest in drawing were clear. But he would also retain an insatiable curiosity and the ability to negotiate with authority, find bargaining advantages, and influence others by using art. All of these traits would serve to carry him through the challenging years ahead.

BENJAMIN KITCHEN DIED WHEN his eldest son was thirteen years old. His death pushed the already struggling household firmly under the poverty line, leaving Margaret Kitchen to raise a family that now included new arrivals James, age seven, and Gayle, age five.

"We were very, very poor," Kitchen recalls. "My mother just barely made enough money to keep us together. I remember feeling very guilty that she worked so hard and we still couldn't afford basic things. It's not like we were living in a slum, but we were definitely lower class in terms of income."

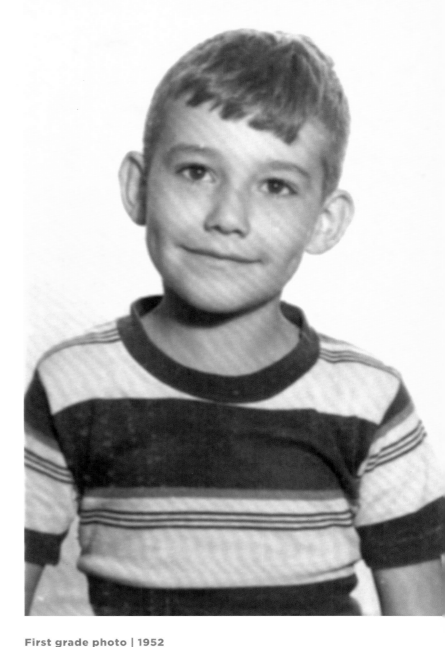

First grade photo | 1952
This photo was taken in Mukwonago, a small community in southwestern Wisconsin, where we lived for a time.

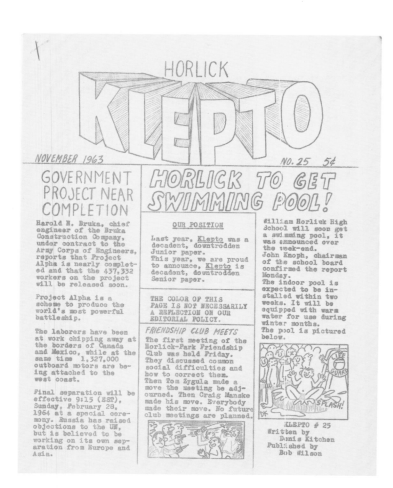

Klepto no. 25 | 1963
I wrote, illustrated, typed, hand-lettered, and sold this satirical newsletter in late grade school and in high school. Without my consciously planning it, *Klepto* proved a perfect training ground for what came later.

In addition to the economic hardship, Kitchen recalls feeling pressure to fulfill a fatherly role to his younger brother and sister, which, he says, "I was either not good at, or unfairly put into." Already out of place as a slightly bookish loner in a blue-collar community, Kitchen had to navigate the needs of his siblings and an overwhelming guilt about his mother's burden on top of the normal turmoil of adolescence. To assuage that guilt and discover his path to independence, he set about finding ways to make money, using his artistic talent and interests.

With no art or business role models in either his immediate family or neighborhood, Kitchen was left to his own initiative for finding methods of scraping up enough spare cash to allow him at least to pull his own weight in the household. Instead of trading comics with his friends, he now began to sell them. He found part-time jobs; the most memorable was painting a mural on a neighbor's garage door. "Mrs. Lewis wanted a nest of robins," Kitchen remembers, "so I drew this nest with a mother robin feeding a worm to baby robins. It was completely cute and schmaltzy, but she paid me fifty bucks, and fifty bucks was a fortune to me then."

As a precocious thirteen-year-old, Kitchen established his first publishing enterprise, a humorous three-page newsletter that he would write and illustrate for the entertainment of his classmates. At first there was only one copy of each newsletter, which he would pass around, charging a penny rental fee. "I remember being very annoyed that at least one time it didn't come back," Kitchen says. "At that point I changed the name of the publication to *Cleptomaniac*, because somebody in the class was stealing it."

Shortly after, Kitchen was called aside by a school secretary with a child in his class. She'd found out about the newsletter. "I think she wanted to see that I wasn't doing anything inappropriate," Kitchen explains. "When she saw it was good, clean fun, she started to encourage me."

Encouragement meant introducing Kitchen to the school's spirit duplicator, a primitive reproduction machine better known as a Ditto, after the name of its manufacturer, commonly used by schools and churches before photocopy machines became affordable and ubiquitous. The Ditto allowed the user to type, draw, or write on a two-ply sheet of master paper. When completed, the two sides were separated, and the back side, which was impregnated with colored wax, would be applied to a drum, where a clear alcohol solvent, or "spirit," would be added to aid the transfer of wax to the blank paper. Then the user would hand-crank out however many copies the wax master would allow, usually yielding between fifty and seventy-five. Dittos allowed users to work in multiple colors by swapping out different-colored wax sheets to fill in details in a drawing.

For Kitchen, the machine was a revelation, and with issue #12, the first to enjoy mass production, came a name change—from the variantly spelled *Cleptomaniac* to, simply, *Klepto*. "Learning that instead of just making a one-of-a-kind, I could actually *reproduce* this paper was a revolutionary thought for me," Kitchen recalls. "I remember thinking, 'Oh, my god. I can make fifty copies of *Klepto*. I can sell it!' Before, I was charging a penny to read it, but now I could charge a *nickel*. And if I sold all fifty copies, that was starting to look like real money, in 1960 dollars. They were only nickels, but they were my own nickels, and it meant I didn't need to ask my mom for money."

Quickly, Kitchen learned how to make *Klepto* into a regular three-color school satire newspaper that he sold around his class. Between the paper and odd art jobs, Kitchen realized with a jolt, "'Wow! People will pay me to do this stuff!' So, whether it was collecting nickels for a newspaper, or painting garages, or whatever, 'I *can* be an artist.' I never earned enough that I actually helped my mother in any financially meaningful way, but I took some pressure off her. It also reaffirmed that making comics wasn't an impossible dream, even though school counselors and teachers uniformly discouraged it."

As high school wore on, Kitchen continued to pursue odd art jobs and schemes, and won a poster contest while also performing well academically. As he showed signs of qualifying for college, he was once again entering uncharted waters. Neither of his parents had pursued an education past high school, and both sides of his family were working-class. Only one person in his extended family had gone to college or shown any aptitude for business—a cousin, Georgie, an electrical engineer. This was not someone who could help Kitchen build a path to becoming a professional artist.

That point was driven home when Kitchen was assigned to write a paper on career possibilities, in his junior year of high school. "You had to pick three careers, and then for the number one choice we had to interview someone who was in that field," he explains. "I wanted to be a cartoonist, but there wasn't a cartoonist I could interview in Racine, Wisconsin, where I went to school. So my distant second choice by default was an electrical engineer, just because I had a lot of family pressure, mainly from my mom. She thought, 'Your cousin's successful; you should do what he does.' It was simplistic, but the pressure was clearly there. I didn't even have a third choice, so I picked *hypnotist* to fill in the blank.

"I made an appointment to visit my cousin Georgie, who lived in a suburb of Milwaukee. It was actually a pivotal day in my life, when I look back. He had a nice home, and in his back yard he had a very large, perfectly manicured garden. That's where he was, on his hands and knees, when I showed up with my notebook in hand. I began asking him various questions about electrical engineering, clearly without a lot of enthusiasm.

"About midway into it, he looked up from his weeding and he said, 'Denis, you don't really want to be an electrical engineer, do you?'

"I said, 'Not really, Georgie. Not at all, to be honest.'

"He said, 'Let me tell you something. If I had it all to do over again, I'd be a gardener. Follow your heart. I don't really want to be an electrical engineer either.'

"That was a liberating moment, because this person I was told should be my role model was, in fact, unhappy himself. He basically freed me to think, 'Maybe I really *can* be a cartoonist.'"

Teachers and guidance counselors failed to share Kitchen's enthusiasm for his new dedication to this career path. He sought out people in his school who he thought could help him to pursue his goal, but all were clueless about how one became a

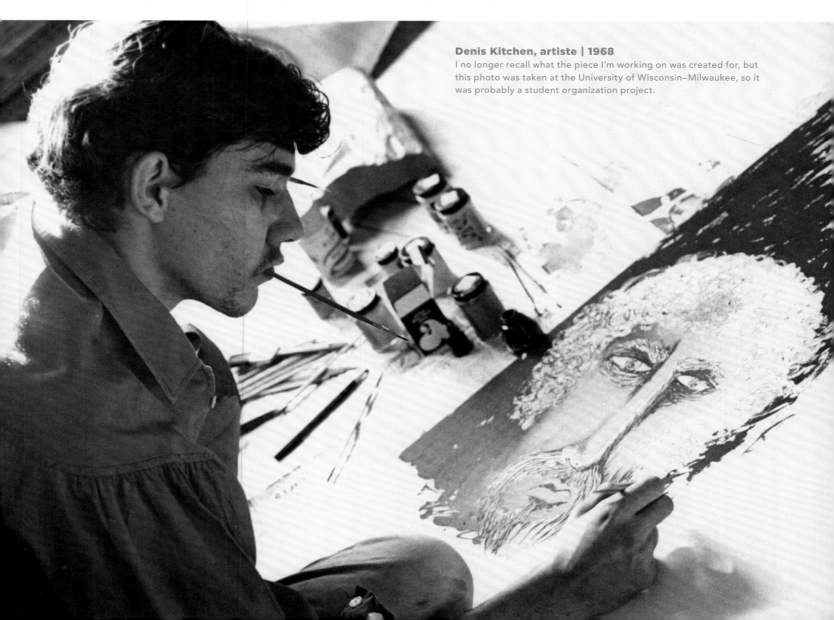

Denis Kitchen, artiste | 1968
I no longer recall what the piece I'm working on was created for, but this photo was taken at the University of Wisconsin–Milwaukee, so it was probably a student organization project.

cartoonist. "The art teacher was downright hostile to the idea of cartooning," Kitchen says. "Almost every art teacher I ever had considered cartooning well outside any definition of art they taught. So I got no help whatsoever."

Harboring the desire to become an artist, but lacking the direction, Kitchen refocused his energy towards getting into college. Here, too, he had to find his own way. His school served the community of a blue-collar region, and Kitchen recalls that guidance counselors weren't especially knowledgeable or helpful when it came to aiding him in evaluating his options for pursuing higher education. "I couldn't get useful answers from anyone. I don't remember the counselors or most teachers being encouraging at all. Only classmates and friends told me I could do it."

Despite the lack of guidance, Kitchen persevered. "I had a strong desire," he says. "If I'd followed the family pattern, I would have gotten a factory job and that would have been it. No shame in that. But I saw my father come home tired every day and just want to drink, listen to sports, or watch TV, and then go back to work. His life to me was very drab. I didn't want that life for myself."

Kitchen overcame the lack of support and stuck to his goal of pursuing higher education. In 1964 he became the first member of his family line to attend college when he entered the University of Wisconsin–Milwaukee.

KITCHEN GOT INTO UWM through a combination of smarts, persistence, desire, and chance. Though he would far have preferred to go to college in Madison, a hotbed of cultural and political activity, there wasn't a chance that he could find the money to do it. As it was, the only way he was able to afford UWM was by taking advantage of the subsidy Social Security provided because his father had died so young, in combination with commuting from home and working a succession of summer factory jobs. Even though UWM wasn't Madison, it still opened Kitchen's eyes to worlds he'd never considered, and helped him find his path through politics, vocation, and life.

Academically, Kitchen first set out to explore the options that would take him towards his goal of becoming an artist. Unfortunately, the university's art instructors were even more hostile to his interest in cartooning than his high school teachers had been. "Cartoons were repulsive to these professionals," he recalls. "It was the lowest form of crap art—maybe slightly above bubblegum wrappers or advertising in the classifieds section. I don't know what they would have considered lower." After one semester of art classes, Kitchen abandoned formal art education. "I was tempted to take the second semester because it had life drawing and you got to see naked girls, but I decided, no, academic art just wasn't for me."

After ruling out a degree in art, Kitchen sought a practical degree that would help him develop his writing skills, eventually settling on journalism. Early in his career as a journalism student, he met Dave Schreiner, who became a lifelong friend and collaborator. In Kitchen's sophomore year, Schreiner was the sports editor of the *UWM Post*, the school's student paper. Kitchen was drafted to provide illustrations for coverage of the school's football games. Those illustrations opened the door for more work with the paper, which served as a practical education in cartooning.

Meanwhile, Kitchen's extracurricular activities found him exploring his political identity. Immediately upon entrance to UWM, it was mandatory for all males to attend a several-week ROTC orientation. Though Kitchen was aware of the sixties youth movement that was developing, he hadn't yet gotten caught up in it. "I was still very straight when I started college," he says. "And I was a very impressionable eighteen-year-old. So, in September of 1964, I took this orientation, which was a pitch by the army to get you to join the Reserve Officer Training Corps. The lure was they would help underwrite your education, and you'd come out of it as a Second Lieutenant with an obligation to serve the government. Other guys were grousing about it, but I remember listening to this and getting caught up in it. I just had an innate sense of patriotism that I think was pretty normal for the time. My dad served in World War II, and I had a trunk full of his war souvenirs that fascinated me. So, I was buying the pitch. And at the end of this orientation, I signed up.

"I quickly found myself wearing a uniform and marching in lockstep with other recruits on campus a couple times or so a week, and being quite proud of it. At the same time I was meeting students, some in SDS [Students for a Democratic Society], who were very much the opposite. They didn't get why I was doing this. Within a month or so of joining ROTC, I abruptly quit. My friends on the Left were congratulating me on making the right political decision. But I never had the heart to tell them the truth. I didn't quit for political reasons, or because I stopped feeling that patriotic surge. I quit for a very pragmatic reason: the uniforms were made of wool and they itched like hell! They were so uncomfortable that I couldn't stand it! I know this is going to sound really stupid, but if their uniforms had been made of cotton, I could possibly be a Lieutenant Colonel right now. It was one of those thin threads of fate."

During Kitchen's brief flirtation with the military lifestyle, the 1964 presidential election was heating up. The race had whittled down to Barry Goldwater running against incumbent Lyndon Johnson. Kitchen recalls, "Nearly everyone I knew hated Goldwater, and I certainly wasn't attracted to the new conservatism he represented. Johnson just struck me as a corrupt politician. Even though he was carrying on the 'Great Society' that Kennedy had started, I didn't think he was a very admirable guy. I just didn't care for either of them. Then I flicked on the TV one day and there was one of these rare, paid political half-hours that the Socialist Labor Party managed to get on the air. They were running a candidate named Eric Hass, and he was saying things that made sense to me. I was very impressed by his speech, and even though he had no chance, it made me curious about the party."

That curiosity led Kitchen, who couldn't afford the bus fare, to walk several miles from campus to visit the SLP local section head. "Her name was Georgia Cozzini," Kitchen says. "In 1956 and 1960 she had been Hass's running mate for vice president, one of the very few times a woman had been on any national party ticket. She was a very sweet and smart woman, and delighted to see a college student interested in her brand of socialism. She was a student of history, a strong woman, and persuasive ideologist, so I found the party even more attractive. In hindsight, it was a dying party, bleeding members from attrition. Georgia was happy to have an acolyte locally and began to do things for me that one wouldn't ordinarily." Cozzini gave Kitchen an education in socialism that included paying his way to join her at the SLP's national convention in New York City, where he got to meet most of the party elders.

"I loved talking to all these veteran activists; I was fascinated by the party's history within the tumultuous labor movement. These people had dedicated their lives to a radically different and more just society. It attracted me. The pants didn't itch, so I applied for membership."

Kitchen was the youngest member of the party's Milwaukee section. "I think I was the only member of the section under forty," Kitchen says. "There may have been someone in their late thirties, but the rest were in their sixties, seventies, eighties. But it didn't bother me. I believed this was the best way that humanity could organize itself. Throughout my life I've always tried to be fair and egalitarian, and this philosophy embodied fairness to me. 'From each according to his abilities, to each according to his needs.' I loved that principle. I didn't see what was wrong with that."

As Kitchen's college career advanced, he was able to put enough money aside to move out of his mother's home and into a two-bedroom apartment he shared with his girlfriend Ingrid Buxton on the east side of Milwaukee, close to UWM and a few blocks from Lake Michigan. Rent was $50 a month, which he had trouble raising alone when Buxton moved out in 1967, so Kitchen took on roommates Terry Shaw and Gene Gessert. "Both were gay, though I had no clue for the longest time, and they hated each other," Kitchen recalls.

With the landlord living offsite, Kitchen seized the opportunity to use the apartment as a large canvas for his increasing interest in surrealistic art. "I got a little bold in my decorating," Kitchen chuckles. "I worked at the Pabst brewery for a summer, so the living room ceiling was wallpapered with a Pabst billboard (a huge hand offering an equally huge can of beer). One night Terry was lying on the couch tripping on acid, convinced that God was offering him a cold Pabst. The living room walls were painted in psychedelic light- and dark-green swirls with a form of fingerpaint. I had an antique Wurlitzer jukebox that played old 78s, neon beer signs, and other early signs of collecting mania. But the *pièce de résistance* was the 'mural' I painted, which covered a good part of the three long walls of the stairwell leading upstairs. I began the mural in degrees. Most was surreal, in the manner of the paintings I was doing at the same time. Some was bolder, with heavily lined, large, grotesque faces."

Back on campus, Kitchen was gaining more opportunities to advance his cartooning. In his last years of college, as a result of Dave Schreiner's encouragement, Kitchen developed a weekly strip for the *UWM Post* called *Sheepshead U*, named after a card game popular on campus. "It was pretty lame stuff, and I'm deeply embarrassed by most of it," Kitchen says, "but it was a chance to develop my craft. I had to come up with an idea every week and turn it in on time. It allowed me to get peer feedback in a meaningful way. I felt that if I were going to do this professionally, I had better get started."

In 1967 another editor at the *Post* took an interest in Kitchen's art, offering him carte blanche with the center spread of the paper. "I think the only thing I wanted to be, more than a cartoonist, was a surrealist painter," Kitchen explains. "I wanted to be Salvador Dalí—before I realized he was crazy. So when I got the opportunity to do this center spread, I did a wild, surreal drawing. It was the first thing I did as a student that I felt really proud of. I remember thinking, 'Those poor saps in art class don't get to do this. I have a forum they can't even dream of. Yeah, they can maybe hang a piece or two in the

Pabst ceiling, Milwaukee | 1970
I worked two summers at the Pabst Brewing Company in Milwaukee to help pay my way through college. One of the perks (besides all the free beer I could consume and still function) was acquiring a billboard graphic which I cropped and wallpapered to the living room ceiling of my "hippie pad." It was good for laughs, especially when friends or roommates were hallucinating.

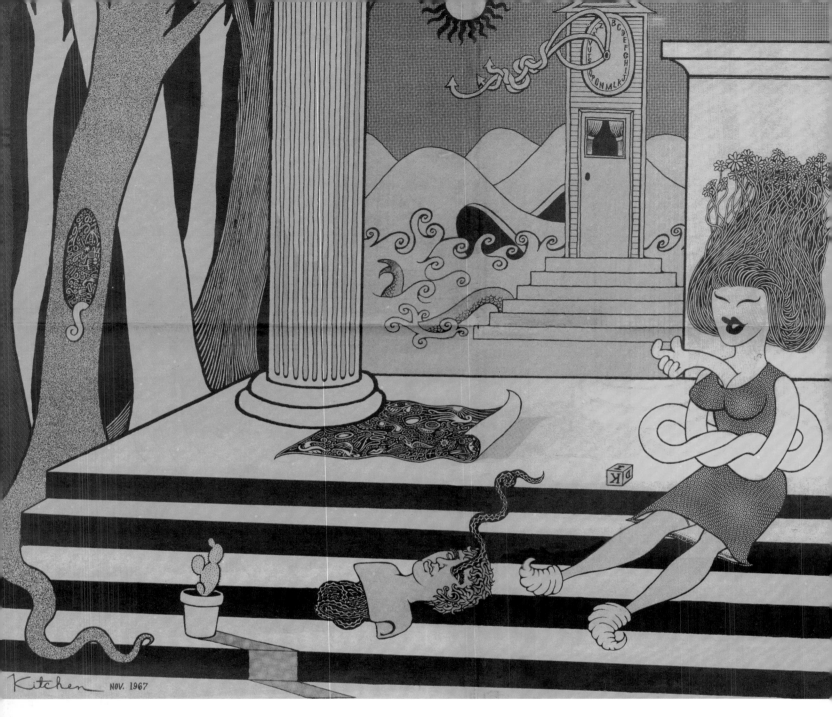

KITCHEN NOV. 1967

gallery when they're seniors, and a handful of people will go see them. I've got 12,000 students looking at my art.'"

That same year, Kitchen met Jeff Winters, whom he describes as a "very brash, cynical, sarcastic, intellectual Jewish New Yorker of a kind I had never met. I was intrigued by this guy. To a Midwesterner like me he seemed like a foreigner. Winters had a friend named Mike Guterman, and these two New Yorkers opened another world to me. They saw things differently. They were aggressive. I'd be sitting at a table with them, someone would walk by, and they'd exchange rude comments and snicker, and I'd think, 'They might be right, and they're funny, but *I* could never say that!' They'd pick up on that and tell me, 'You're too uptight, Kitchen. You should smoke some grass, get laid.' They were a refreshing pair, a

different breed from the straight kids I'd grown up with."

Winters dreamed of starting a satire magazine, which appealed to Kitchen and drew the pair together. They scoured school records to see if there was one they could revive, only to discover that there hadn't been a satire mag in the history of UWM. "So we said, 'Let's just start one,'" Kitchen remembers. "We registered as a campus organization, and after some brainstorming we decided to call [the magazine] *Snide,* because that seemed to sum up the kind of humor that Jeff, in particular, embodied. And we felt there was much to be snide about in 1967 Milwaukee."

Winters edited the magazine and Kitchen art-directed it, which included contributing gag cartoons and assorted spot illustrations. *Snide* would be considered mild by contemporary

Time Out of Whack | 1967
The *UWM Post,* my university's student paper, offered me the prominent center spread position to do whatever I wanted. It was—until this book—the only time my early surreal art had appeared in print. The Assistant Dean of Fine Arts sent a letter to the *Post* favorably critiquing the image. It was helpful encouragement, and my very first from academia.

standards, but Kitchen recalls that "it was naughty enough and provocative enough that it pissed some people off. I think we would have been disappointed if we hadn't." The first issue of *Snide* turned a rough profit of $800, which was to be reinvested in a second, all-comics issue that Kitchen would edit in his senior year. But it wasn't to be. Winters ran off with the money, leaving Kitchen with a handful of the strips that would provide the foundation of his underground comix debut: *Mom's* #1.

KITCHEN GRADUATED UWM IN June 1968 with a B.S. in Journalism, a handful of freelance art jobs, and a growing anxiety about making his way in the world. Shortly after graduation, the *Milwaukee Journal* had an opening in the art department, which he applied for. "To my astonishment, the guy hiring didn't even want to look at my portfolio. He looked at my application and said, 'You don't have a major in art.' That automatically disqualified me. He didn't even want to *look* at my samples because I didn't have an art degree. That's when I realized I was deluding myself into thinking there was logic to getting a job. I probably dodged a bullet, in retrospect. At that point, I decided to just do it myself as a freelancer."

As Kitchen set out to establish a freelance career, the war in Vietnam was escalating. While watching increasingly long lists of American servicemen killed in combat on the nightly news, Kitchen saw his peers getting called for duty with greater frequency. "I had a very nervous summer," he says. He passed the season working on advertising gigs and the odd personal comic. In early September, the letter he'd been dreading arrived. Kitchen was ordered to appear late that month for a pre-induction physical.

"It put the fear of god into me," Kitchen says. Unsure of his options, but certain that he didn't want to go to war, he turned to a draft counselor. "He looked like Karl Marx with a big, bushy, black beard. I showed him my paperwork and said, 'Tell me what I have to do. I don't wanna get drafted!'" Unfortunately for Kitchen, the answer was that you had to plan ahead, something he'd failed to do. Instead of providing a simple out, the meeting underscored that Kitchen's chance of avoiding the draft was slim—literally.

Kitchen and the counselor went down the list of exemptions that could get him out of the draft, but none were promising. As a nonbeliever without any connection to an organized church, Kitchen couldn't prove a claim of being a conscientious objector. He was in good health, so there could be no exemption for high blood pressure, flat feet, or diseases. Going down the list and seeing no out, Kitchen felt his escalating fear turn to frustration. "I was looking for anything," he recalls. "I even remember saying, 'Okay, what about my eyes? I'm seriously nearsighted!' Nope. 'Corrected by glasses. Doesn't count.'"

Clutching at any option, Kitchen said, "I'm skinny. How skinny do you have to be?" For a man of nearly 6'5", the answer was 146 pounds. Kitchen was somewhere in the 150s. "So when I left his office, my only choices were losing eight or ten pounds, or going to Canada, and I didn't really want to go to Canada."

In the weeks leading up to the physical, Kitchen went on a crash diet and steadily lost weight to the point that he was beginning to feel emaciated. But just as the notice to appear in front of the draft board showed up, he hit his goal weight of 146. He would beat the draft.

"And then I did the stupidest thing," he says. "I mean, it was so *unbelievably* stupid that I can't believe I actually have a

Stairwell mural on Frederick Street, Milwaukee | 1971
The bare walls leading to my second floor apartment seemed to beg for adornment in the late '60s, so I obliged. My hippie pals loved the work-in-progress, but a new landlord announced that he was painting the hallway. My aesthetic appeals were futile. When he was finished, I bitterly said, "I still can't believe you obliterated my artwork." "*You're* upset?" he protested. "It took me *three coats* to cover!"

college degree. It just shows that you can get a degree but still be a complete idiot." To celebrate his victory over the draft, Kitchen got a keg of beer with his friends and partied the night before going in for his physical. The celebration was premature. The next morning Kitchen weighed in at 147 pounds, and soon after received an order to report for induction.

"I was *stunned*. I'd thought I was free, and before long I'm in a plane with maybe thirty other young guys from Milwaukee, headed for Fort Campbell, Kentucky. We got off the plane, and the indoctrination process began immediately. We were very, very quickly dehumanized. First day, all the hair is shaved off. Then we put on the uniforms and started marching. Immediately. I went from hippie to buck private in twenty-four hours.

"I was scared to death on every conceivable level. I knew what the headlines were screaming. I looked at the next barracks over from us and saw the recruits from a week or so earlier outside stabbing bayonets into bales of hay. I looked around the room at the rest of the guys who came in with me, and I knew that in a few months we were all just cannon fodder in you-know-where."

Sitting on his bunk, completely depressed, Kitchen started commiserating with another guy in his barracks named Mike. "I confided to him that I had been a pound or so away from getting out. Mike was slightly overweight, and he told me that *he* had been just a degree or so off for getting out for high blood pressure. And then a light bulb went off over our heads." With two weeks to go until the final physical, the two conspired to help each other get out. Kitchen started to give his food to Mike, with the hope that the latter's blood pressure would rise from overeating while, in turn, Kitchen would lose the necessary weight.

Kitchen explains, "We assiduously planned what we were doing, but we had to be very careful. Anything that smacked of insubordination was quickly punished. Refusing to eat would have been a trip to the brig. So we had to be sneaky. In the mess hall, I'd say, 'Hey, Mike, I don't like mashed potatoes. You want mine?' He'd say sure. So I'd slide stuff over to his plate. Meanwhile, I couldn't literally stop eating, because we were marching, we were drilling, I needed energy. I was hungrier than I'd ever been. I had to find the balance between losing weight and not fainting. There was no scale in our barracks, no way of measuring any progress."

Then the day of reckoning came, and they stood in a long line waiting to see the inspecting doctor. When they got inside, the examination room was cavernous. The doctor, Captain Kranz, was sitting in a chair at the far corner of the room with a clipboard. A recently discharged soldier, waiting for his paperwork to be processed, was assisting. One by one each new recruit passed through. Kitchen's nervousness mounted.

"Finally it was my turn. I saluted the captain. He took a blood pressure reading and made other examinations. Then he looked at my chart and said, 'I see we have a little weight problem here, Private Kitchen. If you're 146 or less, you can go home. Go up on that scale, and let's see where you're at.'

I crossed the room, stepped on the scale, and my heart *sank*. It read 148—I had just missed the target *again* and was instantly nauseous. The self-torture had been wasted. I was dead meat.

"But the doctor was across the room and this young guy assisting him, who I'd never seen before and never saw again, was recording the weights. I know he saw the same number I did, but he instead called out, 'One hundred forty-*five*, Captain!' Those words possibly saved my life. I remember looking him in the eyes, stunned, thinking, 'Thank you, *thank* you!' I couldn't say it, couldn't say anything. But he knew I knew.

"The captain said, 'We don't have to send you back. If you want to stay, Uncle Sam will fatten you up.' I said, 'I think I'd like to go home, sir.' He said, 'We'll call you back. This is just temporary.' I said, 'I understand, but I'd really like to go home, sir.' He said, 'All right, you have a temporary medical discharge. I'll see you again.'

"Mike got out, too, and we took a bus back to Milwaukee. You get a plane ticket in but a bus ticket back. We celebrated, and then I never saw him again."

Twenty-two days after his induction, in December 1968, Kitchen was back in Milwaukee, and completely out of sorts. His roommates were stunned to see him back. His room was still there, but his then-girlfriend, Diane Roland, pregnant from a one-night-stand before meeting Kitchen, had moved into it. Everyone, especially Kitchen, was surprised that the ordeal was over so quickly.

"I just remember coming back. I was very mixed up. First of all, I had virtually no hair, which took getting used to. Diane, as it turns out, was ready to break up with me anyway. She'd decided to have her kid, give it up for adoption, and move on. It was all kind of awkward: breaking up with her, looking in the mirror, not feeling quite right about things, thanking my lucky stars I wasn't headed to Vietnam. The only thing that seemed important to me at the time was that 'I've got to finish that damn comic book.'"

Kitchen spent the remainder of 1968 and the first months of 1969 compulsively working on *Mom's #1* and reflecting on everything he'd been through. "The whole incident made me wiser earlier. Life is short in general, but it can be really short if you don't plan better. I remember feeling so stupid, so inherently dense for not having seen the draft counselor four years earlier, or for having bought the keg of beer a day too early. And then just the pure luck of getting a sympathetic guy in the final weigh-in. I shuddered to think that I'd done things the way that I did. I remember thinking to myself, 'You have a second chance. Do it right.'"

The following year, the army adopted a draft lottery, with 365 numbers based on random birth dates, with holders of low numbers certain to be called. Kitchen's luck continued: his birthday-based draft number came up 352, and Uncle Sam never called again.

OPPOSITE: **Military costume party, Milwaukee | 1968**
In the fall of 1968, after graduating from college, I was ordered to report for a pre-induction army physical at the height of the Vietnam War. I panicked. Already thin, I starved myself for over three weeks, succeeding in getting one pound below the army's 147-pound weight minimum for my height, 6'4". The night before the draft physical I prematurely threw a "military costume party" to celebrate, consuming much beer. The next morning at the induction center I was a pound over the minimum and before year's end was in Fort Campbell, Kentucky.

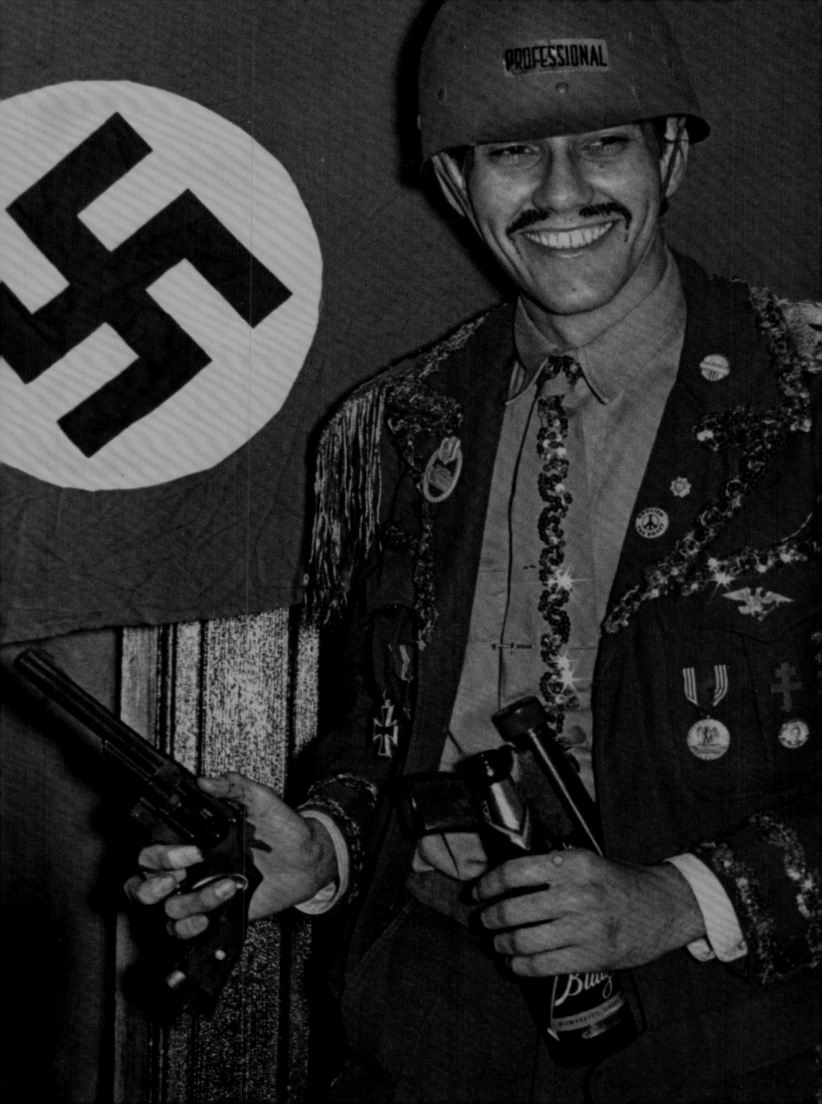

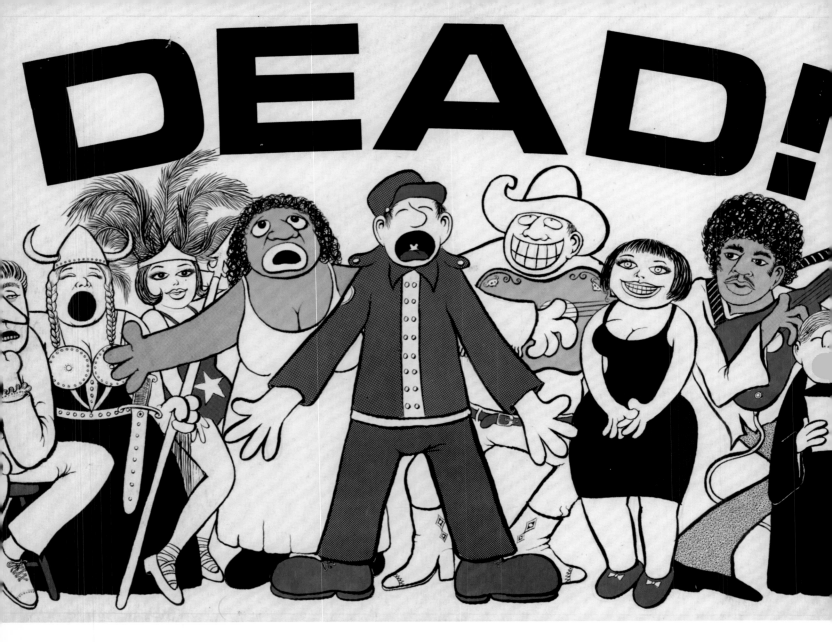

THE UNDERGROUND YEARS: 1969–1975

Mom's Homemade Comics #1 debuted July 4, 1969, at the Schlitz Circus Parade in downtown Milwaukee, where Kitchen, his brother Jim, and a new roommate-cum-business manager, Bill Kauth, walked along the route hawking the 49¢ comic to the parade's thousands of spectators. Eventually a police officer, curious what the longhairs were up to, decided that one of Kitchen's primitively rendered busty nudes was too much for the family-friendly affair and attempted to shoo them away. But, citing the First Amendment and assuring the officer that none of the comics were being sold to minors, they continued without further hassle. It wasn't quite R. Crumb selling *Zap* #1 from a baby carriage on the corner of Haight and Ashbury, but it was the sort of story that would grow to fit well within the mythology of the emerging Underground Comix movement.

Not that Kitchen knew on that July day that he was joining an art movement or committing to a path that would carry him through the rest of his life. *Mom's* was designed to be a comic book for local consumption as well as Kitchen's response to the spirit of the times. He recalls, "I was part of a generation that inherited a war that had no moral justification; racism is rampant; women are politically screwed; gays can't catch a break; the 'Man' wants to put us in jail if we have a marijuana seed in our pocket; and Nixon's in the White House. What a fucked-up situation this is. There were so many things to be pissed off about and worth fighting for or against. Everyone dealt with it in different ways, whether it was literally protesting in the streets, organizing, becoming very radicalized, or joining a commune. My first instinct was to make the cartoons my way of dealing with it."

Mom's #1 is comprised of a variety of strips that range from the gentle social satire of working-class Midwestern life in the story "South Pole," to the primitive, but effective, exercise in tragicomic surrealism, "Message," with a variety of pun and sight-gag cartoons sprinkled throughout. Kitchen says, "I think if anyone was an influence, it would have been Harvey Kurtzman. From him, I got the idea that satire could be an effective weapon, and maybe with my cartoons I could turn a few heads around, but minimally entertain kindred spirits."

In the relative geographical isolation of Milwaukee, Kitchen

Center spread from "Message!" | 1969
My roommate Terry Shaw contributed a few ideas for the first issue of *Mom's*, including a droll take on a man who learns via a singing telegram that his family has been killed.

wasn't aware that there were kindred spirits working on the same sorts of comics until he happened upon a copy of *Bijou Funnies* #1 in a used-books store while he was drawing *Mom's*. *Bijou* hailed from Chicago and was put out by Jay Lynch and Skip Williamson. When Kitchen got his own books back from the printer, Lynch and Williamson were among the first people to be sent copies of *Mom's*. Almost immediately Lynch wrote back to say, "Welcome to Underground Comix, you're the eighth one!"

Kitchen was able to print 4,000 copies of *Mom's* by using all of his savings and the meager proceeds from the local display ads he'd scrounged up for inclusion in the publication. Over the summer of 1969, he was able to unload 3,500 copies from consignment sales to local head shops and bookstores and even a sympathetic drugstore. The remaining 500 copies went with Bill Kauth when he drove to San Francisco. There, legendary retailer Gary Arlington bought them all for his shop, The San Francisco Comic Book Company. Within a month, those had been sold and Arlington called Kitchen, asking for more.

Very quickly, Kitchen realized that with this comic book he'd made for a local audience, he was becoming part of a movement already well under way. By 1969 undergrounds were exploding in cities across the country, and San Francisco was Mecca. With Bill Kauth out there representing Kitchen's interests, a deal was struck with The Print Mint, a publisher of psychedelic concert posters and early undergrounds, to reprint *Mom's* #1 and to publish the nearly completed second issue.

Back in Wisconsin, Kitchen was starting to receive feedback on the book, including letters from Harvey Kurtzman and Stan Lee encouraging him to keep going. Maybe the most significant response came from Robert Crumb, who sent this enthusiastic message: "I dig your comics, pal. Great stuff. Your sense of humor is something unique in all of comicdom. Don't even ask me how, but keep it up! And don't listen to anybody! Do it your way!!"

Mom's #2 was released in January 1970 and showed Kitchen's storytelling and art making small, but notable improvements. The work was still that of a very young artist, with all of the groaner puns intact, but the pacing was more confident and the cultural observations succeeded as gentle but pointed satire. To the major underground markets like San Francisco and New York that were used to more explicit content in their comics, *Mom's* was a charming example of Midwestern hippie humor. To local Milwaukee artists it was a beacon that led to the formation of a small scene. Likeminded cartoonists and graphic artists sought Kitchen out and joined him in the pursuit of making a few bucks while following their own individual muses. Milwaukeeans Don Glassford, Jim Mitchell, Bruce Walthers, and Wendel Pugh became a constellation around Kitchen, and would wind up becoming fixtures during this period of his life.

The new companions were a great boost to Kitchen's morale, but they didn't pay the rent. While waiting for the check to come in from The Print Mint for the *Mom's* reprint and sequel, Kitchen supported himself by continuing to grab at freelance advertising and poster gigs. When the check did arrive, Kitchen was put off that there wasn't an accounting to go with it. He explains, "I called the publisher, Bob Rita, and said, 'Hey, I got the check, thanks, but there wasn't anything with it telling me how many you printed, or how many you sold.' And he said, quote, 'Are you calling me a crook?' He said it in kind

Note from Harvey Kurtzman | August 5, 1969
MAD creator Harvey Kurtzman was one of the first persons to whom I mailed *Mom's Homemade Comics* no. 1. I was thrilled to get this encouraging note back, the beginning of what developed into a deep relationship lasting nearly a quarter of a century. It reads:

> *Dear Denis K:*
> *Thank you so much*
> *for Mom's Homemade Comics.*
> *I enjoyed reading it. You*
> *should consolidate your*
> *efforts with the West*
> *Coast guys—The Underground*
> *Comic Book is becoming*
> *a phenomenon to be*
> *reckoned with*
> *—HK*

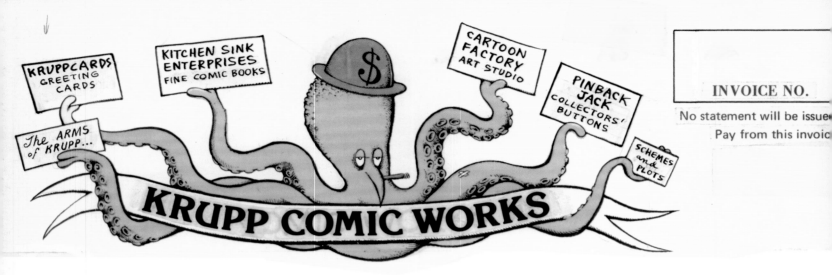

KRUPP COMIC WORKS

The ARMS of KRUPP...

KRUPPCARDS GREETING CARDS

KITCHEN SINK ENTERPRISES FINE COMIC BOOKS

CARTOON FACTORY ART STUDIO

PINBACK JACK COLLECTORS' BUTTONS

SCHEMES and PLOTS

INVOICE NO.

No statement will be issue

Pay from this invoic

of a hostile way, a very aggressive way that made me feel like I had broken some protocol. But also, instantaneously, part of me went, 'I don't like that response.' I wanted to hear something like: 'We printed 10,000, we paid you ten percent, that's what we do with everyone.' I didn't get anything like that."

Unsatisfied by his conversation with Rita, Kitchen called Jay Lynch, who was publishing *Bijou Funnies* through The Print Mint, and asked whether he and Williamson were satisfied with the publisher. Kitchen discovered that they, too, were unhappy because of slow payment and a feeling that they didn't trust, or like, Bob Rita either. Kitchen remembers telling Lynch, "Christ, I just don't want to do business with him. I know how to publish. I already did the first one, so I guess I'm just going to do my next book myself again."

Lynch encouraged Kitchen to take this path, and then he upped the ante. He asked if Kitchen would publish *Bijou* as well.

"Sure," Kitchen said, without thinking it through. "Two's as easy as one."

With those fateful words, dripping naive youthful optimism, Kitchen embarked on an enterprise that would dominate the next thirty years of his life.

AGREEING TO PUBLISH *Bijou* was a classic example of Kitchen's entrepreneurial ambition in action: seize the opportunity now, and figure out how to realize it later. It's a motif that would appear over and over again that year, 1970, and throughout his career.

To his credit, Kitchen saw the opportunity in very clear terms. "What I had going for me was that there was a rapidly growing market amongst hippies—what we now call a niche market. And hippies included a lot of middle-class kids who had disposable income. They also had a certain fashion sense, and clearly had tastes that weren't being fulfilled by the mass market, in literature and certainly in entertainment, like comics. The handful of underground comics that were out there—like *Mom's*, or at first *Zap*, and *Bijou*—as far as I could tell, were being eagerly snapped up by freaks who could find them. And freaks seemed to be everywhere, not just the Bay Area. What

that told me was that countless young, hip readers were looking for comics to take back to their pad or their dorm room, to get stoned, and have a few laughs. That's exactly what I would have done with a *Zap* or *Bijou*.

"My own little experiment with *Mom's* #1 confirmed it. I printed 4,000, because that's how many I could afford to print. I sold 3,500 of those just in my neighborhood on the east side of Milwaukee. And I sold them all on consignment. I remember thinking, 'Jeez, if hippies in Milwaukee-fucking-Wisconsin will buy my comics, they're gonna buy 'em in Topeka, and they're gonna buy 'em in Cincinnati. There are hippies everywhere, and there are head shops everywhere'—so it was just getting the comics out in front of them."

Though his reasoning would prove to be solid, the truth was that Kitchen pulled off self-publishing a single comic book in a receptive marketplace, but he had no idea how to run a publishing company and absolutely no working capital to establish one. He was still living a bohemian hand-to-mouth existence that relied on commercial work from local clients to make his meager rent. Although not having a job to report to was an advantage in terms of time, Kitchen still had to slave many hours a day at the drawing board to meet his obligations to clients while also making his own comics. Solving the problem of obtaining the capital and labor to make his publishing ambitions a reality went through a variety of trials and errors.

The first solution involved turning to his roommates, Gene Gessert and Terry Shaw. The latter had contributed some writing to *Mom's* #1 and had some of his own money. Gessert found an investor, V. Frederick Nast III, heir to a local cement fortune, who was willing to buy into the enterprise. The three decided to form a company, which they called Kumquat because they found the word to have a vaguely erotic edge. Kitchen Sink Enterprises, the label Kitchen had placed on the cover of *Mom's*, would remain the name of the publishing imprint of the new company, which would incorporate when Nast's investment came through.

The first book on deck was the anthology *Teen-Age Horizons of . . . Shangrila* #1, edited and packaged by Jay Lynch. Kitchen's "I Was a Teen-Age . . . Hippie!" led off the book, which also

Krupp Comic Works trademark | 1970
When I decided to form a cartoonists' cooperative, I invited Jim Mitchell, Don Glassford, and other artists over to brainstorm on the name. Hours of animated discussion led nowhere. Finally, well past midnight, I turned in desperation to a nearby book, *The Arms of Krupp* by William Manchester. "How about 'Krupp'?" I tossed out wearily. By then all resistance had broken down, and I interpreted grunts of "I don't give a fuck" as yes votes. Naming ourselves, even ironically, after a Nazi munitions manufacturer didn't faze us. Being fond of octopuses (see *Mom's* no. 1 cover), I took the "arms of Krupp" rather literally, with each tentacle grasping ever-changing company divisions.

included contributions from Lynch, Justin Green, Dan Clyne, Don Glassford, and Jim Mitchell. The book was finished during negotiations with Nast, so rather than wait for their deal to be finalized, Kitchen published it, listing the still unconsummated company Kumquat Productions in the indicia.

Thinking Nast's participation was a done deal, Kitchen proudly presented the investor with the freshly printed comic. Clyne's "Hungry Chuck Biscuits," an outrageously crude tale of a teenager afflicted with anal worms who infects his entire school, was a deal-breaker. The story was chock full of toilets, enemas, and butt jokes. Nast and his squeamish fiancée were appalled and pulled out of the nascent operation. By this point, Kumquat had already committed to publish *Quagmire*, which turned out to be appropriately named. The well-drawn, but incoherent one-shot by Green Bay discoveries Pete Poplaski and Dale Kuipers was, in Kitchen's words, "as big a dud as an underground comic could be in an insatiable market." Fortunately, Kitchen's freelancing had become lucrative enough that he was able to pay for the book out of pocket, but it taught him the hard lesson that he had to be more discriminating if he was going to survive as a publisher.

Luckily, *Quagmire* proved to be a temporary setback. Late that summer of 1970, Robert Crumb took advantage of the standing offer to visit Kitchen, riding a bus up from Chicago with Jay Lynch. Both artists were taken in by the far-out Dalí-by-way-of-Bushmiller mural decorating Kitchen's entry stairwell. Crumb poked around the pad and found that he and Kitchen shared many interests, including an affinity for old *Little Lulu* comics, and especially for 78 rpm records. Crumb even offered to trade pages from *Snatch* for some of Kitchen's records. Over the course of the visit, talk turned to business. Lynch taking *Bijou* to Kitchen was a strong show of confidence in the young publisher's abilities. That, in concert with their kindred interests, inspired Crumb to pledge his next comic to the fledgling imprint.

Kumquat ultimately failed to get off the ground, so Kitchen decided to try again. With *Bijou* #5 and *Mom's* #3 in the pipeline and a new Crumb book expected soon, he established a new entity with a different business model. Gessert, guilt-ridden over the ordeal with Nast, invested $1,000 in the new company with the understanding that he'd be repaid with ten percent interest and would give his shares back when that happened. Knowing that he'd need labor and talent as well as capital, Kitchen organized the new company as an artists' collective under the principles he believed in as a card-carrying Socialist. To that end, Don Glassford and Jim Mitchell were recruited to become partners in the new venture on a sweat-equity basis. On top of delivering their own books, *Deep 3-D Comix* and *Smile*, respectively, they were expected to edit books, as well as to participate in business chores like filling retail and wholesale orders, packing boxes, and stuffing envelopes. The entity would eventually include several distinct operations. Kitchen Sink would continue under the new umbrella as its publishing arm; Cartoon Factory would be the commercial art shop; Kruppcards would release greeting cards; and Pinback Jack's would offer collectible buttons. The company incorporated in September 1970 under the unlikely name Krupp Comic Works, Inc., after a book on Kitchen's coffee table called *The Arms of Krupp*, about a centuries-old German munitions manufacturer.

At the same time as he was assembling his socialist comics-publishing enterprise, Kitchen was chosen as the SLP's candidate

Denis Kitchen and Robert Crumb | 1970
Robert Crumb famously collects vintage 78 rpm records, and I collect 78 rpm jukeboxes. In September 1970 he visited me in Milwaukee. Joined by Dave Schreiner, we went record hunting in Sheboygan and nearby Grafton and Port Washington, small towns north of Milwaukee where a significant percentage of America's "race" records were recorded and pressed in the 1930s. A few months later Robert delivered his art for *Home Grown Funnies* and memorialized the trip by putting "The Snoid from Sheboygan" on the front cover.

Bugle-American no. 3 cover art | 1970
Loose women (free love), a smorgasbord of drugs, and revolution all beckoned in 1970, but some young cheeseheads could resist all three temptations. Finding Madison a somewhat unwelcoming market, the addition of Milwaukee to the logo foretells the *Bugle*'s eventual move to a new headquarters.

for Lieutenant Governor of Wisconsin. "I reluctantly accepted the nomination, partly because I was flattered, but at the same time because I realized, from a pragmatic point of view, these old-timers were looking for fresh blood to carry on. I was part of a larger youth movement, but in this narrower instance I represented their own youth movement. So, even though I felt inadequate to the task and was already busy as hell, I accepted." The office was a part-time job and would have provided an income if he won, which, of course, he had no chance of doing. Kitchen got 5,000 votes, mostly from his neighborhood on the east side of Milwaukee.

In another example of saying yes to an opportunity first and figuring out how to make it work later, Kitchen became a founding partner in *The Bugle-American,* a Madison-based alternative weekly that also started in September of 1970. With all of his limited financial resources devoted to establishing Krupp, Kitchen had no money to invest in the paper, so he put in sweat equity as its art director. College pal Dave Schreiner, with journalists Mike Hughes, Mike Jacobi and his wife Judy, were the other partners. The commitment meant that Kitchen spent three days a week in Madison, where he was responsible for laying out the paper and providing most of its illustrations. On top of that workload, he also established a page of comic strips, for which he and his Milwaukee colleagues Glassford, Walthers, Mitchell, and Pugh, and sometimes others, would draw a strip every week. Having a regular and repeating deadline for the first time led all of the artists to become more accomplished.

Perhaps it was because he was so diligent in doing his own unpaid, sweat-equity work for the *Bugle* that Kitchen quickly became very frustrated to find that his partners in Krupp didn't share his work ethic. "I assumed everyone would be as motivated and hard-working as me, which was a big mistake," Kitchen says. "I literally, on faith, gave away something like seventy percent of the company. And basically, nobody wanted to do the shit work. I had to wrangle them to help me physically pack and ship the books, and other mundane tasks. We couldn't pay anyone, and they were partners, so they had to do the work, and eventually they'd see the reward. But there was always grousing. I understood that they had other personal obligations, too, but the tasks had to be done or they'd back up. Since the 'office' and 'warehouse' were my apartment and attic, it was too often just easier to do it myself late at night."

For a while the partners had clerical help from an eager volunteer and underground comix fan named Linda, self-described as "the Dragon Woman." A counterculture veteran of the Alternative Press Syndicate and the *Bugle*'s rival alternative paper, *Kaleidoscope,* she was well organized, kept thorough meeting notes, had good connections, and asked for nothing in return. Nothing in monetary terms, that is. A free-love advocate, she regularly and aggressively expressed a desire for the partners—the handsome Mitchell in particular—to satisfy her in other ways. Since not one of the partners could motivate himself to show physical affection for the approximately 250-pound Dragon Woman, an unusual crisis developed.

The three partners realized they had to end the awkward situation, but critical Krupp business files were maintained at Linda's apartment. They went there to delicately inform the Dragon Woman that they were terminating her services and retrieving their records, but there was no delicate way to explain their rejection to the volatile volunteer. Exploding in anger, she

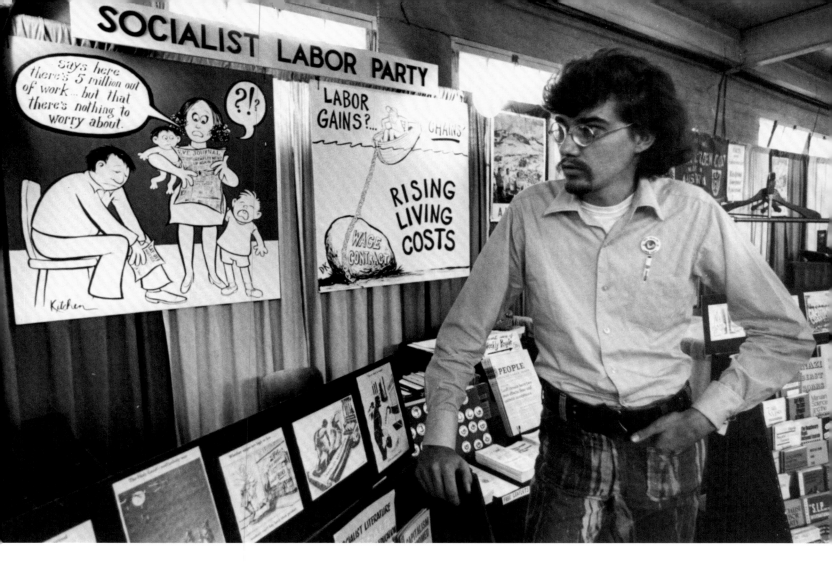

threw a heavy glass ashtray at Mitchell. It shattered inches from his head. The three men grabbed the files and fled in terror.

With the Dragon Woman out of the picture, the paperwork load fell solely on the already exhausted Kitchen. The lack of effort and enthusiasm from his partners contributed to Kitchen's growing disillusionment with the tenets of socialism. "I honestly thought that when the revolution came, everybody would work equally hard and share the labor and rewards," Kitchen recalls. "I remember going to a socialist lecture where the guest speaker said it took forty hours to assemble a Ford Fairlane, from start to finish, and that under socialism, anyone who worked forty hours could exchange their labor credits for a car like that. No matter what you did—doctor, garbage man, factory worker, or cartoonist—labor was what mattered. If you worked forty hours, you'd get your car. That was the kind of simplistic egalitarian thinking that I had. I also believed that people are basically good, that they'll work hard when properly motivated, classless society or not.

"So, when I started Krupp as this idealistic collective, my premise was that artists would be paid a fair share and they would get accurate and regular accountings, a lesson from my Print Mint experience. They'd retain all rights and have creative freedom. Those essential principles remained in place always. But my other assumption was that my collective partners bought in to the same ideals: we're going to work hard, we're going to build something, and we're going to share the wealth together. The revolution's not necessarily around the corner, but this is a fair way to structure things. Well, in reality, these guys—any guys—would rather get stoned, be with their girlfriends, go to a movie, whatever, than doing their full share of tedious, unpaid work."

During the state's gubernatorial election, Kitchen appeared at forums organized by groups like the League of Women Voters, which invited all minority party candidates to participate. He found himself answering some questions in a "rote party manner," not necessarily believing he was right. His growing loss of faith with socialism—and with Krupp's flawed business model—was accelerated by ridicule from his increasingly serious girlfriend Irene Nonnweiler. "She was adamantly opposed to my politics," he recalls. "She thought it was a waste of time, especially when I was stretched from so many other obligations. Ultimately I concluded that the Socialist Labor Party was a form of religion. Its belief system was principled, but rigid, and in many ways inflexible to changing times. The party's literature treated Karl Marx, Friedrich Engels, and Daniel De Leon like the equivalent of

Denis Kitchen at the Socialist Labor Party booth at the Wisconsin State Fair | 1970
In the late '60s I was a member of Section Milwaukee of the Socialist Labor Party. America's original socialist party (1877), the SLP peaked in influence around the turn of the twentieth century under the leadership of Daniel De Leon. I painted the backdrops and helped man this state fair booth. In 1970, not yet twenty-four, I was the party's nominee for Lieutenant Governor, not for my political acumen but so the aging state membership could groom the only person in its youth movement. In 1971, under pressure from my wife, and disillusioned with Marxism, I resigned.

Catholic saints, which especially bothered me." After nearly six years with the party he resigned, never looking back.

By the end of 1970, Kitchen was still starving (to the degree that he'd placed an ad literally saying as much and hawking his original art, in a December edition of the *Bugle*), but he'd found his place in the world. As an artist, he'd had two well-received, commercially successful books come out, and had established a presence in the alternative press, while continuing to pull in commercial jobs. As a publisher, he'd released four titles under the Kitchen Sink imprint: *Bijou #5*, *Quagmire*, *Smile #1*, and *Teen-age Horizons of . . . Shangrila #1*. At twenty-four years old, he had established himself in his chosen field. His next challenge lay in figuring out how to make a living from it.

THE FOLLOWING YEAR, 1971, began with a special delivery from New York. Phil Seuling, the organizer of that city's famous comic book conventions, had somehow run across a copy of Kitchen's *Bugle* ad pleading for people to buy his original art, and responded not with a check but with a large Coney Island salami instead! The attached note read: "Never let it be said that Phil Seuling let cartoonists starve." It was an auspicious start to what would become a momentous year.

In mid-January, Crumb turned in *Home Grown Funnies*, which would become Kitchen Sink's first bestseller, eventually moving over 160,000 copies. The book's immediate success allowed Kitchen to pay Gene Gessert's investment back in full, leaving Kitchen, Glassford, and Mitchell as the sole remaining partners in Krupp. *Home Grown* took the company to the next level. No one was drawing a salary yet, but the book's success allowed the partners to reinvest in inventory. Most satisfying to Kitchen was that after *Home Grown* and *Bijou* were released, no one would call Kitchen Sink "the Charlton of underground comix," a slur made by west coast cartoonist Roger Brand in an early fanzine, that had infuriated Kitchen. Kitchen Sink was now seen as a serious player in the world of comix publishing.

Continuing the year's high spirits, Kitchen and Irene Nonnweiler married in February. The newlyweds moved into a new apartment on the east side of Milwaukee. Kitchen took his newfound domesticity as an opportunity to get more serious about making it as an artist. To that end, he made an appointment to visit Bill Sanders, the *Milwaukee Journal*'s respected editorial cartoonist, to solicit craft advice. Sanders patiently looked through the young artist's portfolio and saw potential. Kitchen recalls, "He said, 'You have great promise, but you're using the wrong tools.' I had been using ordinary ballpoints, felt-tips, and sometimes crow quill dip pens. Then [Sanders] did a very important thing. He opened a drawer, and he gave me two new Winsor & Newton Series 7 #3 sable brushes, which I sometimes call 'the cartoonist's violin.' He told me that learning to use a brush would take some practice, but once I got the hang of it, I'd never go back. These were very expensive brushes, not something I would have gone to an art store and bought. Once I learned to control the point and the pressure, it was like I had been driving a Ford and now was in a Cadillac. That was a very important professional step."

The weekly strips in the *Bugle* proved to be an important outlet to put the new tools to the test. By now, Kitchen had settled into a routine that caused endless anxiety for his partners at the paper, but proved invaluable to his artistic development.

He recalls, "Every week I'd be in Madison for three intensive days, spending all that time laying out the paper,

drawing ads, sometimes drawing the cover—just helping in every respect that I could. And so, when it came to the strip, I would wait until the last minute to get started, which tended to be the way I dealt with deadlines regardless. What I found out, and what I thrived on, was a certain creative adrenaline. I could wait until the last minute, which meant until around six o'clock on press days. I would sit at the drawing board, when everyone knew the paper had to go to the printer at midnight. And the same thing would happen every week. Usually Mike Jacobi or Dave Schreiner would come over and say, 'You got your strip?' and I'd go, 'I'm starting it now.'

"They'd go, 'You're starting it now? It's six o'clock!'

"'Yeah.'

"'You got an idea?'

"I'd say, 'No. Leave me alone.'

"I knew it would take me a good three hours or so to pencil, letter, ink the panels, and hand-cut Zip-A-Tone screens. So I'd sit there, tap my pen, put my feet back, have a drink, and make them nervous as hell. The other cartoonists had delivered their strips on deadlines I'd imposed. I think I was scared as hell the first few times—but I'd be sitting at the drawing board, and suddenly, it's like 'poof!' And once the 'poof' happens, and it happens again, and happens again, you start to have faith in that 'poof.' There are certainly a few weeks where you would think, 'Aw, man, that one was a stretch.' But oftentimes, something somebody would say, something I'd read in the newspaper, a conversation I'd overheard would give me the angle, and sure enough, sometime between eleven and midnight the ink would be dry, and everything would go in a big, flat box, and my final task was to drive all the mechanicals to the Port Washington printer's third-shift crew, because it was in the general direction of my drive to Milwaukee and my other unpaid job. This routine gave me confidence that I could come up with something under extreme duress, a stress largely self-imposed, because I had this arrogance that I would come through. If I didn't, there'd be a big blank spot on the page, and I couldn't let that happen. That would be unacceptable."

Concurrent with achieving the ability to deliver a gag under pressure, these eleventh-hour performances showed Kitchen making radical strides over the drawings that had appeared in the first two issues of *Mom's* and the first *Shangrila*. In relatively short order, Kitchen achieved a greater economy of line and a more fluid brushstroke that enabled him to convey a much fuller range of expression and atmosphere. Readers following Kitchen's art over the course of 1971 saw his mature style come into flower at a rapid clip.

Unfortunately, this personal and creative honeymoon wouldn't last long. Within weeks of marriage, Kitchen and his wife were expecting their first child. Kitchen says, "Suddenly it was like, 'Whoa, I've *really* got to get serious now. It's not just meeting the rent now. I'm in love, my wife is pregnant, there's a kid on the way. How am I going pay for things? Jesus Christ, what am I gonna *do?*'"

Kitchen evaluated his situation and decided that, of his various options, publishing comics seemed like the most viable bet for supporting his new family. "My freelance income was very erratic," he recalls, "and even then, in its infancy, publishing, ironically enough, seemed like a safer way to make money than just my own labor. Publishing meant I got a piece of everything, and if I did enough things in a year, a piece of each project would theoretically add up to more than all of

what I could do myself." Publishing also promised more creative fulfillment to Kitchen. "The commercial stuff I did was largely boring or restrictive assignments for clients like Schlitz Brewing Company, the *Milwaukee Journal,* and local retailers or concert promoters. So I decided: I'm gonna get really serious about producing comics."

Though Kitchen's dedication was sincere, his and his partners' lack of formal business acumen was a significant obstacle that had to be overcome before Kitchen Sink would produce even the most meager profit. Although he and his partners were elated by *Home Grown Funnies'* strong sales, Kitchen still concluded he was disproportionately pulling the company's weight. Glassford managed to get *Deep 3-D Comix* out in 1971, which, Kitchen admits, "was a legitimately mind-blowing comic at that time," but Glassford was reluctant to do any of the heavy lifting, literal or figurative, that went into making the publishing company function.

Every time a new comic was printed, Kitchen had to drive his 1953 Cadillac hearse to Port Washington, fill the cavernous vehicle with product, drive to his apartment, and get one or both partners to carry the heavy boxes up three flights of steps to his attic, the only storage space available.

It was an exhausting, repetitive task no one was eager to do, but unavoidable. Conversely, as orders came in, the same boxes had to be repacked, labeled, and removed from the apartment for delivery to the post office. With each passing month the burden grew and tempers occasionally flared, but no one had a better solution.

Kitchen found Mitchell to be a somewhat better partner on the labor side. He could more reliably be counted on for packing orders, and he made his weekly strip deadlines for the *Bugle*, but, critically, Jim wasn't able to deliver the anthology titles that he'd been announced as editing. Mitchell was also responsible for the Krupp Syndicate, which distributed the weekly *Bugle* strips to about fifty subscribing alternative and college papers, but very few ended up paying, and the division had to be aborted.

For the most part, Kitchen was the one whose sweat and funding were moving the company ahead. He got a third issue of *Mom's* out the door, while also shepherding issues of *Cloud Comix, Bijou* #6 (along with KSP reprints of earlier *Bijous*), and *ProJunior,* an all-star anthology dedicated to Don Dohler's reverse-pupil, common-use character, featuring stories from Kitchen, Mitchell, Lynch, Williamson, Crumb, S. Clay Wilson,

***Group Self-Portrait* | 1971**
Six fellow underground cartoonists and I jammed on this group self-portrait for *Funnyworld* magazine. Back row (from left): me, Don Glassford, Jim Mitchell, and Skip Williamson. Front row: Jay Lynch, Bruce Walthers, and Wendel Pugh.

Bill Griffith, Justin Green, and many others, along with a jam strip that was a veritable Who's Who of underground comix. Kitchen did all this while maintaining his three-day-a-week commitment to the *Bugle* and organizing the day-to-day affairs of Krupp.

Somehow, Kitchen was also able to find time to teach a non-credit course in Comics Appreciation at his alma mater during the summer. Thirty students registered for the course, which brought in guest speakers Robert Crumb, Jay Lynch, and, most significantly, Harvey Kurtzman, who delivered a public lecture that June called "Why Flash Gordon Uses a Sword Instead of His Ray Gun." Kitchen worked hard to spread the word about Kurtzman's appearance. His hustle yielded a standing room only attendance in a 500-seat lecture hall in the middle of summer, with eager TV crews and journalists waiting to talk to the creator of *MAD* and of *Playboy*'s "Little Annie Fanny." It was Kitchen's first face-to-face contact with Kurtzman, who was won over by the effort the young cartoonist/publisher had put into managing the appearance. That event created a professional bond between the two that would permanently link their careers.

After the triumph of the Kurtzman appearance, Kitchen went to New York as a guest of Phil Seuling's July 4 Comic Art Convention. Seuling had invited Kitchen to come out for the event in the course of the correspondence they'd struck up following the exchange of the life-saving salami. By this point, Seuling was one of Krupp's best customers, distributing the company's comics to the east coast. Kitchen had heard about the New York conventions, but had no idea what to expect. This turned out to be another life-changing experience.

Kitchen recalls, "It was an unbelievable eye-opener for somebody like me, who had grown up loving comics in an era when there were no comic shops, no place you could find these things except through hard digging at maybe a used-books store that had a cardboard box in a back room. Nobody was selling them in any organized way. To suddenly attend a convention with dealers selling comics in a very methodical way—actually seeing back-issues in numerical order and priced—it was very heady.

"The undergrounds were treated with respect in a way that definitely surprised me," Kitchen says. "The fact that Phil was willing to display all the undergrounds, and to have an underground panel, and to bring me out on whatever limited guest budget there was, made me feel somehow legit. Not only were there organized fans out there, we weren't ostracized. The newsstand comics were clearly a different world from undergrounds, but the one place they overlapped was at a gathering like this where a reader could be looking for both undergrounds and back-issues of newsstand comics, and it wasn't contradictory. It was just being a comics fan."

At the convention, Kitchen got to meet a number of people he'd only known through correspondence and/or their work, including Bud Plant, Leslie Cabarga, Vaughn Bodé, and Art Spiegelman. The biggest surprise, and most significant encounter of the event, came when French comics historian Maurice Horn approached Kitchen and told him that Will Eisner, who was also attending his first comic book convention, wanted to meet him. "It just blew my mind!" Kitchen says. "To this day I'm still astonished to think that Will sought me out. Even then he was a legendary figure, and I was still pretty much in my infancy."

The two went up to a private suite, and Eisner, after the initial niceties, started peppering Kitchen with questions about how the underground business worked. Kitchen says, "He asked about non-returnable distribution, copyright ownership, the lack of censorship, and all manner of things. I remember answering as carefully and accurately as I could. When it seemed like there was an opening or a pause, I'd start to say, 'You know, I'm really curious how things were in the old days,' and he'd brush it off. He'd say, 'We can talk about that later. What I'm really interested in is . . .' and then we'd go back to the mechanics of how the new system worked with undergrounds. The fact that we sold non-returnable blew his mind the most. He asked how we got away with it, and I explained that we just offered an offsetting deeper discount, and customers came back. I took for granted that this was an obvious and efficient method, but it just blew his mind. It violated every business model he had ever worked with in publishing.

"I think what fascinated him was that elements he wished he'd had as a young cartoonist, but never did, suddenly seemed like they might actually be within reach. So, instead of encountering the clichéd 'hippies who haven't bathed for a week,' he saw artists who were getting royalties, who were creating for a peer audience, dealing with sometimes deep subjects, and whose books were distributed, not by newsstands, but in some peculiar system he didn't quite understand.

"We were having a wonderful conversation. Then Will asked me to show him some of the undergrounds, which, until that point, had been very theoretical to him. So we went down to the convention floor, where Seuling had a very long spread: two or three tables of undergrounds. And, of course, Will at random picked up an S. Clay Wilson comic and, well . . . he didn't react well. The artistic freedom, in principle, was important to him, but to actually see an explicit example clearly turned him off. The irony, I guess, was that although our business model was enormously appealing, the actual product provoked a generational culture shock that took a while for him to get over. I didn't see him again the rest of that show, and felt really bad about it, because I thought we had made a connection. Of course, obviously, I followed up by mail, and the rest is history."

After two seasons of strong creative and networking strides, the business still barely fed the Kitchen checkbook, and Irene's pregnancy meant an addition to the family. Books were selling, but Krupp was still only breaking even. *Mom's* #3 and *Hungry Chuck Biscuits* each eventually moved 40,000 copies, and none of Kitchen's titles sold less than 10,000 copies, but the ever-growing demand to keep work in print meant that as soon as money came in, it had to go right back into the company to maintain momentum. Kitchen's own royalties—from *Mom's* and from his contributions to anthologies—were decent, but with all of the commitments on his plate, those royalties wouldn't be enough to raise a family and keep his enterprise healthy.

That fall help arrived in the form of Tyler Lantzy, an aspiring comics writer who had just graduated from Notre Dame with a business degree. Lantzy was coming through Milwaukee to visit Jim Mitchell, who was friendly with both Lantzy and Dan Molidor, Lantzy's cartooning collaborator. Mitchell wanted Kitchen to sign off on publishing the pair's submission, *Dirtball Funnies*. Lantzy and Kitchen met, sparked a joint, and hit it off. Before long the conversation turned to business. After hearing how the underground comix supply chain was structured, Lantzy observed that Krupp looked like a potential gold mine. The company was selling comics as fast as they could be printed, in remarkably high numbers. The sales were non-returnable. The comics were generating an average of forty to fifty percent

THE MILWAUKEE JOURNAL

INSIGHT

Sunday APRIL 29, 1974

Milwaukee's
Comics
Capitalists

page 10

***Insight* cover feature | 1973**

The city's "Comics Capitalists" were featured in a *Milwaukee Journal* Sunday magazine article just before the underground comix market crashed in 1973. Front row: artist Peter Loft and business manager Tyler Lantzy. Back row: artist Peter Poplaski, retail and mail order manager Terre Lantzy, me, and my assistant Annie Guthrie. The ghoul standing behind us is by John Pound from his cover of *Death Rattle*, volume 1, no. 2. The lovely building served as our offices and warehouse at the time.

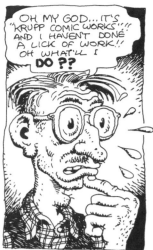

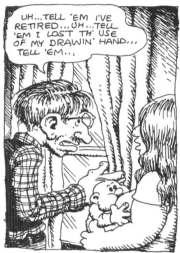

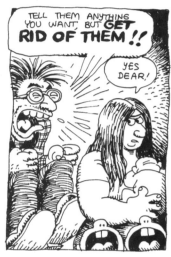

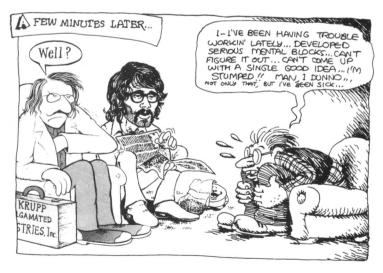

Detail from "California Jammin'" | 1971
In December 1971 Jim Mitchell, his girlfriend Donna, his malamute Kemo, and I set off in his van on a cross-country trip, jamming with cartoonists we visited along the way: Richard Corben, Jack Jackson, Dave Sheridan, and R. Crumb. Here Crumb depicts himself unsuccessfully dodging us.

of cover price for each book, and the printing was reasonably inexpensive. "So," Lantzy asked, "why aren't you rolling in dough here? Who's running the business?"

"I told him the honest-to-god truth," Kitchen says. "We were just breaking even. 'And to the degree that anybody's running it, it's me, and I'm stretched thin and don't really know what I'm doing on the financial side.'"

"Well, shit," Lantzy said, "you need a business manager. I'll apply."

Kitchen said, "I don't have any money to pay you. I'd give you the same deal I gave these other guys—a piece of the company. But I have to know you're really serious and will do your share."

Lantzy assured Kitchen that he was serious, and asked for a week to study the company's books. Kitchen turned over all of his accounting records, and a few days later Lantzy came back, still very interested. He made some calls and discovered that what Krupp was paying for printing seemed right, and the wholesaling terms looked standard, so it didn't make sense that the company wasn't making any money. He asked Kitchen where their royalty—sixteen percent of cover price to artists—came from. That figure in particular jumped out.

Kitchen said, "The guys who ripped me off take ten percent, so I want to be more generous." One-sixth had seemed a fair royalty to Kitchen. "I'm a socialist," he remembers, answering with a sheepish grin. Lantzy took out a calculator and explained, "Look, you just gave away all your profits last year to these artists." Lantzy's research showed that ten percent was in fact the royalty each of Krupp's competitors paid, as well as what old-line publishing houses in New York had settled on historically as the right business model, so the extra six percent Kitchen was paying was money he was needlessly, and to his own detriment, giving away. Lantzy agreed to be Kitchen's business manager and partner under two conditions: that they wouldn't overpay the artists and that Lantzy would make the business decisions, while Kitchen would continue to make editorial and creative decisions. Kitchen still owned the largest share of Krupp, but Lantzy had the option to acquire a significant portion. He also examined Glassford's and Mitchell's option obligations and insisted that if they didn't deliver on their sweat-equity duties, they'd have to be ousted. Kitchen, pleased to have a serious and ambitious partner aboard, agreed.

Kitchen recalls, "I was impressed by the fact that Jim Mitchell was his friend but Tyler was ruthless enough as a businessperson to say if Jim and Don don't do their agreed share, they're out. I had difficulty with those kinds of confrontations. He had a business head, but was also a 'head' in the hippie vernacular, he loved comics, and he was willing to relocate to Milwaukee. Bringing Tyler in as a partner was the first really smart move I made, because it allowed me to edit books and focus on the correspondence with artists, while he took charge of the side of business that I found very unappealing."

Lantzy came on as the company's first salaried employee, pulling in $75 a week. He ran the office, and immediately set up a new bookkeeping system, oversaw an aggressive sales push, and put measurable demands on his partners. For the first time, Krupp was doing better than breaking even.

It was a period of adjustment for everyone. The area Kitchen was most worried about was how the artists would respond to the reduced royalty. "For some of them it didn't

matter," Kitchen remembers, "but for others—like Jay Lynch, for instance—the extra royalty was one of the selling points." The moment of truth arrived when R. Crumb came through town shortly after Lantzy set up the new royalty structure. Crumb was the company's best-selling artist, and had pledged his newest, *XYZ Comics,* to Kitchen. Kitchen was incredibly nervous about breaking the news to Robert. "So we're in my living room, and we're chatting about stuff, and I finally get brave enough to say, 'Robert, I have to talk to you about something really serious. I don't know how to tell you this, but I can't pay a sixteen percent royalty anymore.'"

Crumb shrugged. "You've been paying me sixteen percent? The checks go to my wife. I don't pay attention to the details and don't really care, as long as it's fair." The two then went back to talking about old recording artists.

BY THE END OF 1971 Krupp was on the surest footing in its history. With Lantzy overseeing the day-to-day operations, Kitchen and Mitchell were able to take a trip west to visit artists in San Francisco, with stops along the way. An unfinished jam comic marks their progress and includes contributions from Crumb, Dave Sheridan, Jack Jackson (Jaxon), and Richard Corben. The trip was cut short by an emergency call from Irene on New Year's Eve—she was having complications and needed Kitchen to come home immediately.

He took the next plane back. Three weeks later, on January 22, 1972, the Kitchens' first daughter, Sheena, was born prematurely. She needed to stay in the hospital for nearly two months before the new parents woud be able to take her home. Kitchen started to panic. Even though things were looking up for the company, his mediocre health insurance policy wouldn't cover Sheena's hospital bill, and, without a salary, he'd have to find other work to pay it off. He went to Lantzy to deliver the bad news that he'd have to withdraw from Krupp, effectively ending the enterprise. Lantzy told Kitchen not to worry. In the six months that he'd been with the company, he'd turned things around enough that Krupp could afford to start paying Kitchen a salary of $100 a week.

Kitchen says, "Suddenly, it was like, 'Wow, I'm making a hundred dollars a week publishing comix!' Paying the rent and keeping my kid in diapers—that's all I wanted. It wasn't about making money. It was about making comix, having fun, and being a part of the movement—and we were able to keep doing that."

It stopped being practical for Kitchen to commit every week to the *Bugle,* now headquartered in Milwaukee, so he pulled back on his work there, although he continued to help out with guest covers and other art chores as often as possible. As a partnership, Lantzy and Kitchen were both performing in top gear, which drove home the uncomfortable fact that Glassford and Mitchell were dead weight.

Glassford gave back his sweat-equity shares with little resistance. He was immersed in a secret project that he was sure would make his fortune: manufacturing marijuana jewelry, with intact marijuana leaves embedded in molten plexiglass. He believed that the fact that the marijuana was unsmokable made his enterprise legal, but local authorities disagreed. Glassford kept his freedom, but his enterprise collapsed. He didn't try to resume his relationship with Krupp.

Mitchell's departure was more difficult. He was involved in several schemes separate from, and in some ways competing

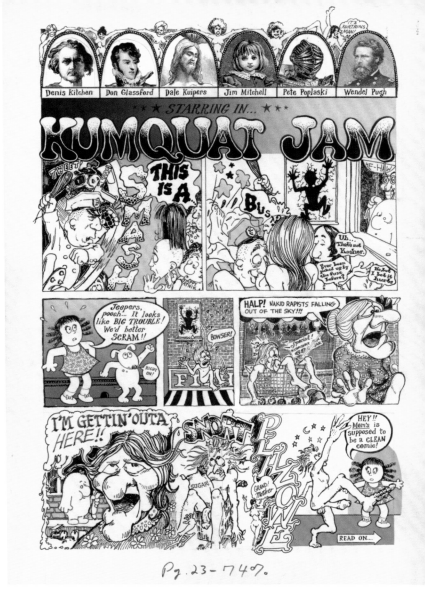

"Kumquat Jam" page 1 | 1971
Any time a group of underground cartoonists got together, there was a good chance of a "jam" being created, the visual counterpart of musicians jamming. This splash page of a four-page "story" in *Mom's Homemade Comics* no. 3 features art by Jim Mitchell, Don Glassford, Wendel Pugh, and myself, joined by other artists on subsequent pages.

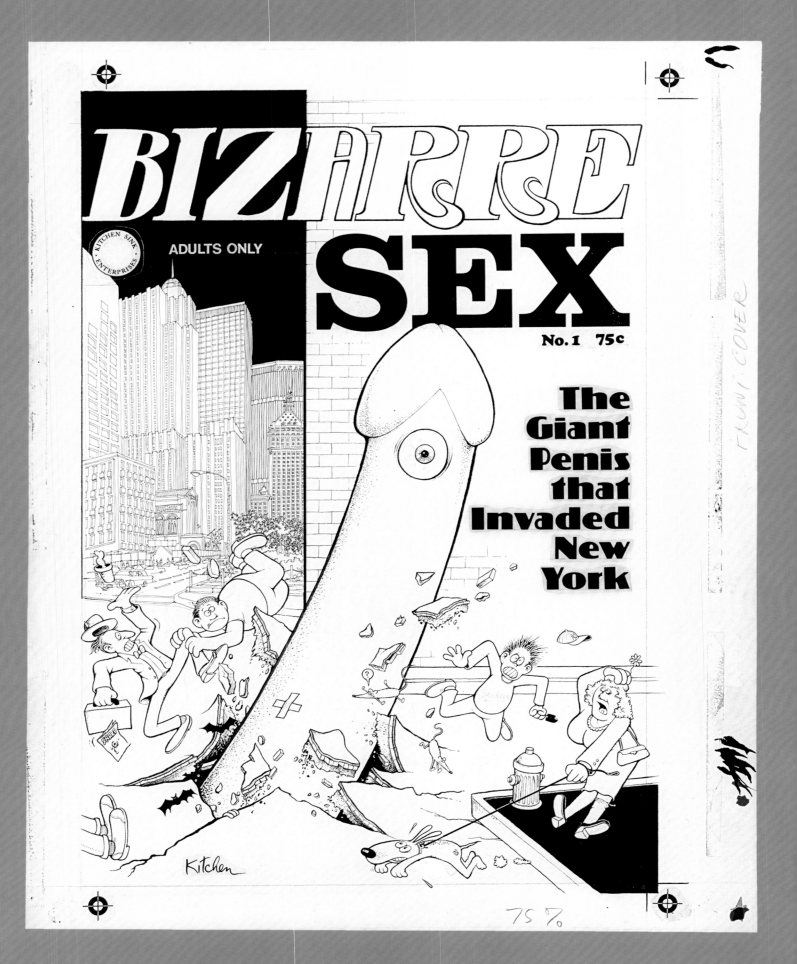

Bizarre Sex no. 1 cover art | 1972
For better or for worse, "The Giant Penis that Invaded New York" is probably my best-known image. The pavement-busting phallus could invade any city, but he especially enjoys startling hard-to-rattle New Yorkers. Next step: a Hollywood option.

against, the Krupp partnership. Kitchen and Lantzy confronted him about his obligations to the company. They gave him a deadline to turn in his overdue projects or forfeit his stock. He failed to deliver, and his shares reverted back to the corporation. Mitchell was bitter about being removed from the company, particularly that it was his friend Lantzy, whom he'd brought into the fold, who engineered pushing him out. Mitchell insisted he was committed to Krupp, wanted to have more time to earn his stock, and felt betrayed by Kitchen, who had sided with Lantzy. But before Mitchell could mount a legal protest, he was arrested in Mexico City, accused of smuggling drugs, and would spend the next several years in a Mexican prison.

Across the board, things were looking up. Underground comix sales continued to climb nationwide. For Krupp, that prosperity had the positive effect of pulling in enough money above the salaries paid to Lantzy and Kitchen to allow for an office and support staff. For the first time Kitchen was able to have a personal assistant, Annie Guthrie, helping him to focus on being in touch with artists nationwide and to develop the company much more effectively than he'd ever been able to working out of his various apartments.

Peter Poplaski and Peter Loft became full-time staff artists for the Cartoon Factory, the Krupp commercial art studio. The three artists served a diverse clientele, working on the *Chicago Sun-Times*, magazine posters for Schlitz, Heil garbage-truck ads, and even educational color comic books for heavy equipment manufacturer Allis-Chalmers.

Meanwhile, Lantzy was expanding Krupp Distribution and launched the head shop Strickly Uppa Crust, named after a line on the cover of Crumb's *Your Hytone Comics*. Lantzy's wife Terre ran the store, which boasted the largest selection of both underground and newsstand comics in the Midwest. Kitchen swapped his twenty percent stake in the *Bugle* for a substantial advertising space over time in that paper, and used it to aggressively promote Strickly Uppa Crust.

"Everything was building momentum," Kitchen says. "At first we were only able to put out a comic every other month or so, but by now things were starting to get more efficient. By now we had our proven sellers that we'd keep going back to press on, and those became relative cash cows. We finally had the cash flow to try new things. We were able to do a book or two a month. When Crumb told us he was going to give us his next book, I called the relatively small printer and told him to order a lot of paper, because we were doing 50,000 copies. He said, 'Whoa, are you sure?' But we had absolute confidence. At that point, for our own Krupp Distribution, I'd order 10,000 copies at a time of a *Fabulous Furry Freak Brothers* comic from friendly rival Rip Off Press. We had become Rip Off's biggest customer. We were getting into serious numbers."

Freed from the obligation to run every aspect of Krupp's operation and having the capital to try new things, Kitchen came into his own as an editor and artist in 1972. He established the new anthologies *Snarf,* a humor series; *Death Rattle,* a horror title; and the self-explanatory *Bizarre Sex.* The latter debuted with one of Kitchen's most iconic cover images: "The Giant Penis that Invaded New York."

Kitchen would never return to releasing solo comics, but his output in '72 would have filled a small one. Besides the cover to *Bizarre Sex #1,* he had work appear in *Smile, Snarf,* the *Bugle-American,* the *Milwaukee Journal's* Sunday magazine *Insight,* and a novelty minicomic, peculiar for the time, called *The Great*

Marijuana Debate, wherein he and Kim Deitch offered the pro-pot perspective while Jay Lynch and Pete Poplaski spoke for the opposition.

Kitchen also had fun releasing another novelty item, a ten-inch 78 rpm vinyl recording of R. Crumb & His Cheap Suit Serenaders (Robert Armstrong and Al Dodge) performing roots music. It was an obsolete format that few modern turntables could play, and it took Kitchen months to find the last manufacturer in America who could do the pressing. But Crumb was charmed, it played on the office jukebox, and it sold well enough as a novelty item to go through two pressings of 5,000 records and garner national press, including *Rolling Stone* and *Creem.*

That fall, Irene learned she was pregnant again. With the business doing well, Kitchen received this news with much less anxiety than he had when Sheena was on the way. Unfortunately, the issue wasn't just having another child—Irene craved a change of scenery. Kitchen recalls, "She wanted to be part of the back-to-the-land movement. I was resistant. I liked Milwaukee. Krupp, Kitchen Sink, and Strickly Uppa Crust were all headquartered there, and I liked the east side community, the hippie scene. I had a lot of good friends. But she was pregnant, having a rough time of it, and was insistent that we move to the country."

The couple looked unsuccessfully for a place within an hour's commute. "We couldn't find anything affordable until we got into the sticks," Kitchen says. They eventually found a farmhouse with a cabin and outbuildings on ten largely wooded acres two hours away, between Princeton and Green Lake, for $19,500. Though he was making a decent enough living from Krupp, Kitchen had no liquid cash and had to sell many of his collectibles to put down ten percent on a farmer-financed land contract. The Kitchens moved to the farm in January 1973. Scarlet was born in May.

After having spent the previous five years building a niche for himself as pillar of the hippie community in Milwaukee, Kitchen felt isolated by the move to Princeton. He recalls, "The farm was about five miles from civilization, and each town had fewer than 1,500 residents, so it was rather remote. Our 'neighbors' were farmers, only one of whom was ever friendly. We were surrounded by three things in all directions: trees, cows, and cornfields." To keep up with the operations at Krupp, Kitchen was back to commuting—this time, the two-hour drive from the farm to Milwaukee three days a week.

On the business front, 1973 started strong, with a number of relationships coming to fruition. Kitchen's correspondence with Will Eisner yielded a Spirit cover for *Snarf #3,* which showed the venerable artist poking fun at Krupp's "underground" office, literally in a sewer. The company also released two *Spirit* reprint comics, each with new Eisner covers and some new interior pages. The books would be a success. Kitchen Sink sold 20,000 copies of *Spirit #1* and had the second issue in the warehouse when Jim Warren lured Eisner away with a better deal, to produce a *Spirit Magazine* for newsstands under the Warren Publishing imprint. It was a disappointment for Kitchen, but not devastating. A condition Eisner wrote into the deal was that Warren purchase Kitchen's unsold stock so that the young entrepreneur wouldn't be harmed by the move.

Though Eisner moved on in 1973, the Krupp publishing slate remained strong, with two issues each of the Kitchen-edited *Bizarre Sex, Death Rattle,* and *Snarf* on deck, along

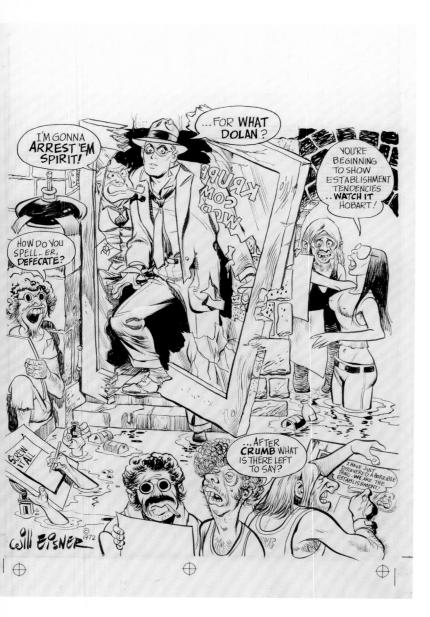

Snarf no. 3 cover art | 1972
Invited to do a guest cover for Krupp's humor anthology, comics legend Will Eisner depicted his most famous character, the Spirit, and Police Commissioner Dolan bursting into our company's "underground" headquarters, where cartoonists and editors literally work in a sewer.

with the instant classic, all-color issue of *Bijou*. The special issue features Jay Lynch, Kitchen, Crumb, Skip Williamson, Bill Stout, Bill Griffith, Kim Deitch, and others parodying underground characters, often each other's. The book had all the ingredients to become a bestseller, but unfortunately didn't get past a second printing, because the underground comix market was starting to become unstable.

The insatiable appetite of the boom years had created a glut. The big four of Krupp, Last Gasp, The Print Mint, and Rip Off were all issuing several comix every month, both new titles and reprints of proven sellers, which in itself was almost more than the head shops could handle. But there were other, smaller publishers releasing comix, too. To make matters worse, some of the new publishers were releasing inferior, non-returnable books that not only languished on the shelves, but soured readers on the undergrounds in general. Soon head-shop shelves were clogged up with the unsalable mistakes made by the majors and scores of unsold dreck dished out by the minors.

The comix business might have been able to weather the storm caused by the glut, but in June the Supreme Court issued its decision in *Miller v. California*, which decreed that obscenity is determined by local communities. The decision created a profound chilling effect on all media, and mortally wounded the underground business. Now vulnerable to obscenity busts, head shops slashed their orders or got out of selling comix entirely. With so many of the dregs of the boom clogging up the shelves, it was an easy decision for most to make. For the shops that wanted to keep a hand in selling undergrounds, the vulnerability was still great. When Crumb's "Joe Blow" story from *Zap #4* was the basis of an obscenity conviction in New York City prior to the *Miller* decision, what chance did a head shop have in a less liberal locality, selling anything but the tamest of titles?

"Tyler was starting to panic," Kitchen recalls. "His bulletin board had a chart with our monthly sales, which had been climbing and climbing and climbing. We'd hit the quarter-million-dollar gross revenue mark in 1972 and had clear projections to beat that in '73. But at a certain point, sales dropped. Then dropped again, and dropped again, and dropped again. And I remember walking into his office one day, and Tyler had taped two pieces of paper underneath the chart and continued the line down to show the bottom falling out. As black humor his joke was effective, but we were scared to death."

The industry was in freefall. Artists were leaving to find work wherever they could find a berth. Some were asked to take books as royalty payments. Crumb accepted 11,000 copies of *XYZ* and *Home Grown* in lieu of $3,000 he was owed. With dollars declining, Krupp was forced to lay off staff. By year's end, the Krupp operation in Milwaukee was reduced to Tyler Lantzy working out of a one-room office. Kitchen quit commuting and established an office and warehouse in Princeton in a former moccasin factory. Poplaski moved to Princeton, where he worked and lived in a studio within the warehouse.

Kitchen's domestic life hadn't fared much better than his business. He and Irene had brought three friends to live on the farm with them in a loose communal arrangement. The friends weren't charged rent, but were expected to provide reasonable labor on the property. While they were pleased to live out in the

country, all three showed more interest in meditating and getting high than in helping maintain the farm. Kitchen recalls, "After Krupp, it was *déjà vu* all over again. There was a lot to do that first spring and summer, starting with literally shoveling rancid pig shit a foot deep out of the bottom of the barn. I ended up doing it alone. I ran into much of the same with repairs, cleaning the chicken pen, and the actual work related to 'getting back to the land.' I finally had a confrontation with the freeloaders. They were all 'bummed out' by my 'not cool' manner and split before 1973 ended. I never saw any of them again."

By the start of winter, Kitchen's company was running on fumes, and he was living on a vast, remote property he had to maintain by himself, with two infant daughters and a wife who was having second thoughts about country living. A cartoon of a tattered Steve Krupp contemplating suicide best epitomizes Kitchen's state of mind in those cold months.

A LATE WINTER PHONE call from Stan Lee offered some hope. Lee had been following Kitchen's progress since receiving the first issue of *Mom's*, and had on several occasions tried to lure Kitchen to New York to work for Marvel. This time, after his usual pep talk, when Lee asked, "So, when are you going to come work for me?" Kitchen replied, "Let's talk."

Kitchen flew to New York and sat down with Lee and his managing editor Sol Brodsky. Neither had a firm idea of what they wanted from the other. Lee had been doing the college lecture circuit and saw a lot of creative energy happening in the undergrounds, but didn't exactly get it. He just knew he wanted to capitalize on it. And Kitchen needed a life raft. In the space of an afternoon, they hammered out the broad strokes of a magazine that would bring a wide array of underground creators to the newsstand. Kitchen was offered a salary of $15,000 per year to do the magazine, which was enough money to save his personal economy in 1974. The sticking point was that he wouldn't relocate to New York, which, after some back and forth, Lee acceded to.

The magazine, which would eventually be called *Comix Book,* was a radical experiment for Marvel. Artists would be offered $100 a page, which was four times the going advance per page from the comix publishers. What made the deal remarkable was that for the first time Marvel would return all original art and allow the artists to keep their trademark, and after further wrangling, Lee agreed copyrights would revert after first printing. On the content side, there were a variety of compromises. Minor nudity—such as bare female breasts—was allowed, but full frontal nudity was not. No explicit sex could be shown. The word "fuck" was *verboten*, but other profanity was acceptable.

Kitchen returned to Wisconsin and began contacting artists. "I told them I wasn't embracing this like it was the be-all and end-all—this was just a very pragmatic thing. I said, 'The

Krupp Comic Works postcard | 1978
Peter Poplaski drew the core Krupp crew at the former Mukluk factory in Princeton, Wisconsin. Bottom row (from left): business manager Mike Jacobi, my assistant Sue Schmidt, and UPS driver Mark Nelson. Back row: Editor Leonard Rifas, myself, and Poplaski, who hangs from one of the office mooseheads.

Marvel Comics Group

625 Madison Avenue New York, New York 10022 212 TEmpleton 8-7900

A DIVISION OF
Magazine Management Company, Inc.

STAN LEE
EDITOR

6/25/70

Dear Den:

I aint gonna comment. The reason I aint gonna
comment is 'cause you're becoming too successful.

When I first discovered you, you were just putting
out your one little Mom's Kitchen Sink Comics, or
whatever it was. It was great and I toldja so.

But now, fortified no doubt by my unstinted praise,
you've become a virtual cartel. Now you're big
business, grinding out comics mags like love beads!

If I'm gonna haveta comment on all your issues, I'll
have to hire an assistant to help me. And you know
what a cheapskate I am. (If you don't yet know, you
will-- when this letter reaches you with postage due!)

So from now on you'll have to do it the hard way--
you'll have to become a comic book conglomerate without
any help from me.

But don't go 'way mad. I may be asking you for a job
some day.

Onward!

Stan Lee

P.S. I aint gonna comment!

Letter from Stan Lee | 1970
I began an unlikely correspondence in 1969 with the co-creator of Spider-Man and Fantastic Four, culminating with Stan hiring me in 1974 to edit the experimental magazine *Comix Book*.

bottom's falling out; we all know that. This is a hundred bucks a page, you're going to get your art back, and Marvel's going to get first publishing rights.' Almost everybody said okay. On principle a handful would not work for Marvel. Crumb wouldn't, Jay Lynch initially said yes, and then balked. But most artists were happy to."

Kitchen managed to pull together an impressive roster, even if it wasn't everyone's finest work. Key contributors to the first three issues of *Comix Book* included Robert Armstrong, Joel Beck, Howard Cruse, Kim Deitch, Justin Green, Bill Griffith, Lee Marrs, Willy Murphy, Pete Poplaski, John Pound, Ted Richards, Trina Robbins, Skip Williamson, S. Clay Wilson, and Basil Wolverton. A notable contribution would turn out to be from Art Spiegelman, who would publish an early version of *Maus* in the title's second issue, the first national exposure for what would become a Pulitzer Prize–winning graphic novel.

Comix Book "just came at the right time," Kitchen says. "I didn't really want to work for Marvel, but it saved my ass, and the real irony here is that it saved Kitchen Sink, because I didn't draw a salary for over a year. Marvel paid me, and while I did that, I was simultaneously still running Kitchen Sink, just unpaid. So, with that overhead gone, it managed to slide by."

The saddest irony is that Kitchen took the job in the first place because he knew Irene would have a meltdown when Krupp stopped paying his salary, which looked inevitable before Stan Lee's call provided a solution. He says, "When I told her that this was happening, I thought it would be a great relief to her. Then in June of '74 I woke up one morning and there was a note by the bedside. She was gone. I awoke with a crying baby, a toddler, and no wife. If you look at the page, 'The Birth of *Comix Book*,' that's me and Irene in the first and third panels, because I had started that while we were still together—and the little girls clinging to my leg are Sheena, age two, and Scarlet, one year old. By the time I finished drawing that page, Irene was out of our lives."

Kitchen's world was in a state of complete collapse. "I had no fallback," he recalls. "I had literally nobody else in the house. I had to scramble. I was taking care of a two-year-old and an infant in my office, answering the phone, trying to do paste-ups on catalogs, trying to take care of business. I think I came close to a nervous breakdown. I just literally couldn't do it all.

"I've blotted out a lot of that time, but I remember tracking down Irene in Milwaukee. I knew she wasn't coming back, but I still said, 'I don't know what to do. What should I do? Help me.' Her advice to me was to put the girls up for adoption. She said it very coldly and calmly. She had no interest in helping, she had little interest in seeing them, and she didn't know why I would, either. She struck me as being more reptile than mammal at that point. It was unthinkable to me to give up Sheena and Scarlet.

"I had to find a nanny very quickly. My sister Gayle helped for a while; she was a real lifesaver. Then I advertised in *The Bugle* with a forlorn image of a single dad with two little kids, some cute little farm animals, and described the idyllic location. Several young women applied, and I eventually went through several nannies. They never lasted very long. It was a lonely environs and I couldn't afford to pay much. It was a little money, room and board, and fresh air."

Kitchen was able to hobble through the rest of the year, and managed to get the first three issues of *Comix Book* out on schedule. Kitchen Sink released two books, also edited

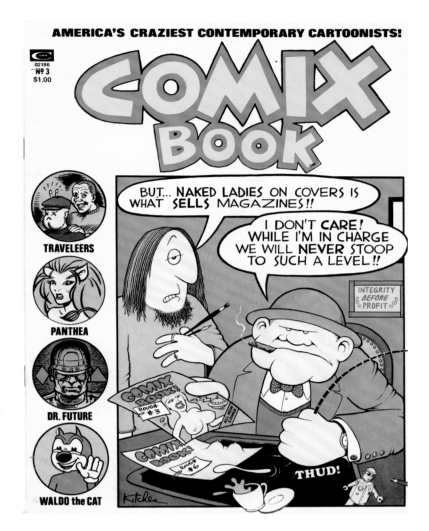

***Comix Book* no. 3 cover | 1974**
Marvel Comics bankrolled this newsstand magazine. Though sometimes an uneasy balance of counterculture attitudes and its mainstream base, *Comix Book* permitted many underground cartoonists—and a certain Wisconsin publisher—to survive the aftermath of the "Crash of '73" that nearly destroyed the comix cottage industry.

FAMOUS CARTOONIST SERIES No. 38 SPAIN RODRIGUEZ

FAMOUS CARTOONIST SERIES No. 21 JUSTIN GREEN — MR. SENSITIVE, THE ARTIST — ©'75 JUSTIN GREEN

FAMOUS CARTOONIST SERIES No. 14 HOWARD CRUSE

FAMOUS CARTOONIST SERIES No. 16 WILL EISNER

FAMOUS CARTOONIST SERIES No. 52 BASIL WOLVERTON

Famous Cartoonist Button Series | 1975
I invited a variety of cartoonists from my own generation and earlier to contribute self-portraits to a "Famous Cartoonist Button Series." Over fifty contributed to the offbeat set. Besides the examples shown here, Carl Barks, John Stanley, R. Crumb, Art Spiegelman, Trina Robbins, Will Elder, and even one-time cartoonist Hugh Hefner complied.

by Kitchen—*Snarf* #5 and *Weird Trips* #1, the latter a combination comics and text magazine.

By the start of 1975 there wasn't much life left in the Krupp operation. Lantzy and his wife wanted to move to Colorado, so he and Kitchen talked about how to break up the business. Strickly Uppa Crust was shut down, and the two split the profits. Kitchen recalls, "I was obviously emotionally attached to the publishing part, which was struggling the most. Tyler and Terre had developed the mail-order business, which had become the most successful division. In the end, I kept Kitchen Sink and Krupp Distribution, and he took Krupp Mail Order to Boulder. After we agreed on everything, I said, 'Be honest with me. Do you think the publishing company has a future?' Tyler looked me in the eye and said, 'With a lot of hard work and dedication, it could be marginally profitable.' And I remember thinking, 'You think so? You really think so?' Like that thin thread was my ray of hope!"

With Lantzy gone, Krupp was dissolved as the corporate umbrella. Kitchen established a new corporation to carry forward the publishing and called it Kitchen Sink Press, Inc. Mike Jacobi, a partner at the *Bugle*, came in as a partner on the new company. It was around this time that Marvel pulled the plug on *Comix Book*. The problem wasn't sales, but the business terms under which the title was developed had created dissension among some of Marvel's creators, who couldn't understand why the hippies were getting to keep their art and copyright. "When Stan finally called me about it, he kind of spoke around it," Kitchen recalls. "He said, 'Look, this isn't working for us. You've opened up some things here, and we're going to have to put this down.' And I guess I wasn't shocked." Kitchen had the next two issues assembled. Marvel had already paid the artists for their work and let Kitchen Sink publish the inventory issues under its own imprint.

By the end of 1975, publishing was still crippled, but the business climate was slowly beginning to show signs of new life. Another issue of *Bizarre Sex* was released, as well as Howard Cruse's *Barefootz*. A $5,000 grant from the Wisconsin Department of Consumer Affairs bankrolled *Consumer Comix*, an educational comic distributed free to the state's high school seniors, which explained the basics of consumer rip-off schemes, contracts, and credit. KSP was also able to keep 10,000 copies for sale through its own channels. Between these and the free issues of *Comix Book*, the company was able to start rebuilding.

While the comics publishing began correcting itself, Kitchen occupied his time with the meditative task of hand-making the Famous Cartoonist Button Series. Fifty-four cartoonists, including mainstreamers like Carl Barks, Neal Adams, John Stanley, Will Eisner, Harvey Kurtzman, Will Elder, Gahan Wilson, and Basil Wolverton, contributed self-portraits, alongside virtually all of the underground cartoonists. Even one-time cartoonist Hugh Hefner participated. Kitchen colored all the drawings using hand-cut overlays, and then manufactured individual buttons with a manual punch press. It was laborious, repetitive work, but it was also a meditative tonic. Working late into the night, punching button after button after button, with the faces of friends and idols staring up from the punch press, Kitchen had time to think about the crises of the last two years and the fact that, ultimately, he'd survived them all.

UP FROM UNDER: 1976—NOW

In August of 1976 Kitchen celebrated his thirtieth birthday with the community that had developed on his Princeton farm. By then most of the outbuildings on the property were in the process of being converted and occupied by an assortment of artists and craftsmen who paid reasonable rent or bartered. Nearby townies started referring to the property as "the Kitchen commune," but it really wasn't that. It was an unconventional community of fellow travelers.

For the most part, the contractions that had scorched the earth of the underground business had passed, and slowly Kitchen Sink and its founder were getting back on their feet. With the responsibilities of running the company, maintaining the farm, and raising two toddlers, Kitchen's cartooning had dropped down to a trickle of his former output and was now largely limited to drawing occasional covers for the *Fox River Patriot,* a regional rural weekly paper recently founded by Kitchen and Jacobi.

Although his cartooning had dwindled, Kitchen's creative vision as a publisher and editor remained sharp, even though he was able to publish only a small fraction of the output Kitchen Sink had at the peak of the Krupp days. The need to be more discriminating about projects made Kitchen Sink's line more focused, so increasingly the work the company acquired reflected

Kitchen's tastes and convictions, his social conscience, and singular artistic vision. "We were consciously trying to put out things we thought were either aesthetically tops or culturally significant," Kitchen says.

In late 1977 KSP acquired Will Eisner's *Spirit Magazine.* Sixteen issues had been published by Warren, but steadily diminishing newsstand sales had forced its cancellation. Kitchen Sink's low overhead allowed the magazine to continue, launching the company's reprint line and further cementing Kitchen's relationship with Eisner.

In addition, the anthologies *Bizarre Sex* and *Snarf* continued, partly because they could sell on brand recognition, and partly because they were strong venues to find and nurture new talent. Established cartoonists were given their own platforms, with the first years of the new KSP bringing to market solo comics by Joel Beck, R. Crumb, Howard Cruse, Aline Kominsky, Harvey Kurtzman, Lee Marrs, Trina Robbins, and Skip Williamson.

Seeking to correct a gender imbalance in his line and to create a venue for female voices, Kitchen invited Trina Robbins to edit a title for KSP, which became *Wet Satin,* a short-lived, controversial anthology of erotic comics by and for women. Kitchen's printer, normally comfortable printing underground newspapers and titles like *Bizarre Sex* and *Weird Trips,* even when he had to tough out a boycott because of it, inexplicably refused

Holly Brooks and Denis Kitchen | 1977
My second wife Holly worked at Kitchen Sink Press and helped raise Sheena and Scarlet for a decade. We divorced in 1987 but remain friends.

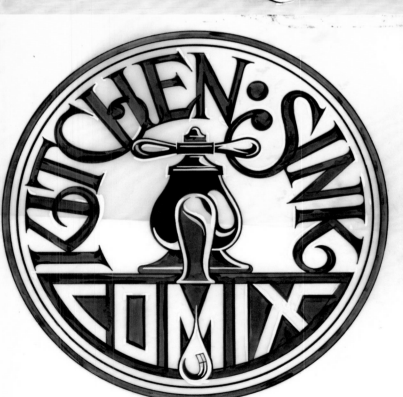

Kitchen Sink Press trademarks original art | 1981
For many years the Kitchen Sink trademarks on our comix covers were uniquely hand-drawn, often by me. I finally decided to establish a firm brand image around faucets and in 1981 hired the best letterer and logo designer in the business, Leslie Cabarga, to create a circular logo for comic book covers and a square version for Kitchen Sink's growing book line.

to print Robbins's anthology, forcing Kitchen to locate another, more liberal printer.

Young west coast cartoonist and writer Leonard Rifas further ignited Kitchen's interest in socially relevant comics when he entered the KSP stable with his 1976 bicentennial comic *An Army of Principles,* a work of nonfiction that expressed the philosophy of the American Revolution. The next year Rifas followed up with *Corporate Crime Comics,* which examined criminal abuses committed by big business. The first issue of the title took a long look at the Karen Silkwood/Kerr McGee case, one of the first outlets to do so in any medium. Kitchen would contribute to both issues of the publication. Rifas moved to Princeton in 1978 to become the company's first full-time editor besides Kitchen. "I wanted a smart humanist on board helping put books together," Kitchen says.

Late 1977 saw Kitchen's girlfriend Holly Brooks move to the Princeton farm where she helped raise Sheena and Scarlet, as well as restore domestic order in Kitchen's life. The impact on his artistic output was almost immediate. From 1978 through the early '80s, Kitchen produced covers for a variety of publications, and a handful of short stories. A project he looks back on with particular creative pride is *Mondo Snarfo,* an anthology of surreal comics to which he contributed both covers and the story "Major Arcana." Kitchen and Holly would marry in 1980.

With his domestic life coming under control and his creativity percolating, Kitchen began thinking about getting out of the business side of comics entirely. Although he was interacting with talented people and publishing work that he believed in, Kitchen had seen his life's aspiration to be an artist slipping further and further away from him when the demands of publishing and single parenthood had occupied so much of his energy. Now that Holly was in his life, he had a companion to help him raise the girls and bring normalcy to what had been a chaotic, isolated existence. It all made Kitchen feel creative again, and the art he was making now was better than anything he'd done in his most prolific days. It was a second chance, and Kitchen took it every bit as seriously as he had taken the opportunity he'd received by getting out of the Army. It was time, he felt, to follow his dream and at last dedicate his energies to being an artist.

He went to New York to visit Will Eisner and Harvey Kurtzman to provide the courtesy of advance notice of his decision so they could plan their transitions away from Kitchen Sink Press more painlessly. Both men were mentors to Kitchen, and he valued their opinions above all others.

"I knew in advance what they were going to say," Kitchen remembers. "Will, with his strong business side, was going to try and talk me out of it, and Harvey, whom I saw as a pure creator, was going to encourage my decision. When I finally got around to breaking the news, I essentially said to each of them, 'Look, I've decided to quit publishing. I'm going to figure out a way to sell KSP. I want to get out of there and get back to the drawing board. I want you to have advance notice in case you want to seek other publishing options in the not-too-distant future.'

"I met with Will first, gave him the spiel and braced myself. Will smiled sympathetically and said, 'If that's how you feel, you have to follow your heart.' I said, 'That's it?' He said, 'It sounds like you've already made up your mind, so I'm not going to dissuade you. I know there's an artist in there. Follow your dream.'

"Wow! I was certain I was going to get a full-press argument from Will. Greatly relieved, I said my goodbyes and I went to see Harvey, and I gave Harvey the same career change announcement. And again I was dead wrong.

"Harvey gave me a long lecture. He could not believe I was prepared to throw in the towel for a drawing board. He said he'd had problems with publishers his entire career and knew what he was talking about. 'Artists are plentiful,' he said. 'No disrespect, but cartoonists are a dime a dozen. Good or not, you won't make a difference. What we need are good *publishers. That* can make a difference.'

"It seemed an elaborate trick had been played on me! I went home and thought long and hard. Obviously, I didn't give up publishing as planned, and it was largely because Harvey made me think about my career in a way I hadn't. I didn't think publishing was special enough. I thought, 'Anybody can publish.' Harvey dissuaded me by persuading me I could have a creative career in broader strokes. At the same time I saw another side of Will, and the encounters, unexpected though they were, made me feel closer than ever to each man."

THESE ENCOUNTERS WITH HIS mentors changed the way Kitchen approached his work and his life. Publishing had started as the pragmatic thing to do to support his family. It was the day job that kept the lights on and the fridge full. But until then, he'd regarded it as a distraction from being an artist. He had never considered that there was more to art than pulling a brush across a board, that if commerce could be fair, there was no reason it couldn't be artful as well.

What Kurtzman showed Kitchen is that there was an inherent artistic impulse in the publishing he excelled at. Kurtzman should know. He had spent much of his career as an editor, finding, nourishing, and developing some of the greatest artists in the history of comics. Kitchen wasn't nearly as hands-on as Kurtzman, but he had a knack for identifying talented cartoonists and bringing out their best work. Kitchen had the skills and circumstances to do that work with a freedom that Kurtzman had never enjoyed. Kitchen brought an understanding, affection, and respect for the material he published to every project, which Kurtzman insisted made him unique. This made him more important to his profession as a publisher than he would be as a creator.

Kitchen came back from New York with a different plan than he'd departed with. He didn't abandon his desire to be an artist, per se, but he decided to channel that energy differently. Instead of advancing his own muse, he would advance the art form he loved so greatly. He would find the artists and the projects that he believed in, regardless of their subject matter or era. He'd present their work with painstaking attention to detail and with higher production values than was the norm for comics at the time. All the care that he would have dedicated to projecting his own voice now conducted a choir comprised of much of the medium's finest talent.

After the talk with Kurtzman, cartooning would become Kitchen's sideline rather than his vocation. Though his personal art output would dwindle to a trickle and then a very occasional droplet, his work as a publisher, editor, and manufacturer became far more robust.

For the next twenty years, Kitchen Sink would become one of the most adventurous publishers in comics, releasing a line that encompassed a wide range of material from the earliest

Self-portrait for *Cascade Comix Monthly* no. 13 | 1979
Cascade was a nifty fanzine devoted to underground comix, published and edited by Artie Romero. Normally my character Steve Krupp served as the alter ego for my entrepreneurial side. But when it was my turn to be featured in *Cascade*, I used the opportunity to dramatize my actual split personality. "The Publisher" vs. "The Artist" has been an ongoing and unresolved internal conflict.

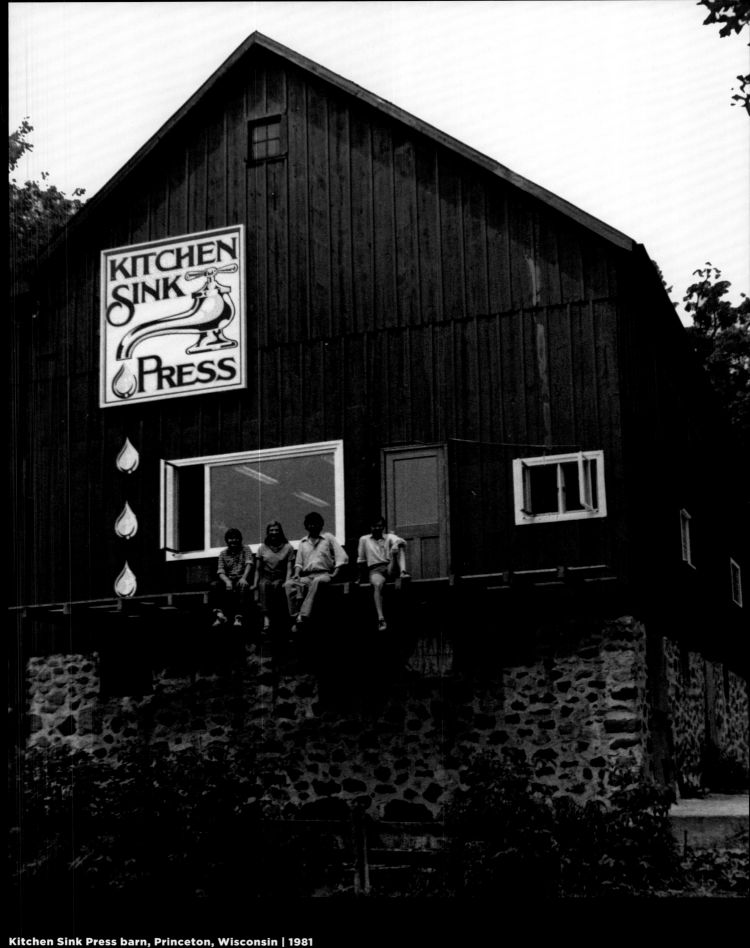

Kitchen Sink Press barn, Princeton, Wisconsin | 1981
In 1980 I vacated the Mukluk factory and relocated the business to my own farm. With early remodeling of the former dairy barn in progress, my sister Doreen Riley, wife Holly Brooks, me, and art director Peter Poplaski pose on the cantilever deck. Eventually the exterior was sheathed in cedar, more windows were added, and four floors developed. The interior was carved into offices, studios, conference room, and even bedrooms were provided for certain artists.

masters of the comic strip to the edgiest voices of the alternative press. Kitchen explains, "To me, the thing that unified Kitchen Sink was to say simply, 'We do good comics.' That's all I cared about."

Kitchen Sink was among the earliest publishers to invest in a graphic novel line, with Will Eisner as the flagship author. Kitchen would publish all of Eisner's graphic novels, a full dozen titles, from 1983 until the company dissolved in 1999, in addition to *Hawks of the Seas* and various compilations of Eisner's *Spirit*. Kitchen also collected several of Harvey Kurtzman's works, such as *Jungle Book*, *Goodman Beaver*, *Hey Look!*, and *From Aargh! to Zap!* R. Crumb's KSP books would include *Carload o' Comics*, *Kafka*, and *The R. Crumb Coffee Table Art Book*.

Over the years Kitchen released original graphic novels or book collections by artists such as Mike Allred, Charles Burns, Howard Cruse, Neil Gaiman, Dave McKean, Jack Jackson, Mike Kaluta, Carol Lay, Joe Matt, Scott McCloud, Alan Moore and Eddie Campbell, James O'Barr, Steve Rude, Richard Sala, Mark Schultz, Bill Sienkiewicz, Jim Woodring, Bernie Wrightson, and Skip Williamson, among many others.

KSP was also one of the first comics publishing companies to invest in preserving classic comic strips and presenting them with top-quality production values. "There was a special satisfaction in being able to bring back some of the classics and do them right," Kitchen says. One of his proudest achievements is having published twenty-seven volumes of a projected fifty-four–volume set of the complete *Li'l Abner* by Al Capp. He also published five collections of *Nancy and Sluggo* strips by Ernie Bushmiller; Milton Caniff's *Male Call*, *Terry and the Pirates*, and twenty-six volumes of *Steve Canyon*; four volumes of V. T. Hamlin's *Alley Oop*; *Krazy Kat* by George Herriman; *Polly and Her Pals* by Cliff Sterrett; Alex Raymond's complete six-volume set of *Flash Gordon*; Raymond and Dashiell Hammett's *Secret Agent X-9*; R. F. Outcault's complete *Yellow Kid*; and Lionel Feininger's historic early strips, among others.

Working in conjunction with DC Comics, Kitchen Sink assembled eight volumes of the earliest *Batman* and *Superman* daily and Sunday newspaper strips, with new wraparound covers and art direction by Peter Poplaski.

And, of course, Kitchen continued to pride himself on identifying new talent. Charles Burns (*Curse of the Molemen*, *Blood Club*), Mark Landman (*Buzz, Blue Loco*), Joe Matt (*Peep Show*), Richard Sala (*Hypnotic Tales*), Mark Schultz (*Xenozoic Tales*), Don Simpson (*Megaton Man*), and the teams of James Vance and Dan Burr (*Kings in Disguise*), Sylvie Rancourt and Jacques Boivin (*Melody*), and Reed Waller and Kate Worley (*Omaha the Cat Dancer*) are among the cartoonists Kitchen is proudest to have published.

Kitchen's sensibility as a collector also led him to be one of the pioneers in the production of comics-related merchandise, an endeavor in which he took great pleasure. "I loved tracking down manufacturers and doing things that you could hang on a wall or put on a bookshelf. Would I equate that with publishing Will or Harvey or Crumb? Well, no, but it was one of the pleasures of having your own company." KSP would produce a wide variety of items, including numerous boxed card sets, figurines, hundreds of buttons, T-shirts, cartoon neckties, vinyl picture disks, and various boxed candy bars and tins. In addition, Kitchen was the first comics publisher to produce high-end limited-edition signed serigraphs, or silkscreen

Spot illustration for *Amazing Heroes* no. 78 | 1985
The "Kim" referenced in the word balloon is Kim Thompson, co-owner of Fantagraphics and then-editor of *Amazing Heroes*. He asked me to provide an illo for a preview of upcoming Kitchen Sink titles. "Secret Crisis" was a joking reference: an amalgam of Marvel's *Secret Wars* (1984–'85) and DC Comics' *Crisis on Infinite Earths* (1985), two highly popular series that dwarfed sales of anything my company was producing. The Megaton Man vitamin bottle was a clue to one of KSP's higher profile titles during the prior year. The chart for "Plans to take over Comic Book Industry" was clearly in jest. But it was apparently a successful gambit according to the chart that appeared in the final panel of "Square Publisher" a decade later (see page 187).

prints, by artists like Crumb, Eisner, and Schultz, and signed lithographs by numerous artists.

Over the years Kitchen's personal and professional fortunes rose and fell, though his dedication to putting out great comics remained constant. In the 1980s the direct sales market in which he'd been an early player had grown in a way that let KSP grow with it. The company went from publishing nine comic books and an art portfolio in 1980 to, a decade later, releasing twenty-two books, eighteen comics, four T-shirts, four neckties, three pieces of wall art, a Spirit mask, and boxes of Cadillacs & Dinosaurs candy bars. The company swelled from Kitchen and a half-dozen staffers to, at its peak, nearly forty salaried employees.

The Princeton property also swelled: from a small and remote farm in the sticks to a bustling community. In 1980 the big barn was remodeled into a company headquarters with several offices, an art department, residences, and archival storage. Most significantly, Kitchen had a large warehouse built, with a separate driveway and loading dock. "The whole place was a small maze of buildings," Kitchen recalls, "a certain community in itself."

In 1986, Kitchen established the Comic Book Legal Defense Fund in response to a case being waged by distributor and retailer Frank Mangiaracina, whose Lansing, Illinois, store manager Michael Correa was facing obscenity charges for selling comics that included the KSP title *Omaha the Cat Dancer*. After getting off the phone with Mangiaracina and hearing the news that Correa had been convicted, Kitchen felt a shock of horror and a sense of responsibility. He felt that Mangiaracina shouldn't have to bear the financial burden of supporting his employee—that this was an issue which the industry should join forces to support by defending the First Amendment rights that were at stake. Kitchen drafted a roster of first-rate artists, including Eisner, Crumb, Frank Miller, Sergio Aragonés, Richard Corben, Steve Bissette, Reed Waller, and others, to create a portfolio to raise funds for the appeal. Kitchen hired *Playboy* counsel Burton Joseph to litigate the case, which he did successfully. Kitchen reasoned that this wouldn't be the last time comics' First Amendment rights would be threatened with litigation, so with the money left over from the Correa case, Kitchen established a bank account that would eventually become the foundation of the Fund. The CBLDF was formally incorporated as a 501(c)(3) not-for-profit organization in 1990. Kitchen led the Fund as its president from its establishment in December of 1986 until 2004, when he retired from the Board of Directors. The CBLDF continues to this day.

In 1987 Kitchen's marriage with Holly ended. He brushed himself off fairly rapidly, having the family farmhouse substantially remodeled and enlarged, with a new master bedroom and new tower that included a hot tub—basically the dream pad he could finally afford to make for himself. He also threw himself into the work. By 1990 his daughters were in their late teens and would be getting ready to move on. It was just beginning to sink in that he was about to be an empty-nester in a remote community when a fateful phone call came during a Green Bay Packers game in 1992. "Who would call me in the middle of a Packers game?" he recalled recently, still amused. It was Kevin Eastman, co-creator of the Teenage Mutant Ninja Turtles phenomenon. He asked how Kitchen Sink was doing. "We're burning our awards to keep warm, but

otherwise we're all right," Kitchen joked. Eastman laughed and said, "Well, I've got a proposition for you, and it's either going to be your worst nightmare, or your dream come true."

"All I heard was 'dream come true,'" Kitchen says.

Eastman explained that Tundra, the idealistic publishing company that he'd founded with his Turtles fortune, had been losing millions of dollars and needed experienced management to help correct it. Eastman said he had long admired Kitchen Sink Press, and proposed a merger between Kitchen's company and Tundra. Kitchen traveled to Northampton, Massachusetts, where Eastman was based, and quickly fell in love with the town for its cultural richness and its abundance of single young women. Between the town, the perceived financial boost Eastman's assets would bring to Kitchen Sink Press, and the opportunity to finally cash out a portion of his company, Kitchen was sold on the deal. In 1993 he moved Kitchen Sink's operations and several of its employees to Northampton, which, for a time, was a company town for comics.

Unfortunately, the deal proved ill-fated. After the operation had been established in Northampton, it became clear within a month or two that both Kitchen and Eastman had failed to do proper due diligence, and the dream scenario they'd both envisioned became a nightmare of accounting, contractual, and monetary entanglements. In addition, Eastman's cash flow became adversely affected, and he could not hold to the financial commitments of the deal. In an effort to stem the negative cash flow, an investment bank group, Ocean Capital, was finally brought in, in 1995, leaving both Kitchen's and Eastman's respective equities and their control over the company considerably diminished.

For a time, the company was carried by the tremendous success of *The Crow,* the graphic novel by James O'Barr that inspired the Hollywood film in which star Brandon Lee was accidentally killed on set. Kitchen Sink sold around 400,000 copies of the book, a bestseller by any definition, but it was not enough to offset other problems. The company's last years dragged Kitchen increasingly away from the editing and publishing duties he loved and into meetings with investors and lawyers, in an effort to keep the enterprise afloat.

The ray of sanity in this tumultuous time was Kitchen's courtship with Stacey Pollard. The two met briefly at a Dallas Fantasy Fair convention in 1992 where she was the young model and editor for a science-fiction series called *Tandra.* The following year Kitchen was back at the Dallas show, had just helped set up KSP's table, and was heading into the hotel next door when he spotted veteran DC editor Julius Schwartz standing in the entrance with Pollard. Kitchen said hello to Schwartz but couldn't remember the young woman's name. He looked at her and said, "Tandra, right?" She nodded yes.

Unable to resist an easy industry joke, Kitchen turned to the DC editor and said, "Julie, I thought I was *merging* with Tandra, but instead I ended up with a stupid company in Massachusetts!" Schwartz laughed heartily, and though the joke was meaningless to Pollard, Kitchen was invited to join them for drinks inside. He and Pollard hit it off instantly and were inseparable over the long weekend. After a six-month long-distance courtship, Pollard moved from Nashville, Tennessee, to Massachusetts and, before long, she and Kitchen were married.

Kitchen Sink Press would finally collapse in early 1999, sending Kitchen into a bleak depression. It lifted when Will Eisner, who by then had become a paternal figure in Kitchen's

These outtakes from a formal photo session with my mentor and myself were taken at the Capital City Distribution Sales Conference in Madison, Wisconsin. Eisner was primarily known as an artist and writer, but loved the business side of comics. I began as an artist, but was increasingly pulled to the business side. That common duality was one of the glues in our relationship. Will went from being primarily an artist to primarily a businessman and finally back to an artist during his long career, a pattern I still hope to follow.

Stacey Pollard | 1992
I met my third and final wife, Stacey, a Nashville model and country/western singer, at the Dallas Fantasy Fair. I was attending the Harvey Awards and she was promoting *Tandra,* a comic book series featuring Tremaine, a character modeled on her. Despite a significant age difference, we've been inseparable since 1993, causing numerous respective friends to lose bets. Our daughter Alexa—god save us—is an aspiring cartoonist.

life, called and persuaded Kitchen to become his literary agent. "He said, 'I don't want our association to end because your company did,'" Kitchen remembers, "and he assured me I could do this." Eisner's confidence liberated Kitchen from the doldrums of second-guessing and despair that his post-KSP life had become. Within weeks he'd identified relationships and skills at his disposal that would allow him to brush himself off and start moving in a new direction, as a literary agent. Kitchen and associate Judy Hansen placed Eisner's works first at DC Comics, then later moved his graphic novel library to W. W. Norton, where they also placed R. Crumb's magnum opus *The Book of Genesis*, among other deals over the past decade.

As the original art agent for Will Eisner and Harvey Kurtzman, and now their estates, Kitchen has overseen the sales and public exhibition of their art to an increasingly receptive museum and collectors' market.

Today he operates Kitchen, Lind & Associates with designer John Lind. The company packages books and represents cartoonists to the mainstream literary marketplace. In 2009, two of the books the partnership yielded were *Underground Classics* and *The Art of Harvey Kurtzman*, both of which Kitchen co-authored for Harry N. Abrams's ComicArts imprint, instantly establishing himself as a notable comics historian.

Kitchen and Stacey are also the proud parents of tween author Alexa Kitchen, deemed by her father as "The World's Youngest Professional Cartoonist" upon publication of her first book, *Drawing Comics is Easy (Except When It's Hard)*, at age seven. Her graphic novel *Grown Ups are Dumb! (No Offense)* was published in 2009 by Disney/Hyperion.

DENIS KITCHEN'S FIRST LOGO was an octopus depicting the many arms of his Krupp organization. It was created as a joke, but, he admits, "It's not completely a joke. I keep thinking I have eight arms instead of two. I keep thinking that I can clone myself in some kind of theoretical way. My problem has been that I've always been pulled in so many enticing directions that I want to do it all: be an artist, write books, publish, run various organizations, clear paths in the woods, collect every tacky postcard.

"Through it all, I've always done what I do because I love doing it," Kitchen says. "I'm proud that I could build something from scratch, twice. And neither time did I know that I had the wherewithal to do it. I think you never know what you can do until you have to. It's sink or swim, and I didn't know I could swim till I tried. Seeing this book come together makes me wish I had drawn more in the past. But there are no regrets. I'll simply draw more in the future."

—CHARLES BROWNSTEIN

Charles Brownstein is the Executive Director of the Comic Book Legal Defense Fund, a not-for-profit organization that defends the First Amendment rights of the comic book field. His previous comics-related publications include *Eisner/Miller* and the CBLDF benefit series *Expo*. For more information on Brownstein and the CBLDF, please visit www.cbldf.org.

***Four-Headed Self-Portrait* | 2002**
A self-portrait (borrowing from the opening of early TV's *To Tell the Truth*) as hard-nosed publisher, effete artist, ardent Comic Book Legal Defense Fund president, and smarmy agent.

Note on Condition of Art:

Almost all of the art in this book was photo-graphed or scanned from my original drawings. I was known for using a heavy amount of "Zip-A-Tone" in my work. In the pre-digital age these semi-transparent manual screens with adhesive backs would be laid over drawings, surgically cut with an X-Acto knife to fill the desired area, and then burnished down. These gray tones could range from a subtle ten percent to darker shades. But over time, especially when exposed to light, the low-tack adhesive tends to yellow and dry, and pieces can fall off the original. The material also tends to slightly shrink, leaving exposed "ghost" lines between tones and drawn edges on the aging originals.

Despite such aging flaws, the decision was made to reproduce all art "as is." No effort was made to restore certain areas, though it was sometimes tempting.

Denis Kitchen

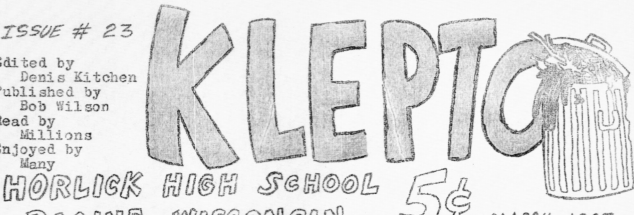

ISSUE # 23

Edited by
 Denis Kitchen
Published by
 Bob Wilson
Read by
 Millions
Enjoyed by
 Many

KLEPTO

HORLICK HIGH SCHOOL
RACINE, WISCONSIN

5¢

MARCH 1963

HORLICK WINS TOURNAMENT

THREE MORE CASUALTIES IN HALLS

Three more students were victims of crowded conditions at Horlick last week, bringing the year's total to seventy-six. The goal for March is twenty.

Mary Barff, home room 135A, suffered minor bruises when she was pushed down a flight of stairs in the new addition, and landing in a box of gym towels.

John Gorsche, home room 223, broke his crutches when he slipped on a sack lunch, crashing into a girl's lavatory, where he immediately lost sight

Gorsche

Driving lay-up by
Muck Mikelin

in both eyes.

In a third case, Ralph Crunch, home room 115, fell in front of the attendance office during rush hour. He was trampled by onrushing students for nearly four minutes before being discovered. His remains were scraped off the floor and given to Miss Houg's biology class.

Big ANNUAL Coming Soon!

PLACES FIRST

Racine Horlick High School won the Annual State Tiddlywinks Championship Sunday held at Lynchville, Wisconsin.

Horlick came from behind in the closing seconds to defeat the defending champions, Arshville Elementary School, 3-2.

We're proud of you, boys!

WINNERS ANNOUNCED

In an unofficial poll conducted by Klepto, Lois Den Hartigh was named "The Girl I'd Most Like to be Trapped in the Second Floor Broom Closet With", and Gary Pinnow was tabbed "The Boy I'd Most Like to Overhaul a Transmission With".

OPPOSITE: **_Klepto_ no. 23 cover | 1963**

Starting in seventh grade, I wrote and illustrated odd publications for classmates. These one-of-a-kind creations, which featured original drawings and snapshots glued to typed manuscripts, proved popular. Annoyed that they often weren't returned after circulating, I began a new series named *Cleptomaniac* (later *Klepto*) in 1960. Soon the principal's sympathetic secretary allowed me to freely use the school's Ditto machine after hours. This limited technology (later replaced by xerography) required drawing, hand lettering, and typing on reverse carbon sheets (errors could not be corrected), but suddenly I could print fifty to two hundred copies of the three- to six-page publication and *sell* them. *Klepto*, which I continued to produce into high school and which contained everything from satire to gag cartoons to gossip, proved an early training ground on several levels for an eventual career.

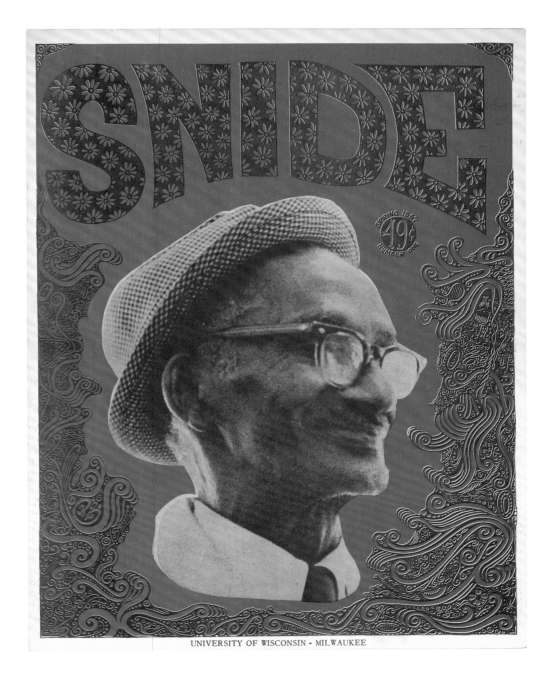

UNIVERSITY OF WISCONSIN · MILWAUKEE

ABOVE: **_Snide_ no. 1 cover | 1966**

In the fall of 1966 I co-founded *Snide*, UWM's first humor magazine, with New Yorker Jeff Winters, a rare out-of-state student at the then-predominantly commuter campus at Milwaukee. I contributed the lead fiction piece and several illustrations, along with the logo and border for the cover of the only issue. The planned all-comics sequel eventually morphed into *Mom's* no. 1.

OPPOSITE: *Sardonic Time* | **November 1966**

At age twenty I wasn't sure whether I wanted to be a cartoonist or a surrealist painter. *Sardonic Time*, one of a dozen or so mixed-media paintings created prior to the underground comix movement, represents the straddling of that youthful uncertainty of direction. The hair-turning-into-flowers motif (repeated a year later in *Time Out of Whack*) is the only sign of life or hope in this stark and dismal scene.

'Gelt' Tree Not in the Money

Staff members of Snide, campus humor magazine at the University of Wisconsin—Milwaukee, were disgruntled this week. They claimed their entry in the Christmas tree decorating contest didn't get fair consideration. The tree, shaped like a dollar sign, was designed by Dennis Kitchen and drew considerable comment for its originality. The entry, entitled "Christmas—the Holiday With the Gelt Complex," finished 10th in a field of 22 other trees. Winners were conventional trees. —*Journal Photo*

ABOVE: **Newspaper clipping from** *The Milwaukee Journal* | **December 1967**

Majoring in journalism at the University of Wisconsin—Milwaukee taught me how easy it was to manipulate the media. *Snide*, the new humor magazine on campus, needed publicity. As an officially sanctioned student organization, we qualified to participate in the school's annual Christmas tree-decorating contest. I clipped all of our tree's limbs and shaped them into a dollar sign with coins as ornaments. Since German culture heavily permeated Milwaukee, I used the German word for money to create a Freudian pun: "The Holiday with the Gelt Complex." As expected, the best traditionally decorated tree won, but I called *The Milwaukee Journal* to report a "controversy" over the results. Our losing entry alone appeared in the city's largest daily, and *Snide* was on the map.

I did not have a serious girlfriend until 1967, which may explain the somewhat over-the-top sexual imagery in a good deal of the paintings I did in the 1960s.

OPPOSITE: ***Succulent Precognition* | 1967**

At three by four feet, *Succulent Precognition* was the largest painting I ever attempted, and also the only one I entered in a competition (it was accepted at the Wisconsin State Fair in 1968). I subsequently cut it into smaller pieces, two of which survive. The central image, renamed *Bearded Man with Horn of Plenty*, is a prime example of my obsession with spaghetti-like hair and was cut to fit a particular round-cornered frame. The second remnant, *Psychedelic Butterfly*, can still be seen as a piece of the jigsaw puzzle connected to the horn of plenty.

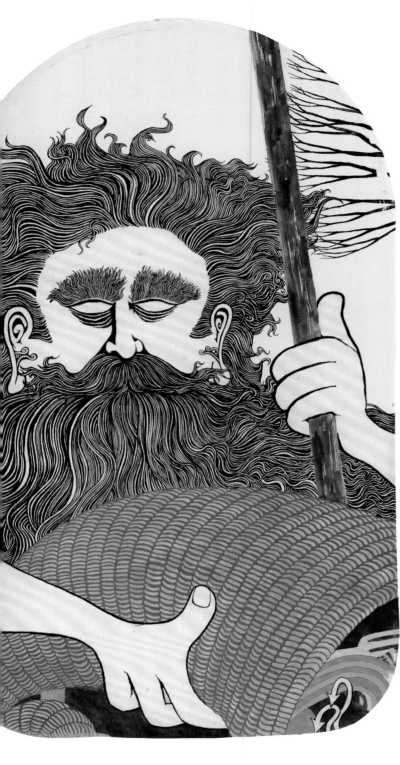

OPPOSITE: **Freak-In!! poster | 1967**
The border of this Milwaukee rock concert poster was inspired by Harvey Kurtzman's elaborate borders on early *MAD* magazine covers. I used this theme again on the cover of *Mom's Homemade Comics* no. 1. The inset art and tiny curlicue border filigree (like all line art from this period) was drawn with a ballpoint pen before I discovered the wonders of a sable brush.

ABOVE: *Evening Cocktail* | **February 1968**
This early mixed-media painting is one of many featuring the thick, wiry hair and beard that became one of my stylistic idiosyncrasies. *Evening Cocktail* obviously combines sexual imagery and surrealism, but, hopefully, it also conveys a certain sense of humor, especially given the title. This image remains a personal favorite among my 1960s work, underscored by the fact that I repeated the essential theme for the cover of *Weird Trips* no. 1 in 1974 (shown on page 122).

I love idiosyncratic off-brand American cars from the late '40s and early '50s. I've owned Hudsons, Packards, Nashes, and hearses, but I only turned one into a "hippie" vehicle: this 1950 Nash. During the Summer of Love I painted it paisley, with a topless mermaid on the roof for truckers. I drove it for one fun-filled year. In the winter of 1968 the Nash developed mechanical problems and sat in my parents' suburban driveway. When the snow melted, revealing the "eyesore" to the neighborhood, my mortified stepfather, George Riley (who was wonderful and tolerant in every other respect), gave me thirty days to get it out of their yard. I tried selling it, but there were no takers, even at $100. As the deadline neared, I desperately offered it for free to friends. But no one had a place to store it. In the spring of 1969 the Paisley Nash was towed to a junkyard and presumably crushed into a cube.

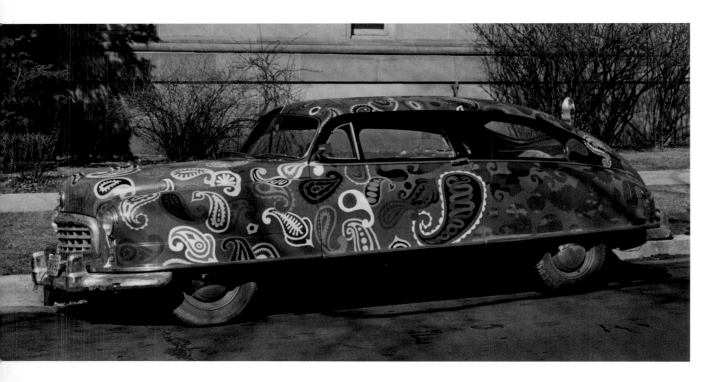

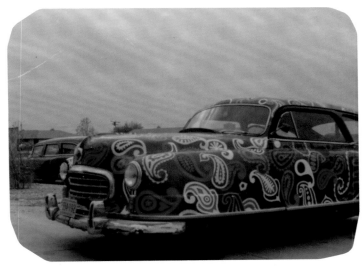

OPPOSITE (BOTH): *Kitchen Visits . . .* **| 1969**
Though I had graduated from UWM nearly a year before, I continued to get steady freelance work from the *UWM Post* during my starvation period of working on *Mom's no. 1*. The latest gig—providing illustrated reviews of colorful local bars for newer students—not only paid ($10 a strip at a time when my rent was $50/month), it included an expense account for beer.

Kitchen visits HOOLIGAN'S

NO. 1 in a NEW SERIES! CLIP AND SAVE

2017 E. North Ave.

Hooligan's is the only tavern in Milwaukee where you can walk in with a dollar, get loaded drunk, and stagger home with a pocket full of change.

How is this possible?

IT SELLS A HUGE 11 oz. "schooner" of BEER

FOR ONLY TEN CENTS!

HOOLIGAN'S FEATURES 2 DISTINCT CLIENTELE: THE OLD TIMERS and the FREAKY STUDENTS.

The two do not necessarily approve of each other...

Goddamn filthy hippie

Goddamn filthy degenerate

In addition to its dime beer, Hooligan's is especially famous for its friendly bartenders.

I ain't servin' ya till ya get yer hair cut.

QUEENS — Gentlemen

The johns confuse newcomers.

Hooligans' Christmas decorations are still up... But some of the decor is even older.

BACK YOUR BRAVES Miller

The bar also features a large selection of quality liquors.

Gimme a gallon 'a Mar Vista

Hooligan's is truly VIRGIN TERRITORY for the student who seeks a unique new hangout. However, it is NOT virgin territory in any other sense of the word.

Kitchen visits THE TUX

NOW A REGULAR FRIDAY EDITION FEATURE!

2649 N. Downer av.

The TUX has the distinction (and advantage) of being the tavern closest to the UWM campus... just 4 blocks away.

Thus, it caters to a regular clientele of straight students, notably the FRATERNITY CROWD.

The TUX also serves food. It is famous for the greasiest pizzaburgers in town.

However, the beat cops often frequent the kitchen to sample the choice cuisine.

With plenty of police about, no under-twenty-one students dare sneak in.

Service is slow.

The door to the men's room has no door-knob.

MEN

Hic Hic CHUG CHUG

The afternoons are noted for the old east side ladies crowd.

In short... The TUX is a DULL place to visit. Its drinks are 50% more than Hooligan's but it has only half the charm. But... it's close to the university and that is its saving grace.

Mom's Homemade Comics no. 1 cover concept | 1968

Aside from the abandoned curlicue borders, this ballpoint sketch is quite close to the final cover design. But as the bottom line of the rough indicates, my vitriolic belly-splitting humor was to have been augmented by the "bold, biting social sarcasm of Tom . . . Budzinski?" Tom, a contributor to *Snide*, dropped out, and *Mom's Homemade Comics* no. 1 became a solo effort.

OPPOSITE: **Mom's Homemade Comics no. 1 cover art | 1968**

Mom's no. 1 officially marks my entry into the world of underground comix. The squeaky clean title was merely a setup for the subtitle pun. I loved drawing tentacles (see the squid villain in *Mom's* no. 2 and the Krupp corporate symbol), so an octopus pie seemed an ideal twist on the all-American "mom and apple pie." But did I miss another obvious pun? Her son *could* have exclaimed, "Gee, Mom. You make the most delicious *octopi* in the world!"

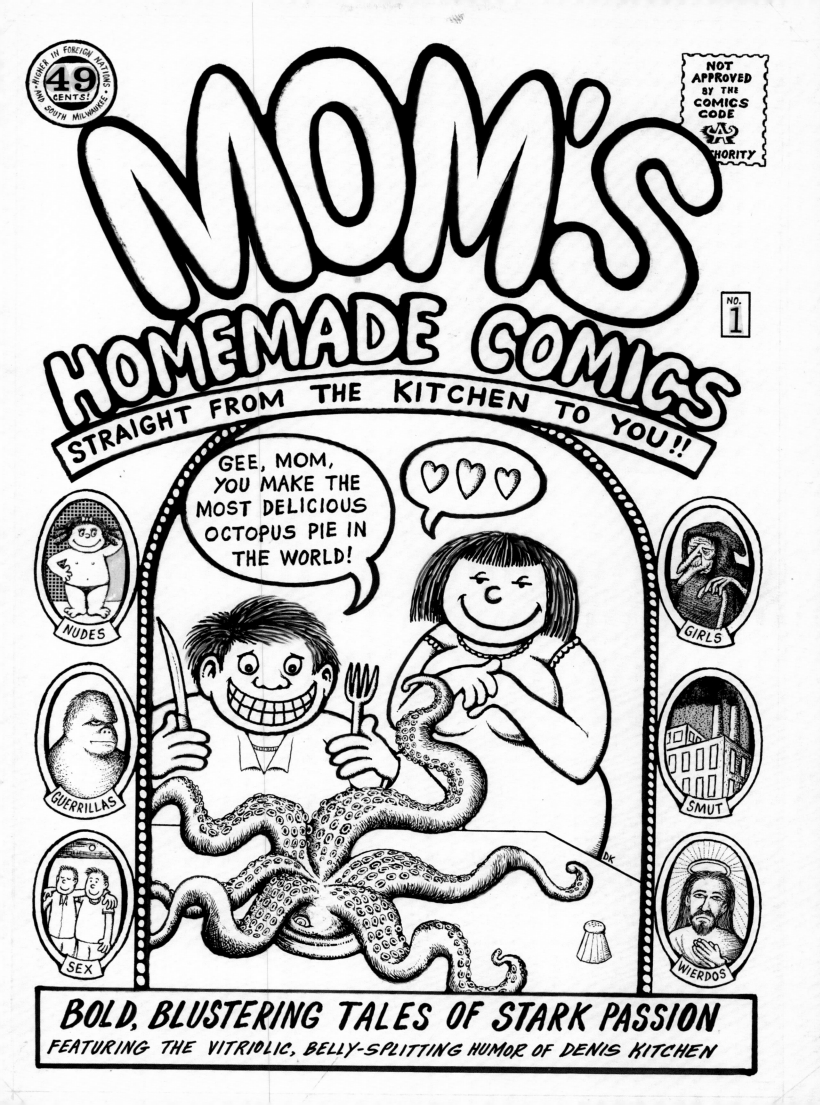

BELOW: *Mom's Homemade Comics* no. 1 cover, 49¢ edition | 1968

Mom's no. 1 evolved from a planned all-comics issue of *Snide* no. 2, the campus humor magazine I co-founded in 1966 at UWM. *Snide's* treasury was depleted, and after graduating in the summer of 1968, I was soon drafted. In late 1968, after a brief but eye-opening army stint, I jumped into both *Mom's* and the counterculture with fervor. By the summer of 1969 I had self-published and self-distributed 4,000 copies of the 49¢ edition, selling 3,500 on the east side of Milwaukee alone. The Print Mint in Berkeley published a second (50¢) edition. At this point, I was totally focused on making my own comix.

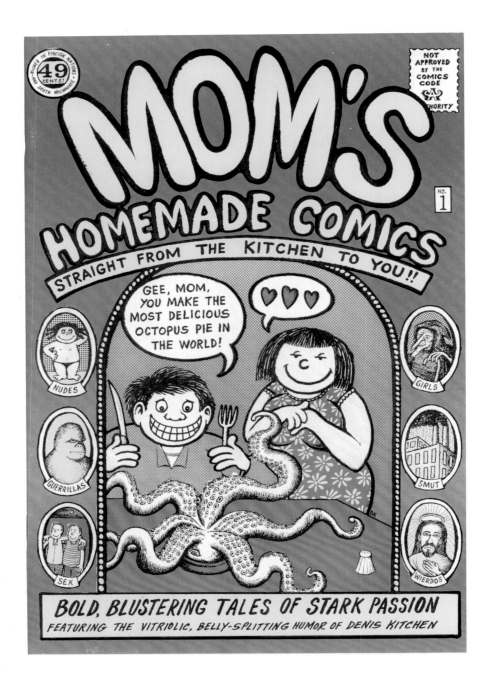

OPPOSITE (AND PAGES 64-66): "South Pole!" | 1969

Mom's Homemade Comics no. 1 was created with a local audience in mind (the circle around the 49¢ cover price says: "Higher in Foreign Nations and South Milwaukee"). Milwaukee was among the most segregated cities in America in the late '60s, and its south side was predominantly Polish, hence the title of this lead story. I grew up with greasers like Mary's boyfriend Roger. His 1949 Nash (built in nearby Kenosha) was among my favorite American cars of the era (see the photo of my own Nash painted paisley, on page 58). Stanley guffawing at cartoonist Ernie Bushmiller is perhaps the earliest record of my lifelong fascination with Nancy and Sluggo.

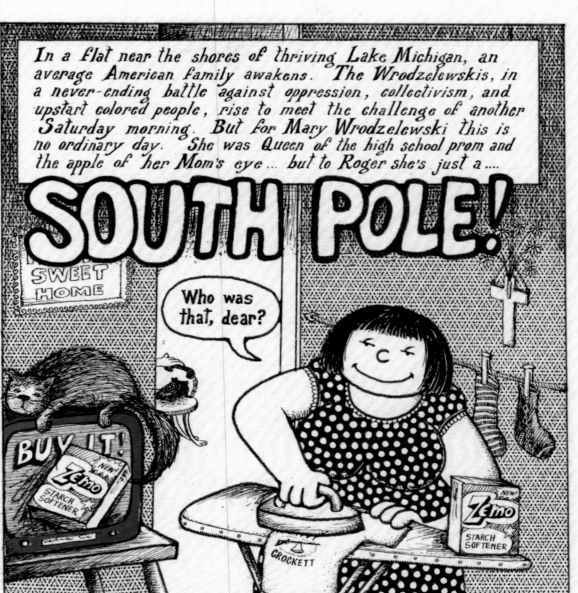

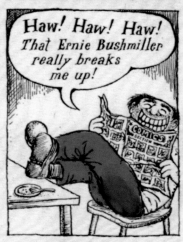

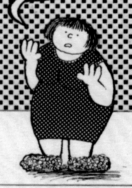
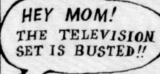
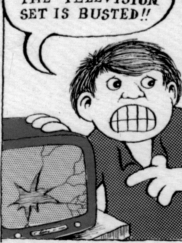
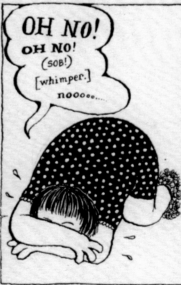

ABOVE: **Freshly baked comix | 1969**

This publicity photo, taken in my east side apartment, plays off the *Mom's* subtitle
"Straight from the Kitchen to You." My hair is still growing out from the army crew
cut administered six months earlier.

BELOW: **"Slum Tourism"** | **1969**
This satire on blasé attitudes toward poverty probably holds up better than most pages in *Mom's Homemade Comics* no. 1.

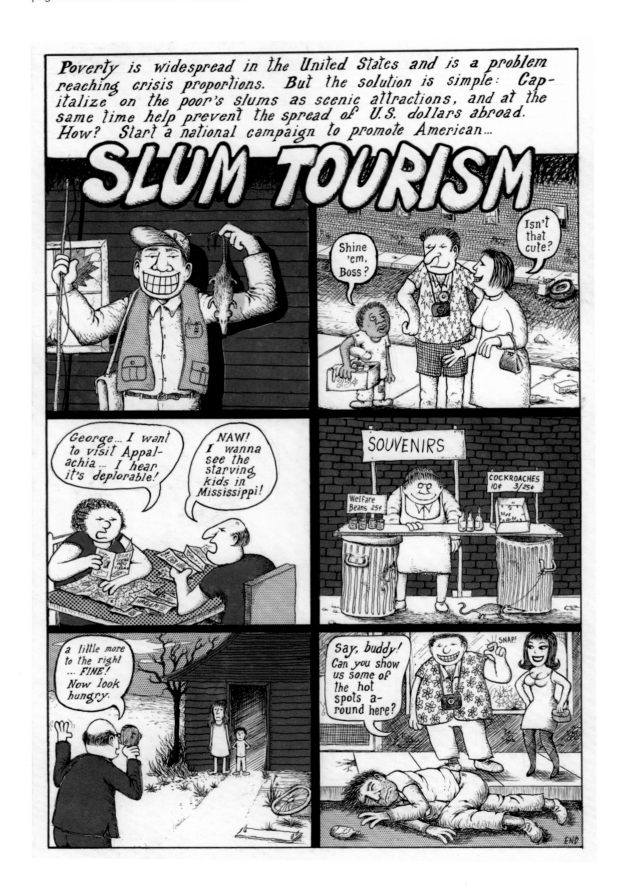

OPPOSITE: **"Granville"** | **1969**
An uplifting kids' page from *Mom's* no. 1.

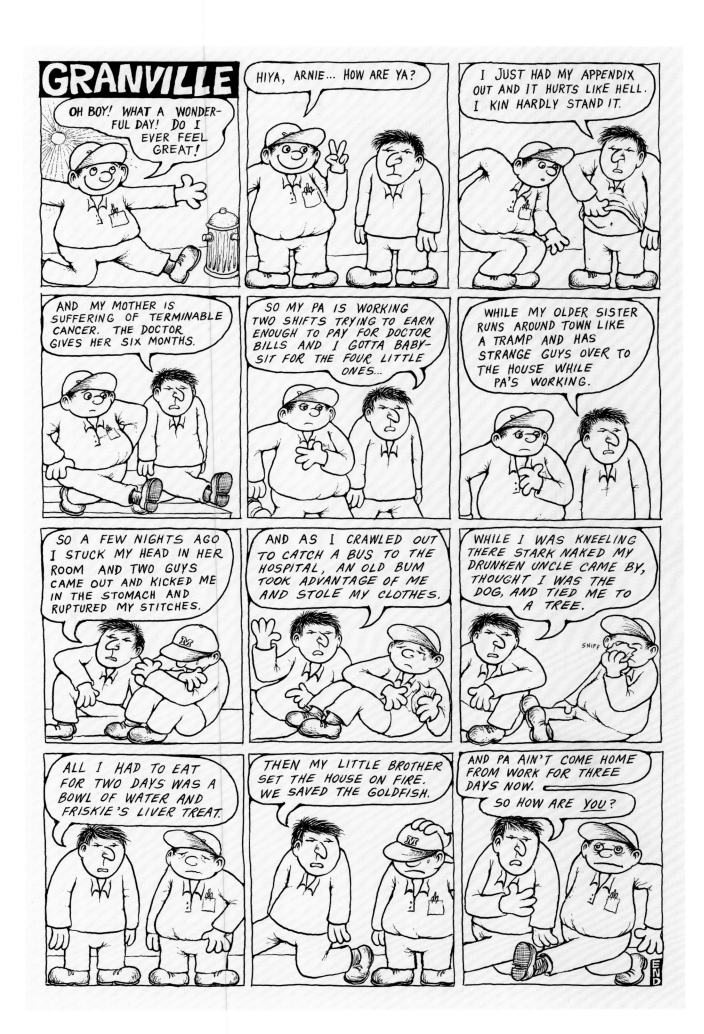

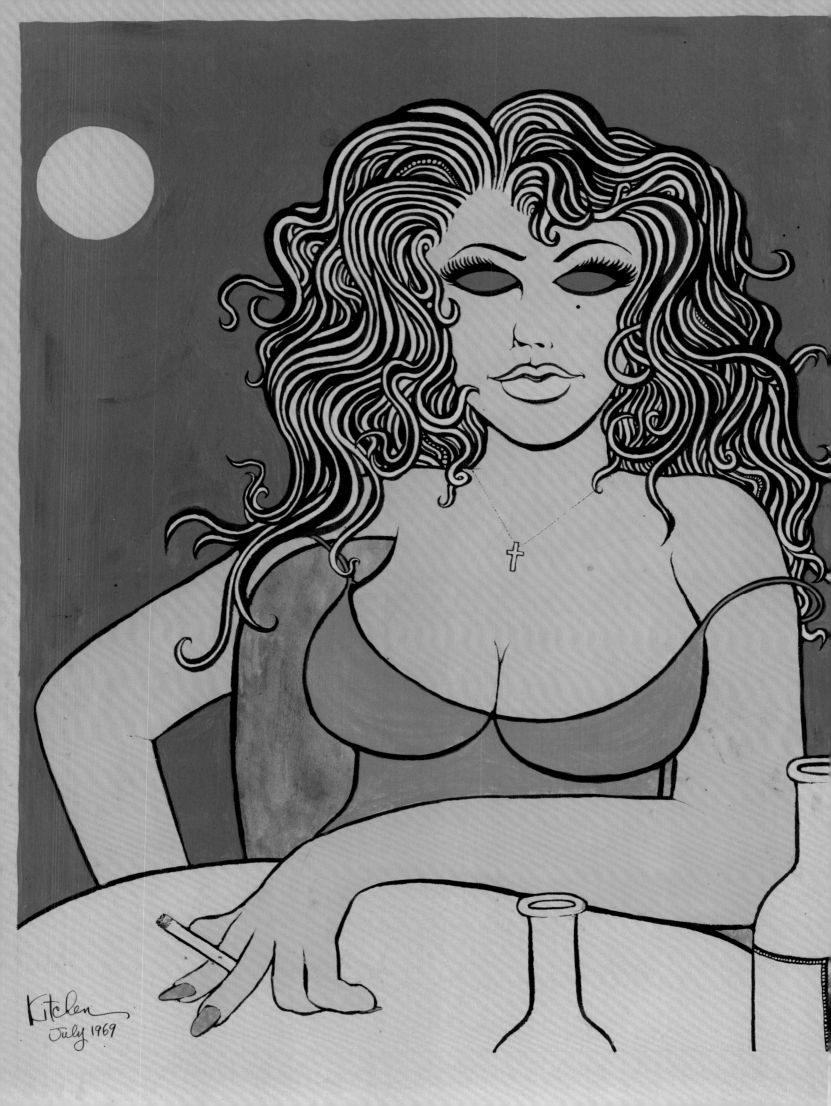

OPPOSITE: **_Girl with No Eyes_ | July 1969**

This painting is my only one inspired by and named after a song, though vacant eyes were already a common motif in my early work. "There's a girl in my room and her face on the wall with no eyes" was a lyric from It's a Beautiful Day's first album, released in 1969—a record I listened to many times, often in an altered state.

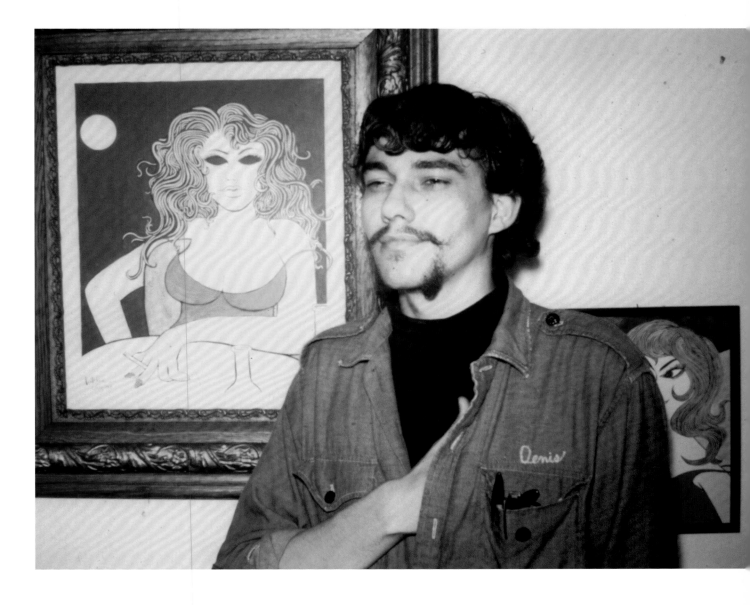

ABOVE: **Napoleonic pose, Milwaukee | 1969**
I had just painted and framed *Girl with No Eyes* when my roommate Terry Shaw took this snapshot.

The banner assuring readers that this was "America's Most Wholesome Underground Comic!"—while blurbs promised "Blood and Gore," "Raw Sex," and "Heavy Stuff!"—was the kind of contradictory humor I sometimes reveled in. What I find hard to look at now is the impossible anatomy—even by rubbery cartoon standards—of the arm holding the broken bottle. The moiré patterns on the shirt-sleeves and vest indicate that I was also still learning the arcane subtleties of cutting Zip-A-Tone color overlays, a now (thankfully) lost art.

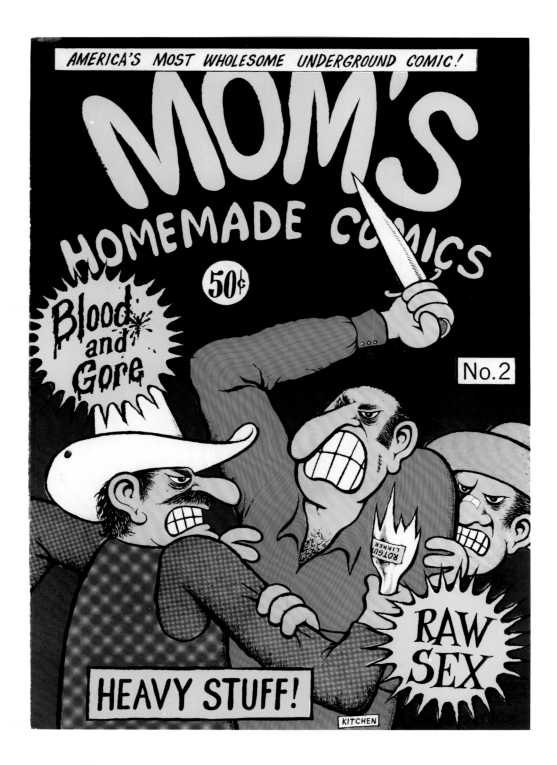

OPPOSITE: **JŌB concert poster | 1970**
In my freelance days I often did work for regional bands, including this promotional poster for a hard luck band that renamed itself for the Biblical character Job after having experienced accidents, abysmal gigs, lost equipment, low draft numbers, and even the death of a band member.

BELOW: *"Teen-Age Horizons of Shangrila" is a Barrel of Laughs* | 1970

The back cover for *Shangrila* no. 1 may seem rather obviously tongue-in-cheek. But in 1970, I learned that irony is in the eye of the beholder, when I was trying to recruit cartoonist Peter Poplaski, who lived at home while attending UW–Green Bay. His mother saw the sample of *Shangrila* that I had mailed upstate and was genuinely shocked, exclaiming, "Why would you want to work for people who'd stick a blade in people's eyes?!" The incorruptible Poplaski nonetheless joined Krupp's den of iniquity.

OPPOSITE (AND PAGES 76-79): **"I Was a Teen-Age . . . Hippie!"** | 1970

In this lead story for *Teen-Age Horizons of . . . Shangrila* no. 1, I was spoofing B movies like *I Was a Teenage Frankenstein* (1957) and 1970 middle-class fears that hippies were part of a pernicious cult. Jughead and a buxom Nancy (a character I parody time and again) make cameo appearances. Actual friends Debbie, Gene, Dan, and Diane all loosely inspired other roles.

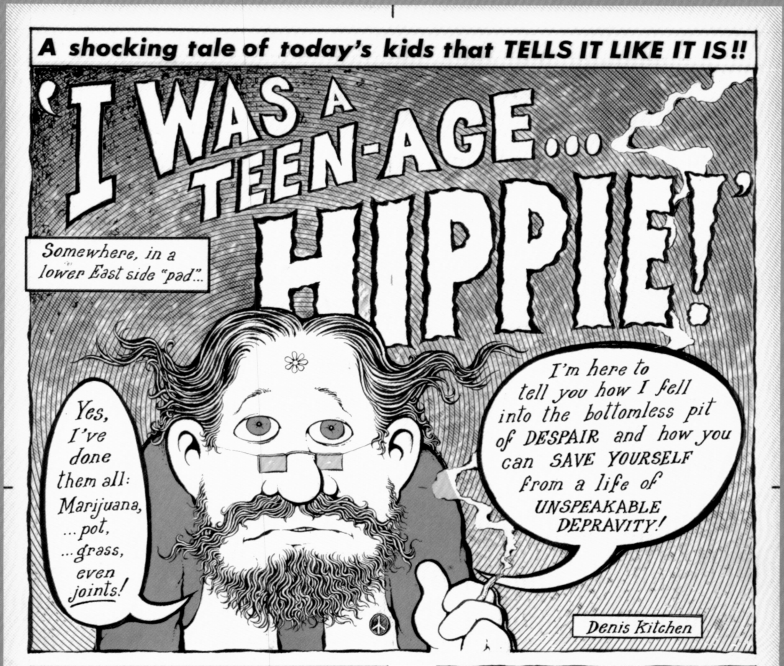

It was Debbie who initiated me into the sordid arena of SEX....

Soon my circle of friends included an increasing number of UNDERGROUND CHARACTERS. One was a notorius dealer named Gene.

Under Gene's influence, I deteriorated into a DRUG FREAK.

Gene's room-mate, Dan, sparked my political awareness...

Dan's profound words struck a sensitive chord deep inside me. I decided to become a REVOLUTIONARY.

Suddenly, my parents began to notice me.

But soon our channels of communication began to break down.

So I decided to forsake my family bonds and leave for California to get my head together.

When I got to Frisco, it was a groovy scene. Everywhere I went there were beautiful people and good heads...

I was looking for a place to stay when I met Diane.

Hi! You wanna come up to my place an' mess around?

Sure.

We went to her apartment and proceeded to smoke MARIJUANA (the killer weed.)

KOFF! KOFF!

First time, buddy?

Under the influence of the drug, Diane forced me to commit unnatural acts on her...

VRºººººOM! Honk Honk

OOOOOOOOH! mmmmmm...

Something inside me, perhaps the remnants of my "conscience," told me what I was doing was wrong. I left Diane and began to walk the streets, deep in thought...

HAW!

AL!

Hey, man... c'mon in!

4

Peace, man... Have a TOKE!

WOW

As I watched the behavior around me I came to a realization.

Groovy

Somethin else

Outasight

Far out

Wow

The romance faded. It became clear to me that Hippies only wanted to lay around, smoke dope, and have orgies!

Gimme a li'l kiss...

FRESH!

I decided to GET OUT...

I QUIT!

I'm gettin' outta this strip!

OH NO YA DON'T!

GRAB HIM!

That's it, boys!

It was then that I discovered the TERRIBLE TRUTH: You can't leave the Hippie cult... It's a rigid, secret society... worse than the Masons, Cosa Nostra, or Roman Catholicism. ONCE IN, YOU'RE IN FOREVER!

So don't make the same mistake I did, kids...

And remember: Always listen to yer folks!

End

BELOW: *Bugle-American* no. 1 cover art | 1970

Through much of 1970, I conspired with three classmates from the UWM journalism school and a fourth friend to start a "hybrid" alternative weekly. Hoping to thread a path between Madison's shrill radical weeklies, boring student papers, and staid, out-of-touch dailies, the *Bugle-American* dove into the fray with little capital and no business plan whatsoever. Far-left zanies had already started rumors that we were someone's "tools" or CIA-funded. My cover for the debut issue hit the military-industrial-complex rumors head on, revealing that the *Bugle*'s staff included a capitalist, a streetwalker, a religious zealot, and a general (typing a memo to J. Edgar Hoover).

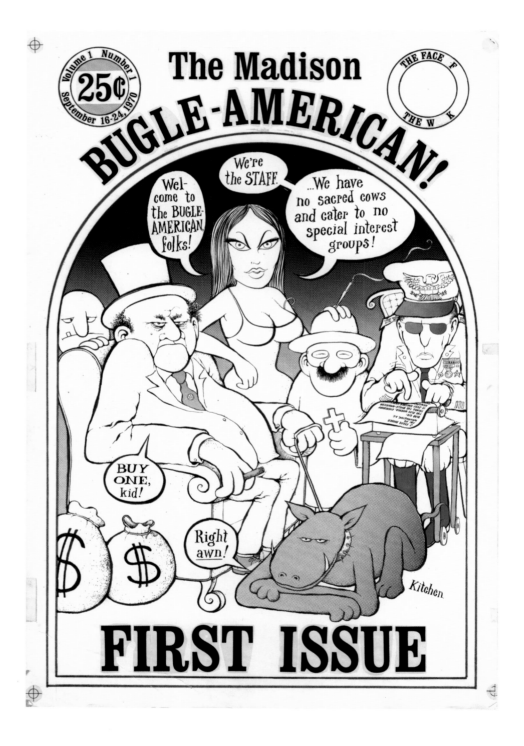

OPPOSITE: *Mom's Homemade Comics* no. 3 cover art | 1970

Anecdotally, the vast majority of underground comix readers smoked pot, and I knew that pot smokers can sometimes get a little paranoid when high. So this mischievous cover of staring "straights" outside the reader's window was intended to provoke a little nervous paranoia. Is nothing sacred?

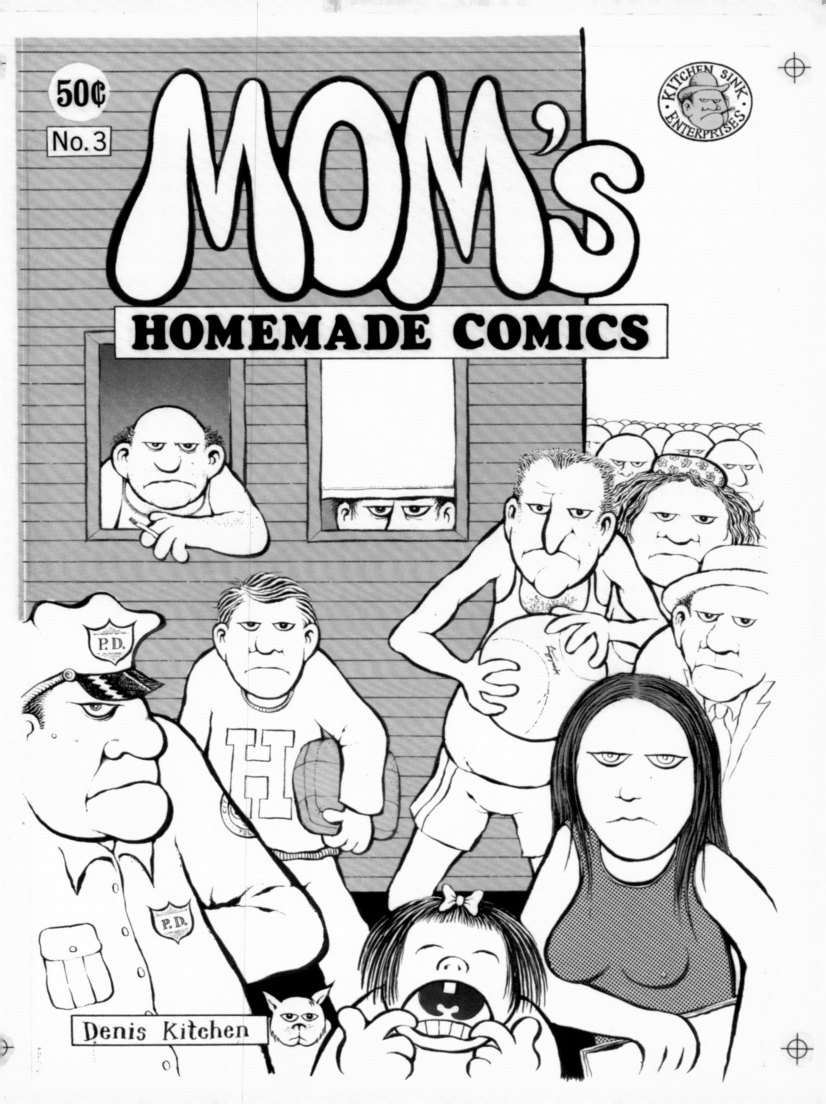

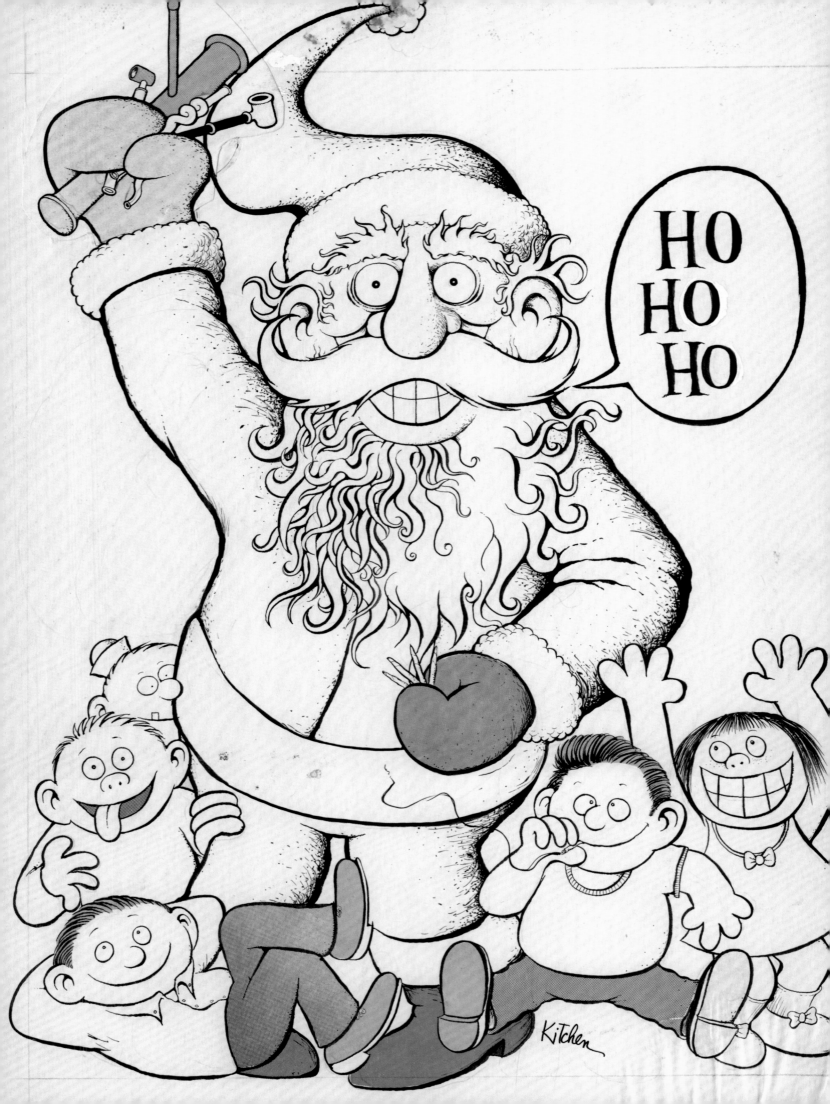

ABOVE: **"Ingrid the Bitch" page 6 | 1970**
Breaking up with my girlfriend Ingrid wasn't pleasant, and resentment lingered. I got
the last word with a bitchy namesake in _Mom's Homemade Comics_ no. 3. But the
cartoon character (a.k.a. "Little Ingrid" in various _Bugle_ strips) had nothing in common
with her real counterpart. At ten pages, "Ingrid the Bitch" with "Hooligan's Bar," its
disconnected conclusion, was my longest single story—too long and too demented
to reprint here.

BELOW AND OPPOSITE: *Bugle-American* comic strips | 1971

It was hard to pigeonhole the *Bugle-American*, but it had one feature that was unique among America's numerous alternative weeklies: early on, every issue boasted a full page or more of comic strips. Jim Mitchell, Wendel Pugh, Bruce Walthers, Don Glassford, and I (and sometimes Peter Loft and others) each produced a weekly strip, which the Krupp Syndicate subsequently sold as a package to other underground or college papers. I came in every week a few hours before deadline, sat down with a blank mind, and never missed delivering, though sometimes the ink dried on the way to the printer. I had some recurring characters (Ferd Pile, Little Ingrid, Rex Glamour) but generally tossed off one-shots, like most of the samples shown here.

OPPOSITE: *Self-Portrait in an Asylum* | **1971**

I was asked to provide a self-portrait to accompany my entry in a book called *Mug Shots: Who's Who in the New Earth* (World Publishing/Times Mirror, 1972). Cartoonists are generally perceived to be on the crazy side, and most are, especially with deadlines and blank panels to fill. My crazy thoughts here involve an ax murderer chasing my character Little Ingrid, while an attendant serves a dead toad for dinner. The mysterious masked figure observing this inmate through the bars also appears on the cover of *Bugle-American* no. 1 and in a long story in *Mom's* no. 3.

ABOVE: **Big Brother & the Holding Co. concert poster** | **1971**

I almost always insisted on autonomy when doing commercial jobs, and my ideas about marketing were not guaranteed to please. Strangely enough, the concert promoter who hired me to create this poster had no objection to my grumpy character telling viewers to save their money and skip the loud bands. The ovals and circles surrounding the grump are all hand-drawn, as is all the lettering. What's staggering to me, in retrospect, is that I drew every tiny circle in the strings of pearls around the letters in "Big Brother & the Holding Co."!

BELOW AND OPPOSITE: **"Juan Cristobal Valdez de ProJunior . . . Explorer" | 1971**
ProJunior was an early reverse-eyed fanzine character created by Don Dohler.
He permitted his character to become public domain. An early Kitchen Sink Press
ProJunior anthology featured stories by twenty-two different underground
cartoonists. My contribution put ProJunior back in time, discovering America.

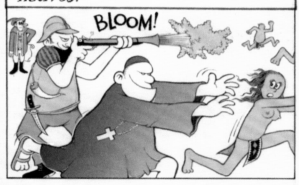

"Beware of Venereal Disease!" | 1971

This sage advice appeared on the back cover of the *ProJunior* anthology. Shortly after this was published, my first wife Irene was pregnant, our $125 rent was due, and I was broke. Irene was in a panic. I assured her I'd come up with something. Completely out of the blue, a fan named Svante Kjellberg called from Sweden, asking if I had any original art to sell. "I have the *ProJunior* back cover for $125," I said, as calmly as I could summon. He agreed if I would hand-color the original. He wired the money the next day. We survived another month.

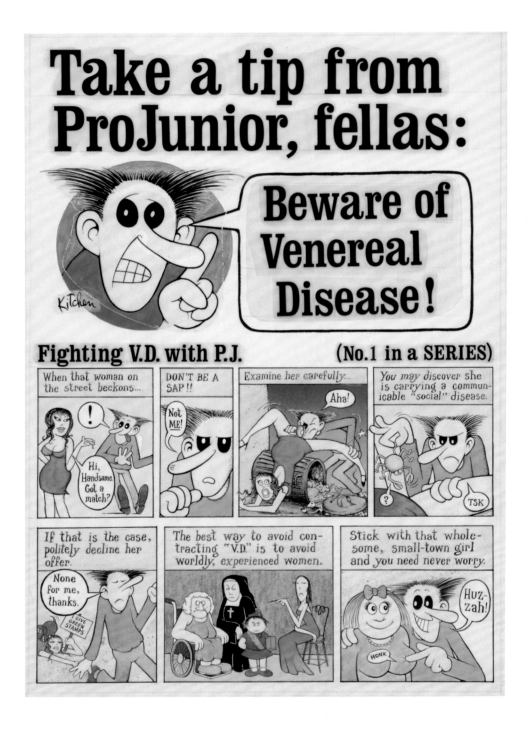

OPPOSITE (AND PAGES 92-93): **"Fred the Louse" | 1971**

This three-page story in *Hungry Chuck Biscuits* was probably inspired by an acid trip that caused me to contemplate molecular levels and existence. It was also an opportunity for me to depict a villain reminiscent of Ming the Merciless, a little romance, and some action-hero sequences—all elements that, for better or worse, I didn't ordinarily tackle or for which my style was not suited. I would love to have done more with these crazy cats, but as we see here, life is short.

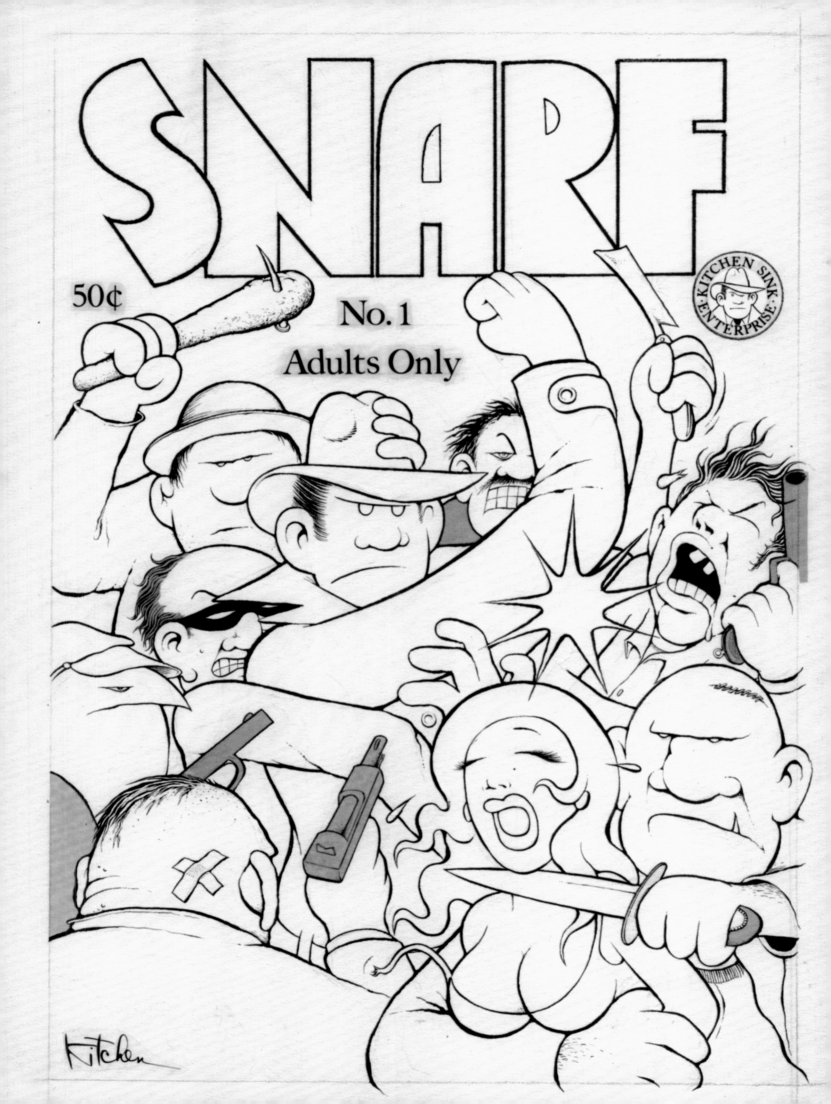

***Snarf* no. 1 cover art | 1972**

Snarf, which lasted fifteen issues, was Kitchen Sink's primary humor anthology. This debut cover features Rex Glamour from the lead story, an eleven-page collection of the dim-witted process server's reconfigured *Bugle* strips. This cover was redrawn in 1977, with essentially the same composition, for the cover to the *Bugle* no. 303.

ABOVE: ***Rex Glamour, Process Server* sample strips | 1971**

My longest-running *Bugle* strip, written with Ed Goodman, spoofed pulp detectives, with a dash of Fearless Fosdick, who tended to be perforated with Swiss cheese bullet holes. Only, Rex wasn't a cop or a private eye; he was an unglamorous and dull process server. The fifteen weekly strips had to be reconfigured to fit in *Snarf* no. 1, with a new header and a fan club ad.

Insight **cover | 1972**

The Milwaukee Journal's Sunday circulation at this point in time approached 500,000 copies, and *Insight*, its popular magazine insert, attracted a far larger audience than I was accustomed to. Editor George Lockwood, a friend of *Pogo* creator Walt Kelly, loved comics and liked me. But George was also on the square side. He didn't "get the counterculture thing" and assigned me to "explain" things, "but be funny." So, as a card-carrying hippie, I had to paint myself as a *Journal* reporter who was posing as an undercover hippie in order to educate him and his readers on Milwaukee's underground scene. Good things I had drugs to help.

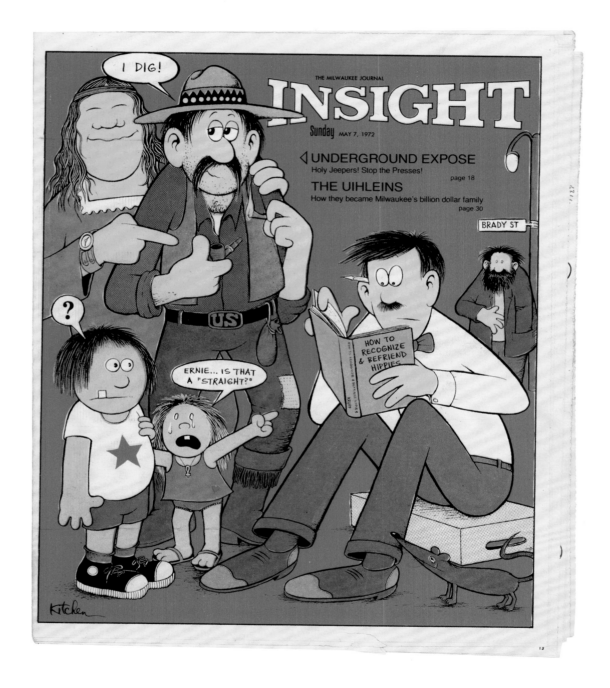

PAGES 98-101: **"Denis Kitchen, Star Reporter, Visits Milwaukee's Underground!" | 1972**

This four-page faux exposé allowed me to poke fun at both the newspaper and hip businesses, while plugging the *Bugle-American* to half a million local readers. My *Bugle* partners Dave Schreiner and Mike Jacobi got caricatured puncturing myths (as their wastebaskets overflow with cash). Finally, an alternate-universe underground is revealed, inhabited by Gilbert Shelton's Fabulous Furry Freak Brothers, Jay Lynch's Pat the Cat, and R. Crumb's Mr. Natural, and a clueless Fat Freddy assumes the role I was assigned. George Lockwood was very happy with the feature, and it was nice to be paid for a form of self-promotion.

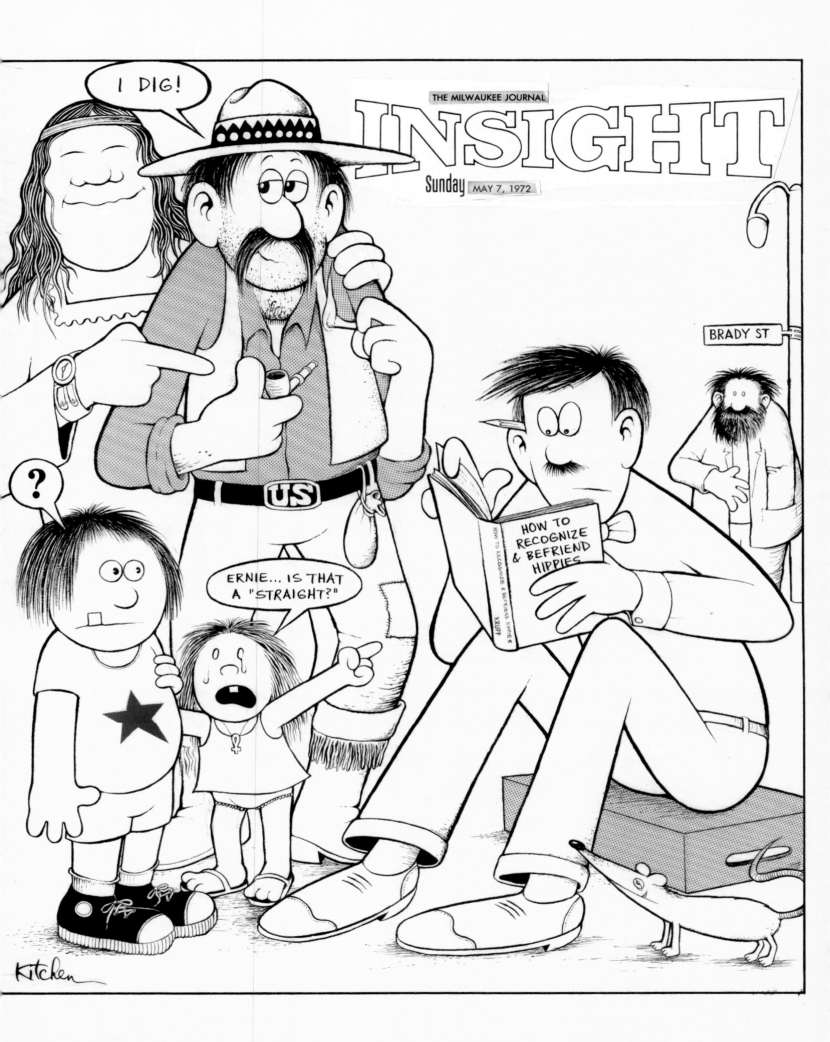

DENIS KITCHEN, STAR REPORTER
VISITS MILWAUKEE'S
UNDERGROUND!

IT WAS A DAY PRETTY MUCH LIKE ANY OTHER. I WAS TYPING MADLY WITH BOTH FINGERS ON AN IMPORTANT OBITUARY WHEN SUDDENLY A COPY BOY APPEARED WITH A WORD FROM THE EDITOR....

TAP TAP TAP

HEY!

GEORGE LOCKWOOD WANTS TO SEE YOU... NOW!

GULP!

GEORGE LOCKWOOD EDITOR Insight Magazine

Grrr...

AT EASE, KETCHUM.

KITCHEN, SIR.

SNAP

I WANT YOU TO DO AN IN-DEPTH ANALYSIS OF MILWAUKEE'S UNDERGROUND!

UNDERGROUND, SIR?

The Editor

YES! AND I DON'T WANT A GLOSS JOB. I WANT OUR READERS TO UNDERSTAND THE UNDERGROUND... TO GAIN INSIGHT INTO THIS CURIOUS SUBCULTURE.... I WANT YOU TO EAT, FEEL, BREATHE, AND SMELL UNDERGROUND... AND THEN WRITE A PULITZER CALIBRE STORY!

BUT WHY ME, SIR?

BECAUSE YOU HAVE A MUSTACHE! YOU'LL BE ABLE TO GAIN THEIR TRUST AND PENETRATE THEIR MIDST!

NOW GET ON IT!

THIS WAS MY FIRST JOURNALISTIC BREAK. I RUSHED OUT OF THE BUILDING BRIMMING WITH CONFIDENCE, MY HEAD GLOWING WITH VISIONS OF BY-LINES AND GLORY.

STOP THE PRESSES!

Sigh...

HONK!

BEEP HONK

HONK

TAXI

TAXI 821

BEEP!

SOON I WAS THERE... SMACK IN THE MIDDLE OF THE HIPPIE SUBCULTURE. I DE-CIDED TO STRIKE UP A RAPPORT WITH SOME OF THE "MOVEMENT" SPECIMENS.

May 7, 1972

19

2

When my Krupp Comic Works partner Tyler Lantzy and I decided to open a head shop on Milwaukee's hip east side, we named it after an Angelfood McSpade comment on the cover of R. Crumb's *Your Hytone Comix*. As a man is blatantly urinating, she intones from a framed bathroom picture, "Strickly Uppa Crust!!" Since our shop would boast the largest selection of comix in the Midwest, we wanted to underscore the generational appeal of our fare. This shocked upper-crust matron fit the bill during the store's five-year run.

OPPOSITE: *Bizarre Sex* **no. 1 cover | 1972**

My close friend and Kitchen Sink's longtime editor Dave Schreiner used to refer to this cover as my "seminal art." The idea came to me in one of those light-bulb moments during an acid trip in 1971. It was one of the few times I jotted down an idea while in an altered state and found the scribbled note in a shirt pocket still funny the next day. *Bizarre Sex* no. 1 was very successful, going through numerous printings and selling about 70,000 copies all told. But this cover, without question, elicited more complaints than anything else I ever drew—not because of the drawing of an erect penis—but because there was no corresponding story inside. In retrospect, I should have complied, ideally providing a story with an arousing start and a satisfying climax. In 1974 Peter Poplaski parodied this image for the cover of *Bizarre Sex* no. 4. With jam assists from Peter Loft and me, his counterpart, "It Came from Alpha Centauri Looking for Love," explicitly depicted a gigantic vulva using the Empire State Building as a dildo.

Ramshackle & Slumlord Realty

WRITTEN BY ED GOODMAN DRAWN BY DENIS KITCHEN

"Ramshackle & Slumlord Realty" | 1972

Fellow *UWM Post* and *Bugle* staffer Ed Goodman and I had our share of awful landlords, so these noxious realtors (one played by Steve Krupp) were easy to conjure. This and a companion "Ramshackle & Slumlord" page ran in *Snarf* no. 3. The characters had real potential, and I wish we had continued the series.

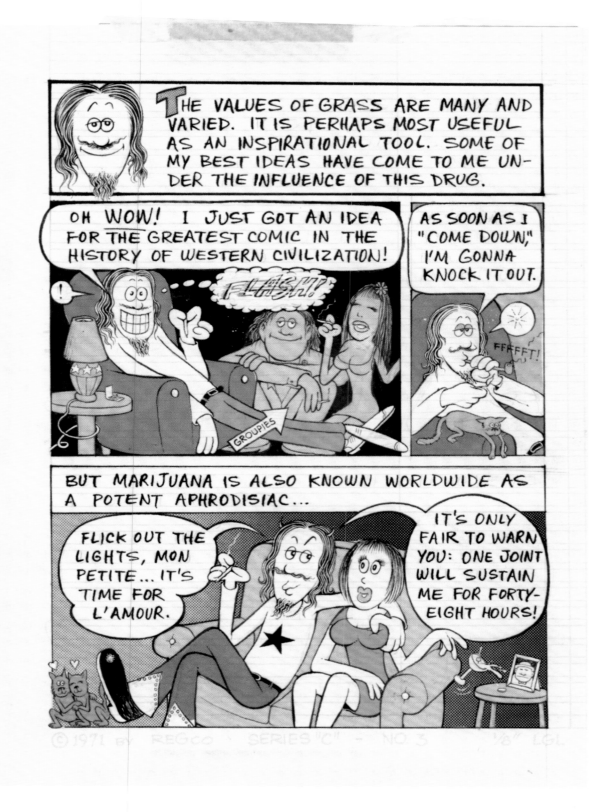

ABOVE: ***The Great Marijuana Debate* page 7 | 1972**

When cartoonists Jay Lynch and Kim Deitch visited Krupp's Milwaukee studio one day in 1972, I shared a joint with Kim while Jay and Peter Poplaski ruefully declined. We decided to create an eight-page minicomic debating the burning issue.

Harvey Kurtzman and Denis Kitchen in Berkeley, CA | 1973
When Berkeley hosted the only comic book convention ever dedicated solely to underground comix, the cross-country comix tribes assembled. Harvey Kurtzman, the self-described "father-in-law of underground comix," was the most prominent guest.

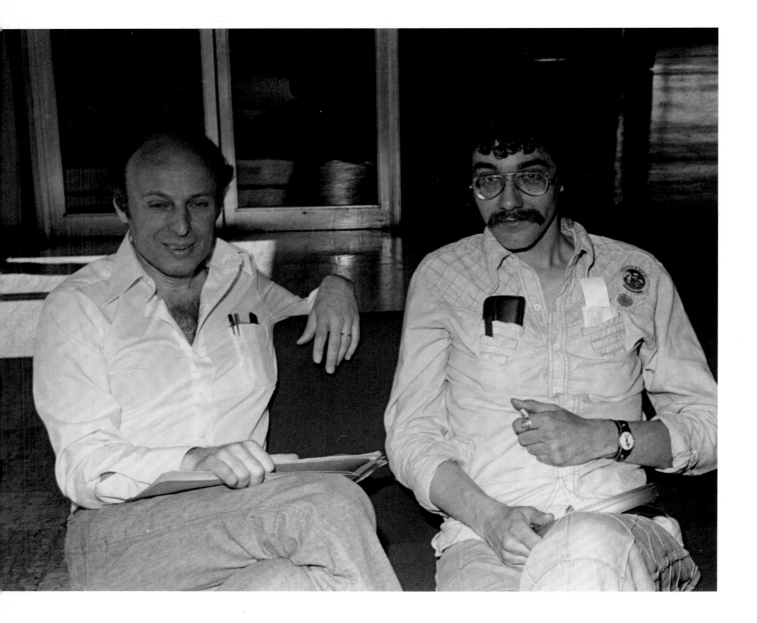

"Let's Be Honest" | 1972
I always had mixed feelings about becoming a publisher. One way I dealt with guilt about my capitalist side was to make fun of it, as I did in this confessional in *Snarf* no. 2. The unnamed cartoonist to whom I advance twenty bucks is Robert Crumb, who would likely be recognizable to readers in 1972. Though "Let's Be Honest" is pure fantasy, the part that seems the most far-fetched—hanging out with Hugh Hefner—is in fact the closest to reality. In May 1971 I brought Harvey Kurtzman to Milwaukee to lecture at UWM. Harvey promised to give me a "ten-minute tour" of Hef's mansion (then on Chicago's Gold Coast) in exchange for driving him there after the lecture. That quick tour turned into a two-day adventure.

Let's Be Honest

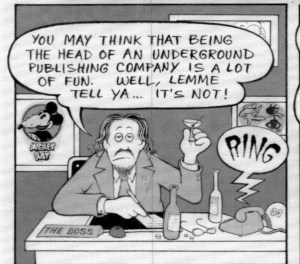

© Kitchen 1972

BELOW AND OPPOSITE: *Bugle-American* **comic strip parodies | 1972**

Bugle-American no. 81 included a pull-out section parodying the *Milwaukee Journal*'s Green Sheet, which included its own comics section. Peter Poplaski, Peter Loft, and I relished the notion of doing strips we'd grown up with. I enjoy mimicking other artist's styles and tackled four, including the usually bath-phobic *Freddy* by Rupe, and Al Vermeer's family-oriented *Priscilla's Pop*. I also did a sexist take on an already sexist character in Tom K. Ryan's *Tumbleweeds*. But I saved my best hippie pun for Ernie Bushmiller's *Nancy* (a not-so-secret favorite). Most comix fans would not have seen these until they were reprinted in *Snarf* no. 3.

OPPOSITE: ***Hot Dogs by the Billion* | 1972**

When *Insight* called me for cover art for its story on Oscar Mayer, the famous meat-processing company with a large presence in Wisconsin, my first instinct was to have Porky Pig himself ground into hot dogs. Oscar Mayer was probably none too happy with the image, nor Warner Brothers (if they ever saw it), but my vegetarian friends gave me high-fives.

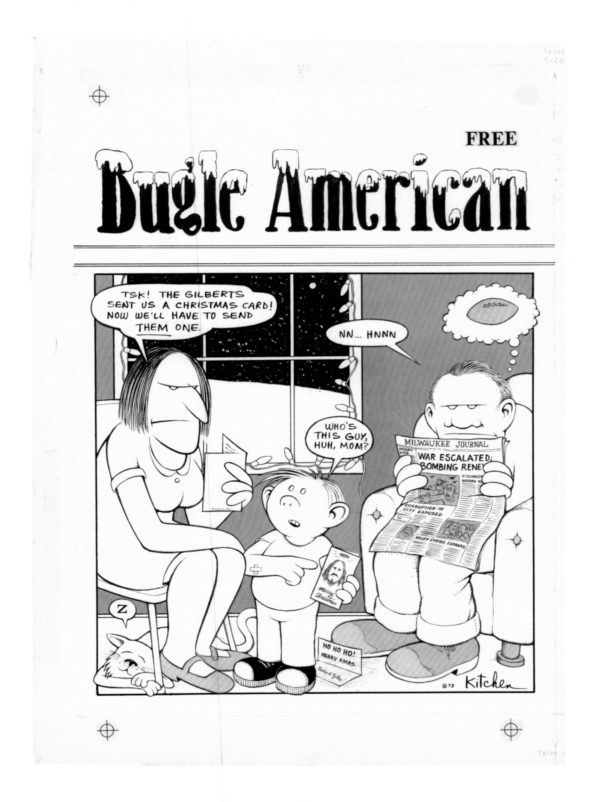

ABOVE: ***Bugle-American* no. 98 cover art | 1972**

This "Christmas" cover didn't bring cheer to many Christians. The parents are self-involved and uncharitable, and their son doesn't recognize Jesus on a holiday card. The headlines are depressing, too, except for the one announcing "Krupp Empire Expands."

BELOW: *Christmas with Snow* | 1972

"Kruppcards" were essentially Hallmark greeting cards for the counterculture and a successful publishing sideline for Krupp/Kitchen Sink in the '70s. Jay Lynch, Peter Poplaski, Steve Stiles, Peter Loft, Howard Cruse, and I created designs for Christmas and for all seasons. One of my Christmas cards capitalized on snow as a slang term for cocaine. I was personally never attracted to coke, but I couldn't resist a cheap pun.

"Ah... Nothing beats Christmas with snow."

OPPOSITE (AND PAGES 114-115): **"Hungry Irving Biscuits!"** | 1973

Editor Jay Lynch asked the contributors to *Bijou Funnies* no. 8, the final issue, to create early *MAD*-style parodies of other underground characters. *MAD* creator Harvey Kurtzman did the cover for the anthology's only color issue. I chose to spoof Dan Clyne's *Hungry Chuck Biscuits*, a now obscure character and title, that was quite popular in the early '70s. Chuck was effectively a self-parody of a gross, foul-mouthed teenager, and thus a special challenge, especially in just three pages. So I took full advantage of the rare use of color to give the obnoxious character his politically incorrect comeuppance in the punch line.

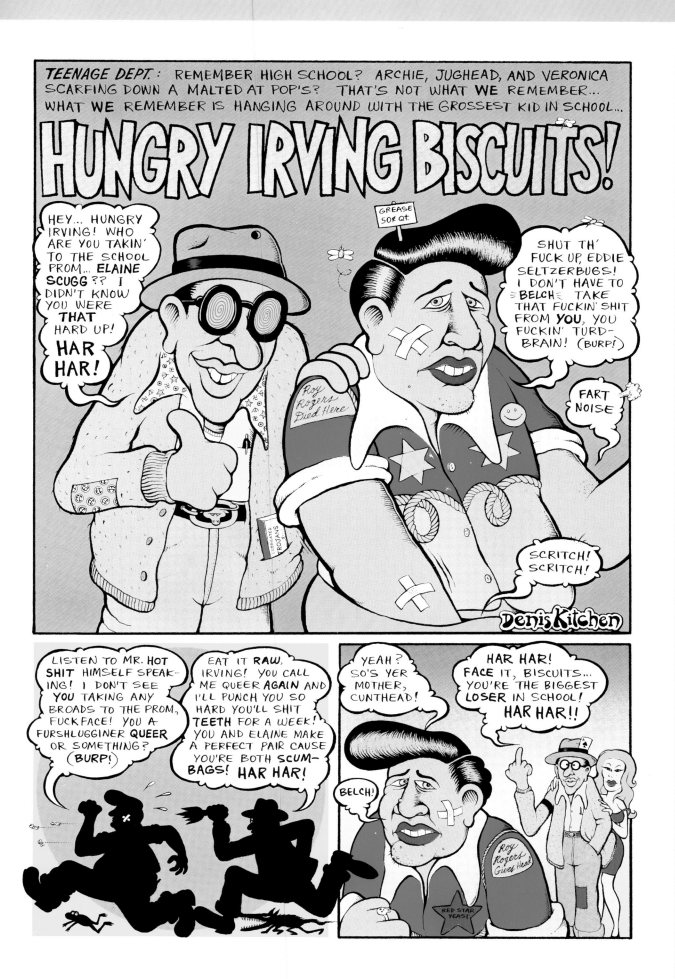

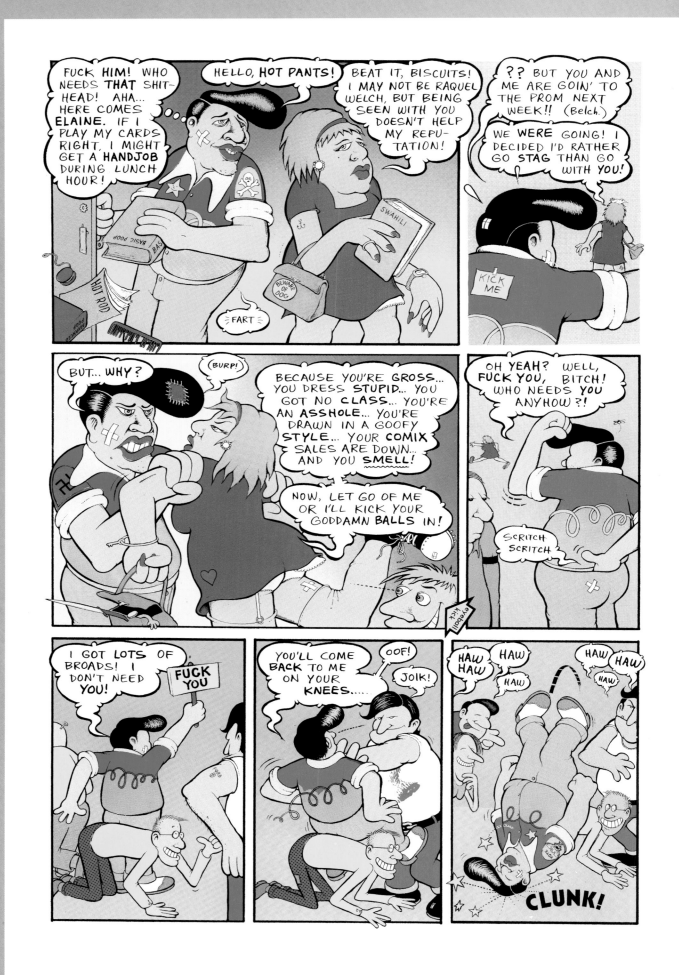

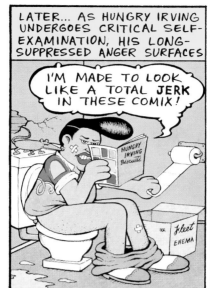

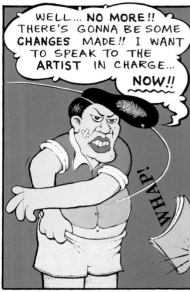

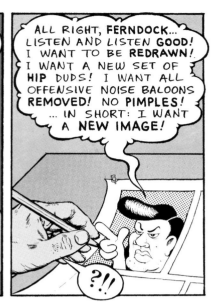

THE ARTIST CAPITULATES... AND HUNGRY IRVING BISCUITS UNDER-GOES A RADICAL TRANSFORMATION...

This photo was taken at the height of my hippie look; my hair would never be longer. The top of six-month-old Sheena's head is barely visible in the backpack. Krupp's head shop, Strickly Uppa Crust, was on Brady Street, the focus of Milwaukee's counterculture. Six months after this photo was taken, our family left the city for a farm in central Wisconsin.

ABOVE: **Blondie** and **Beetle Bailey** comic strip parodies | 1973
The *Bugle-American*'s lampoon of the *Milwaukee Journal* comics section in 1972 was so popular that the following summer we targeted the city's other daily, the *Sentinel*. This time I took on two venerable syndicated strips: Chic Young's *Blondie and Dagwood* and Mort Walker's *Beetle Bailey*. I depicted Dagwood as an oblivious cuckold, but revealed the soldiers in Camp Swampy to be clueless in another way: Beetle, Sarge, Killer, and the Chaplain had no idea the United States had been at war for most of the previous decade. The strips were reprinted in *Snarf* no. 5.

BELOW: **Krupp Comic Works party invitation | 1973**

The company and I used to throw a lot of parties in the early days. I jammed with Cartoon Factory colleagues Peter Loft and Peter Poplaski on this Christmas party invitation card. Poplaski drew the butler, the Tyrannosaurus rex, the monkey, the woman, and the strange alien (sighted in Pascagoula, Mississippi, the previous month). Loft did his characters Flooty the Turtle and Vincent the Teabag in the foreground, the nesting birds, the short hippie, the rabbit, the mouse in racecar, and the large frog. I drew the smoking hippie and three of my characters: Steve Krupp, Pooch, and Terry the Turgid Toad (riding Pooch).

OPPOSITE: ***Bugle-American* no. 142 cover art | 1974**

The *Bugle-American* started out charging for copies, then switched to free copies (to drive up circulation to appeal to advertisers), and then switched back again several times during its seven-year run. This cover, featuring the multi-talented Steve Krupp, was an unsubtle reminder that the paper was no longer free. This original is marked no. 143 but the printed two-color cover was bumped up an issue.

BUGLE AMERICAN

Vol. 5, No. 2 (No. 143) over and over again Jan. 17—24, 1974

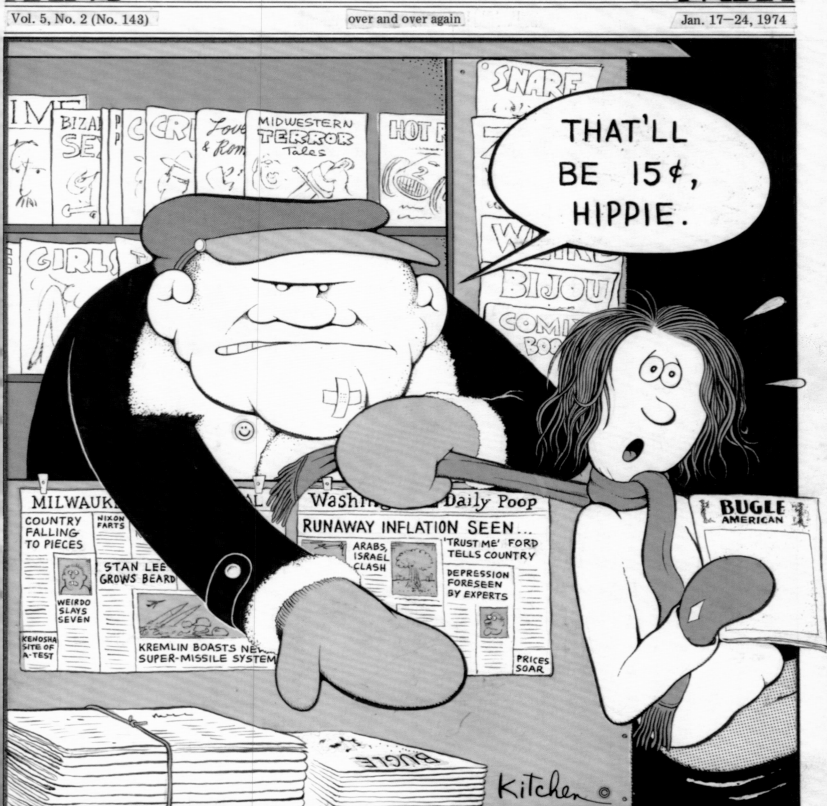

TERRY THE TURGID TOAD
and his sidekick Cosmic Dog in "Weird Trip"

National Lampoon editor Michel Choquette asked me to contribute to his *Someday Funnies*, a much-heralded anthology that was intended to chronicle the '60s via comics vignettes. *Someday*'s contributors, he said, included such luminaries as John Lennon, Federico Fellini, William Burroughs, Salvador Dalí, and Frank Zappa, in addition to ordinary cartoonists like Will Eisner, Harvey Kurtzman, Wally Wood, and Art Spiegelman. My page addressed LSD. For a variety of reasons Choquette's project was aborted and has remained unpublished for nearly forty years. My original art, like others he collected, was not returned. The reproduction here is from a film negative I had the foresight to make in 1972. Two years later I used my "Weird Trip" subtitle for Kitchen Sink's short-lived *Weird Trips Magazine*.

STRANGE PRODUCTS REVIEW

BY STEVE KRUPP

As regular readers of my column are fully aware, I am not prone to exaggerate the qualities of the sundry merchandise that crosses my desk. On the contrary, my objectivity and brutal frankness have alienated many of the quick hucksters and charlatans who flood my mailbox with the latest hipster gear, hoping to win a favorable comment in this column. But I digress.

What I came to talk about is an utterly fantastic item I discovered in an east side specialty shop, Strickly Uppa Crust, 1234 E. Brady Street in Milwaukee. The item I refer to (shown at right) is the **TOKER**, a revolutionary new smoking device.

As a long-time smoker and veteran of countless shapes and sizes of pipes, I have acquired a connoisseur's reputation in rating the quality of such devices. And my ability to rate the level of exhilaration of the stoned state is renown. As regular readers know, it was I who invented the 1 to 10 scale of measuring dope quality. So, when the salesperson at Strickly Uppa Crust boasted that the **TOKER** was unique, I must confess that I had heard this claim before. But I agreed to give it the Steve Krupp test.

Once home, with a detached coolness, I inserted a pinch of average (a-hem) "smoking substance" into the small glass bowl. I lit the substance and inhaled deeply. Expecting only the standard feeling of light-headedness, I did not take care to brace myself. That was costly.

Seconds after my initial toke, a bulging ripple gathered momentum in my veins, gently massaged my central nervous system, blurred my vision, and then thrust itself into the center of my brain with the authority of a quick judo chop thru a soft banana. The instinctive muscular reflex threw me somersaulting backwards, hurtling soundly into my bookshelves, which rained numerous paperbacks and a heavyweight anthology onto my head. In short, it was a thoroughly enjoyable experience.

When I opened my eyes, I was not shocked that large lumps appeared on my forehead (which I did not feel until two days later.) Nor was I shocked that the anthology lay open to Breckman's "Ode to Ecstacy." What shocked me was that the **TOKER** was not shattered in the impact. I then noticed the **TOKER** was made of Pyrex, thus very sturdy.

I further observed that the **TOKER** came with a special brush to keep the instrument clinically clean. And the literature accompanying the **TOKER** explained that it was scientifically designed by physicists and chemists to insure maximum efficiency and mildness.

This is the most remarkable quality: efficiency. The **TOKER** may seem a bit expensive at first glance, but a single toke may render the average person helpless. When you consider how much you spend on your smoking substances and how much literally goes up in smoke, you'll find that the **TOKER** will quickly pay for itself and then **save** you money.

The **TOKER**. Mindboggling.

ABOVE: **"Strange Products Review"** | 1974

The manager of Strickly Uppa Crust, Terre Lantzy, overstocked a water pipe, the Toker, and asked me to create a *Bugle* ad to push our head shop's excess inventory. Since I drew virtually all of the *Bugle*'s column heads, I created the shop's ad as a "review column" by Steve Krupp (the only time a hippie replaced the "real" Steve). I also wrote the purported review in an over-the-top style. After the publication of the rave "review," there was a run on the store. The excess inventory was wiped out, and Terre had to reorder. We periodically repeated the column (always with an "advertisement" disclaimer), and the Toker remained a bestseller. Nonetheless, I refrained from joining the advertising firms on Madison Avenue.

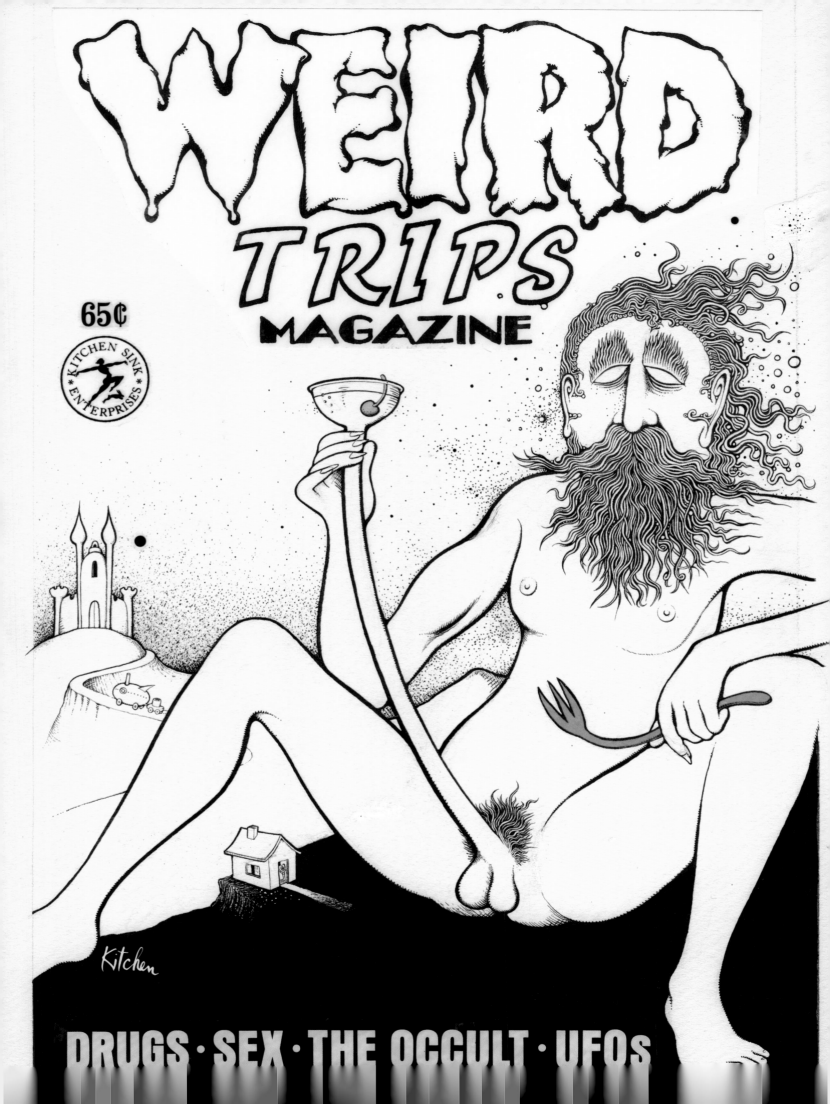

OPPOSITE: ***Weird Trips Magazine*** **no. 1 cover art | 1974**

Weird Trips was an experiment: a comic book format with an odd 65¢ cover price and "weird" illustrated articles. It lasted just two issues, perhaps because covers like this certainly didn't guarantee prime display, even in head shops. This image was clearly inspired by my earlier painting, *Evening Cocktail* (1968), but this God-like creature is trippier and grander in scale; his nut sack alone dwarfs a house.

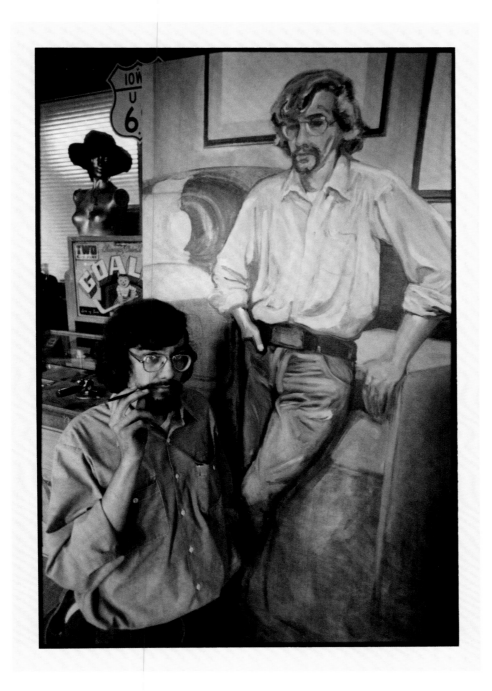

ABOVE: Denis Kitchen, with portrait by Peter Poplaski | 1974

Kitchen Sink's art director and literal artist-in-residence, Peter Poplaski, was always a serious oil painter as well as a cartoonist. In early 1974, he began a life-sized portrait of me posed in my downtown Princeton office, standing next to a 1940s Packard Pla-Mor jukebox. Progress was slow because sitting (or standing, in this case) required carving out long, stationary hours, and Pete was a perfectionist. Some months after this photo was taken, considerable progress was made: a Bushmiller *Nancy* Sunday above my head and my *Let's Be Honest* original to my right, among other details, were fleshed out. In May 1975 I rearranged my office—moving the jukebox—and Pete never finished.

Mail Order Blues

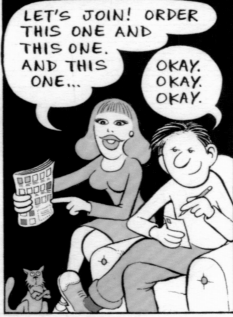

OPPOSITE: **"Mail Order Blues" page 1 | 1974**

This two-page story, one of my contributions to *Consumer Comix*, is a prime example of my tendency to get a little carried away with detail. In the fourth panel of the first page, where the husband and pet cat are eating, any smart cartoonist would simply suggest food on their plates and move on—such mundane details do not propel the story. However, as the blown-up detail (at right) shows, I chose to draw every single pea on their plates!

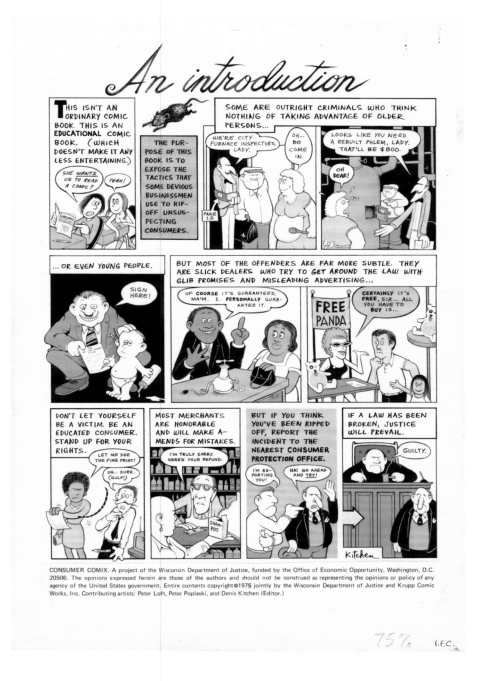

ABOVE: ***Consumer Comix*: "An introduction" | 1974**

In 1973, I was on a stool at Hooligan's Bar talking to a fellow hippie when comics entered the conversation. A stranger in a suit and tie sitting to my left said, "Sorry to interrupt, but are you a cartoonist?" With some hesitation, I confessed. The stranger introduced himself as an assistant attorney general overseeing Wisconsin's Department of Consumer Protection. "Kids don't read the dull brochures we hand out," he complained. "Maybe we should put out a *comic* book?" With that unlikely start, *Consumer Comix* was born. Long before comics or graphic novels became a part of school curricula, 40,000 copies of this educational comic were distributed to the state's high school seniors, with editions authorized in other states (and even pirated).

THE BIRTH OF COMIX BOOK

A sort-of introduction by Denis Kitchen

I THINK I'M PREGNANT!

I SHOULD BEGIN BY POINTING OUT THAT **COMIX BOOK** IS NOT A SLICK NEW YORK MAGAZINE. IT IS PRODUCED IN THE HEARTLAND OF AMERICA.

CARTOON FACTORY

BOX 7

SPECIAL DELIVERY!

LOCATION IS IMPORTANT. IN EDITING THIS MAGAZINE, I WANT TO AVOID THE ARTIFICIALITY OF THE EASTERN ESTABLISHMENT. I WANT TO STAY IN TOUCH WITH THE **REAL** WORLD.

WHY SHOULD WE MOVE TO NEW YORK? OUR RECEPTION IS JUST AS GOOD HERE!

RIGHT FROM THE BEGINNING I EMPHASIZED TO PUBLISHER STAN LEE THAT I WANTED **COMIX BOOK** TO BE A **DIFFERENT** KIND OF MAGAZINE...

BUT STAN, THESE OTHER COMICS APPEAL TO PIMPLY-FACED, MORONIC ADOLESCENTS!

'NUFF SAID, DEN... YOU WANT TO APPEAL TO PIMPLY-FACED, MORONIC INTELLECTUALS!

NO... I WANT TO APPEAL TO PIMPLY-FACED, MORONIC ADULTS!

WHAP!

COMIX BOOK IS DESIGNED AS A HYBRID— A CROSS BETWEEN THE VITALITY AND FREEDOM OF UNDERGROUND COMIX... AND THE DISTRIBUTION AND EXPERIENCE OF AN ESTABLISHED COMPANY.

VITALITY **+** FREEDOM

DISTRIBUTION **+** EXPERIENCE

=

COMIX BOOK

ONCE WE SETTLED ON A FORMAT, STAN PROMISED ME TOTAL AUTONOMY.

OF COURSE THERE'S NO OBLIGATION, DEN, BUT **COMIX BOOK** MIGHT BE IDEAL TO SERIALIZE MY KOREAN WAR MEMOIRS... AND I WANT TO TRY MY HAND AT SOME OF THIS "UNDERGROUND" STUFF. I HAVE A SCRIPT FOR A DOPE-FIEND ANTI-HERO & HIS BARE-BREASTED SIDEKICK THAT I WANT YOU TO HAVE CRUMB PENCIL AND ARTIE SIMEK INK...

Z

I PROCEEDED TO CONTACT AMERICA'S TOP UNDERGROUND CARTOONISTS...

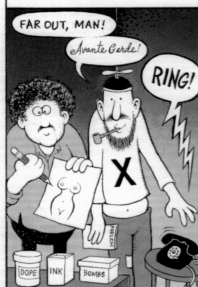

FAR OUT, MAN!

Avante Garde!

RING!

AFTER CAREFULLY WEIGHING THE CULTURAL AND POLITICAL IMPLICATIONS, MOST ARTISTS AGREED TO PARTICIPATE.

LISTEN, MAN, WE'RE NOT GONNA SELL-OUT TO A GIANT, STRAIGHT, MADISON AVENUE PUBLISHING COMPANY!!

UH... HOW MUCH DOES IT PAY?

SOME "OLD PRO'S" WERE ALSO INVITED TO JOIN THE STAFF.

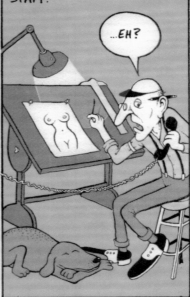

...EH?

AND REMEMBER: COMIX BOOK CARRIES NO ADVERTISING... SO OUR OPINIONS **CANNOT** BE BOUGHT!

RATS!

OIL LOBBY

OPPOSITE: **"The Birth of Comix Book" | 1974**

In 1969 I sent a copy of *Mom's* no. 1 to Stan Lee, who had been my hero during my teen years. This led, surprisingly, to a correspondence and eventual job offers during the formative years of Krupp Comic Works/Kitchen Sink Press. Stan offered me the opportunity to create a magazine for Marvel in 1972, and I declined, not wanting to give up undergrounds. But the comix industry's "Crash of '73" put me in a precarious position. I still didn't want to kill my own publishing company and move to New York City. So Stan and I compromised. I stayed in the "heartland" and continued to run Kitchen Sink while editing an experimental magazine for Marvel. This story introduced *Comix Book* to a largely befuddled newsstand audience. I poke fun here at Stan Lee, myself, and contributors alike. Stan is portrayed as *Spider-Man* villain publisher J. Jonah Jameson. My first wife Irene is depicted in the first and third panels; our toddler daughters Sheena and Scarlet also have cameos in the third panel. Shortly after I drew this page, Irene abandoned all three of us in the middle of the night, never to return.

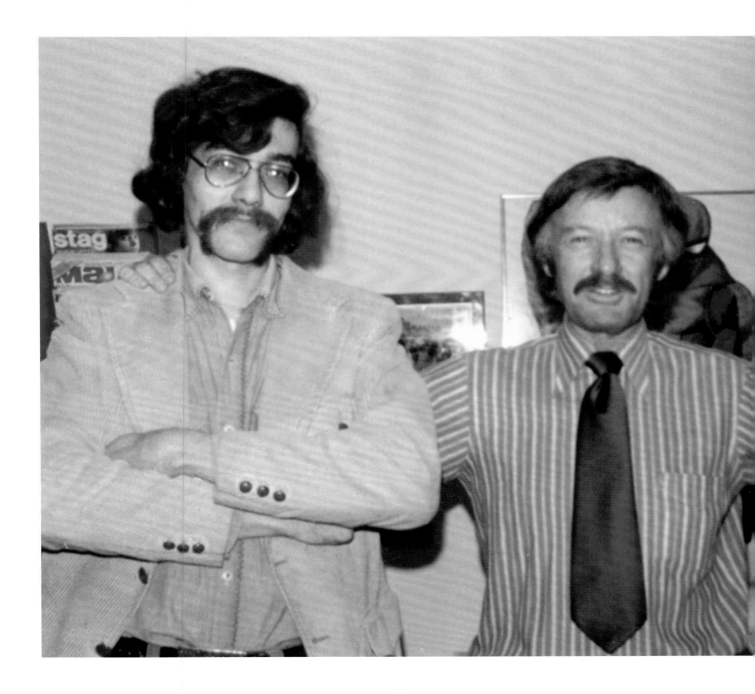

ABOVE: **Denis Kitchen and Stan Lee in New York City | 1974**

I met with Marvel's editor-in-chief to fine-tune the details of our experimental magazine *Comix International*, which ended up being called *Comix Book*. Stan was both open and nervous about getting involved with underground comix.

OPPOSITE: *Comix Book* **No. 3 cover art | *1974***

Editing an "underground" comix magazine for Marvel's mainstream distribution outlets was a dicey task involving much hair-splitting over exactly what language or level of nudity was acceptable. Here, the usually unprincipled Steve Krupp takes a moral stand, insisting that no naked ladies will appear on the cover as long as he's in charge. Of course, the four "rejected" bare breasts *are* on the cover. Somehow this cover gag slipped by Stan Lee. He instead, surprisingly, rejected my new logo. Marvel's production staff stripped in their "acceptable" logo but otherwise ran this intact. Each circle in the sidebar contains a small original by, from the top: Justin Green, Trina Robbins, Peter Poplaski, and Kim Deitch. In the late '90s I produced a signed and numbered multicolored serigraph of my portion of the cover. Coincidentally or not, this turned out to be the last issue published by Marvel (two other issues in the can were later published by Kitchen Sink).

ABOVE: *Krupp Mail Order Catalog* **no. 4 cover art | August 12, 1974**

When Justin Green passed through town in the summer of 1974, naturally Peter Poplaski, Justin, and I ("Pop, Jud, Kitsch") took the opportunity to jam on the latest Krupp retail catalog cover. The rows and rows of pipes, comix, hippie whoopee cushions, and psychedelic hand-buzzers somewhat exaggerated the warehouse's size, product line, and hustle and bustle, but not by much. One of Justin's regular characters, Rowdy Noody, gooses Little Lulu while ProJunior hustles cartons.

AMERICA'S CRAZIEST CONTEMPORARY CARTOONISTS!

02196
No 2
$1.00

TRAVELEERS

PANTHEA

DR. FUTURE

WALDO the CAT

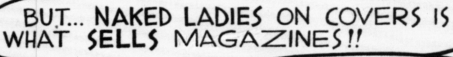

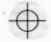
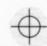

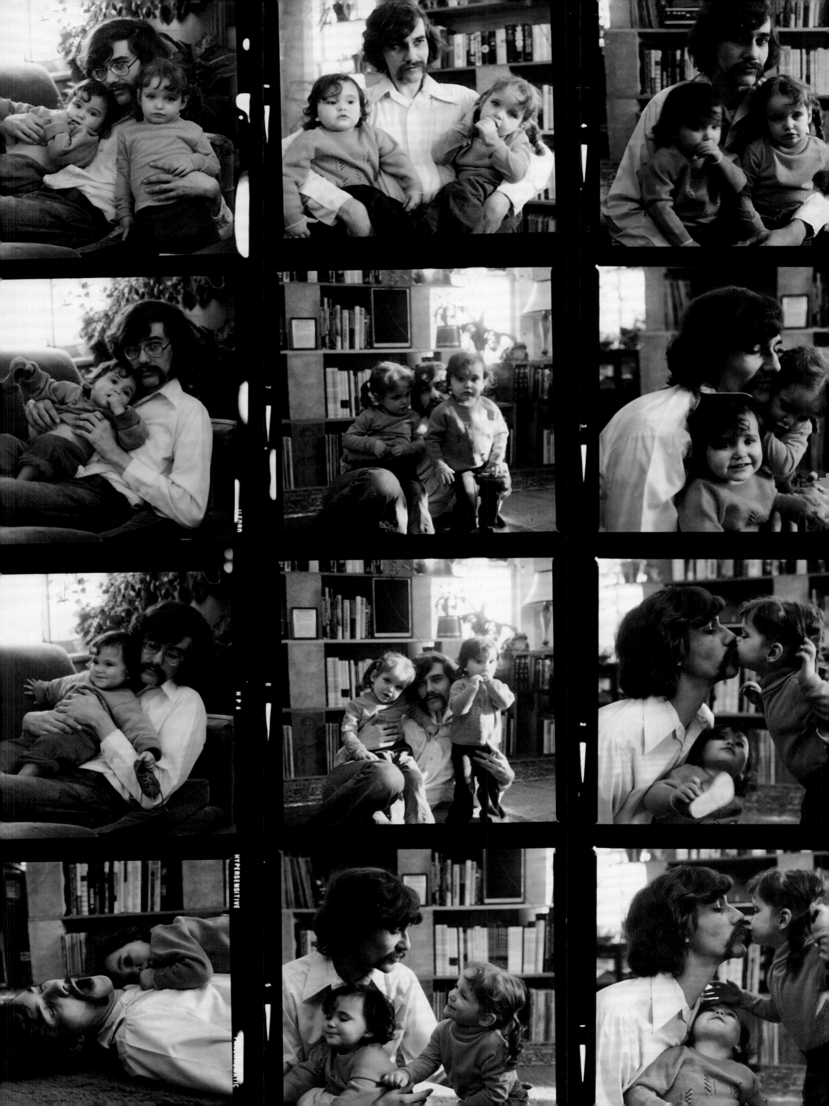

OPPOSITE: Sheena and Scarlet and Denis Kitchen | 1974

Several months after Irene left us, I had these photos taken of me with daughters Sheena, age three (with pigtails), and Scarlet, age two.

ABOVE: *The Kitchen Sink* feature concept | 1977

Milwaukee Journal editor George Lockwood gave me periodic freelance assignments but foresaw bigger things from me. He was responsible for buying all the newspaper's comic strips, had strong relationships with the syndicates, and wanted me to develop a national comic strip, which he believed was every cartoonist's dream. I didn't think I was cut out for a daily. Preferring to do a weekly full-page color strip with regional and topical appeal, I presented this concept drawing, thinking he'd jump on it as a unique *Journal* feature. He rejected it, lectured me on my shortsightedness, and told me I was hopeless.

© 1974 Kitchen

OPPOSITE AND ABOVE: *Bugle-American* **no. 185 cover | 1974**

Terry the Turgid Toad (looking uncharacteristically large), Cosmic Dog, and a posse of exhausted toads march through a blizzard and deep snow to track down the brazen thieves who have stolen the two bugles and the "M" from the newspaper's logo. In the foreground, the villains are revealed as the Beagle Boys, the notorious crooks who are always after Uncle Scrooge's fortune in the classic Carl Barks comic books. I obsessively hand-circled virtually every snowflake on the manual blue color overlay, much like I detailed the pile of peas in "Mail Order Blues."

"Phil Seuling: A Quick Testimonial" | 1975

Except for the joke about inflatable Betty Boop love dolls, every word in this "testimonial" is true. In late 1970 cartoonist Jim Mitchell and I ran an ad in *Bugle-American* no. 11 offering to sell our original strip art. "Save a Starving Artist from Sure Death," blared the breathless headline. I have no idea how a regional paper like the *Bugle* found its way to Brooklyn, but a short time later a Coney Island salami from a virtual stranger arrived at my door with a tag that said, "Never let it be said that Phil Seuling let a cartoonist starve!"

"Plastic Do-Nuts" logo and *Bugle-American* no. 193 cover | 1975

At nearly midnight on February 21, 1975, I left the *Bugle* office in Milwaukee. I had just finished drawing and cutting the Zip-A-Tone screens for a new music column header, "Plastic Do-Nuts." I left the original on the layout department worktable, got in my car, and drove north to my farm in Princeton. I wasn't aware till I was phoned at home, but while I was driving, the office was firebombed. Six people sleeping upstairs, including a baby, barely escaped with their lives before flames engulfed the building. Those responsible for the terrorist act were never apprehended. The majority of the gutted building's contents were destroyed, but a few odd items were salvaged. Among the surviving items was my fire-singed "Plastic Do-Nuts" logo.

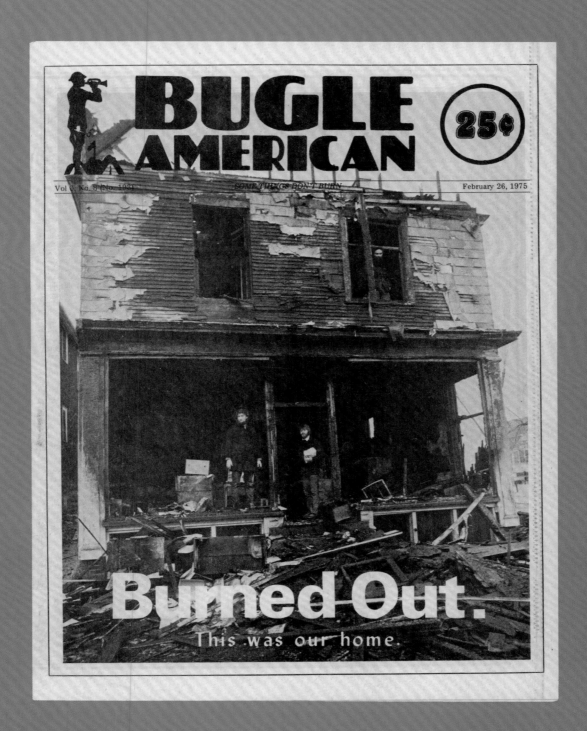

OPPOSITE: *Major Arcana* album cover | 1975

This album art was drawn as a favor to my brother James, who was briefly a member of the Milwaukee-based band Major Arcana, led by poet/musician Jim Spencer. The drawing took about ninety hours, a detail I remember only because it was an unpaid gig during a financially tough year. After inking the thinly outlined title, I stared at the blank background without a clue as to where the composition was going. Then I began in the upper left corner with a "stream of consciousness" approach, and the eventual surreal panorama developed. There is little overt logic in the work, aside from one hidden message and a visual pun regarding the prominent Cyclops-like character juggling objects (not easily discernible in the black-and-white art). Major Arcana was named after the first twenty-two cards in a tarot deck, but I put a military buckle and medal on the juggler's chest to suggest that he was a major of another kind. That conceit was carried a bit further in the three-page *Mondo Snarfo* "story" extension of this image, published in 1978.

ABOVE: Denis Kitchen at his drawing board | 1975

Visible on the drawing board is the *Bugle* no. 209 cover in progress. The peculiar device in my hand is a burnishing tool, used to transfer press type. In the ancient pre-digital age, headlines and other text were often transferred letter by letter from special sheets using the tool's ball-peen tip. The flat end (shown) was used to rub such type or low-adhesive Zip-A-Tone dot patterns securely into place. Strangely enough, the manufacturer of this burnishing tool was the grandfather of John Lind, my future business partner.

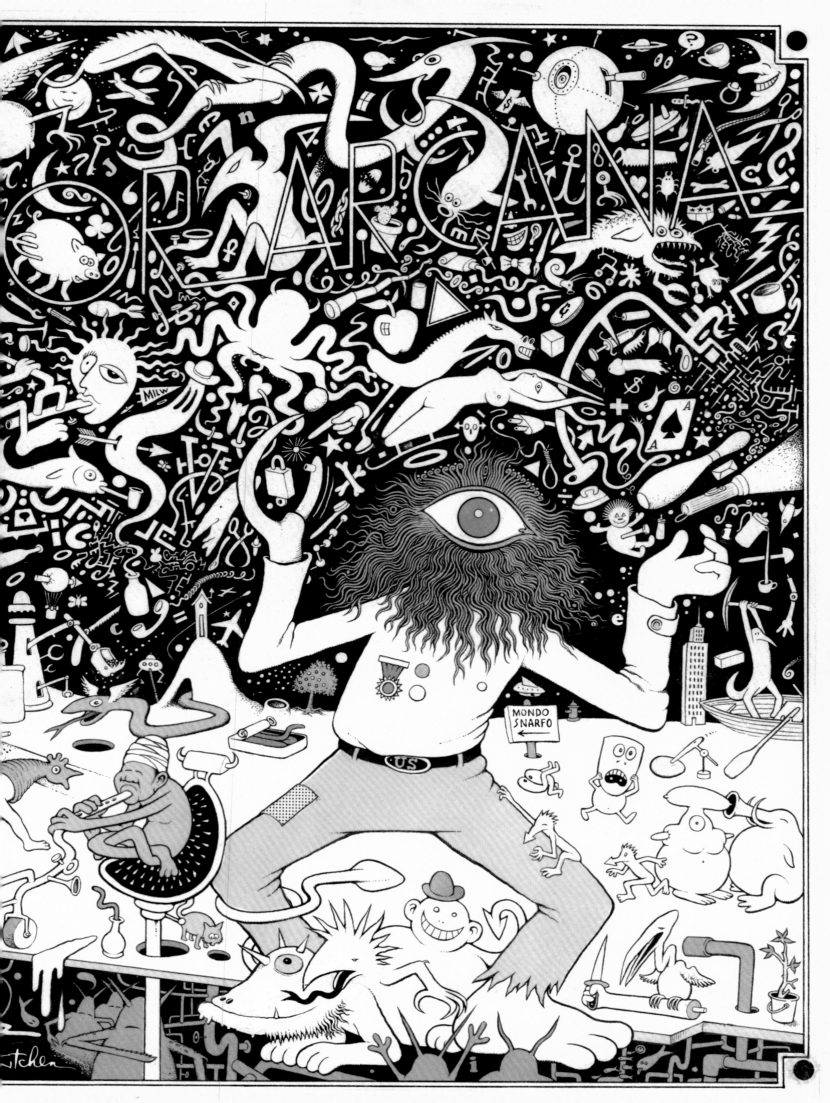

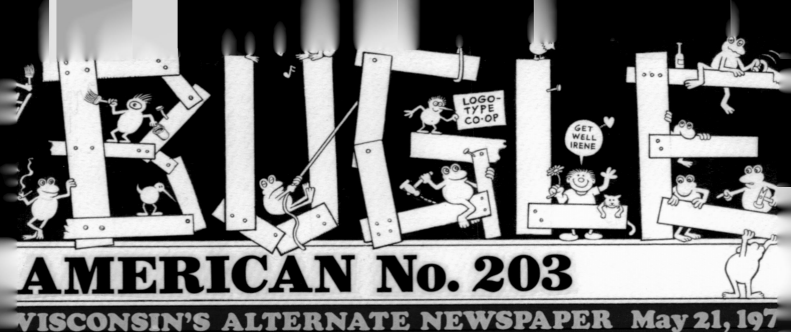

BUGLE
AMERICAN No. 203
WISCONSIN'S ALTERNATE NEWSPAPER May 21, 197

This issue's cover story was on local co-ops, so I integrated several actual and theoretical co-ops into the primary street scene. Still wanting more detail, I decided that the logo itself should be constructed, however crudely, by frog carpenters from the Logo-Type Co-Op. The cover story required a diagonal banner across the bottom for a color headline, which I found intrusive, so I emphasized my point by drawing the inconvenienced hippie who has to step over the journalistic artifice.

ABOVE: **_Bugle_ no. 209 cover art | 1975**

The Music Fest theme allowed me to indulge in a surreal cover design only tangentially related to music. The "HB" in the heart on the flute-playing pig's arm stands for Holly Brooks, who would eventually become my second wife. Note that between issues 203 and 209 "American" has been dropped from the paper's name. Though I had participated in the original naming of the newspaper, I had long lobbied to shorten it simply to _Bugle_, but that change wouldn't become permanent until later.

Most underground newspapers experienced short life spans, so celebrating the fifth anniversary of the *Bugle* called for something special. The usually penurious budget was cast aside and the weekly's cover was printed in full-color process instead of the usual black plus one color. My fantasy anniversary party depicts hippies sharing joints with cops, aliens, Betty Boop, and the Mad Hatter. As with most *Bugle* covers, I drew a unique logo as a part of the original art. Its Band-aid, lumps, melting letters, and puncture wound subtly suggest the paper's actual condition amidst the surface smiles, cake, and balloons.

OPPOSITE: **"Interview with Denis Kitchen" | 1975**

Part of the *Bugle's* fifth-anniversary issue was a semi-serious interview with me. Most cartoon replies are obviously tongue-in-cheek (founding staff as naïfs, my sex life, a pot aversion, and Steve Krupp behind the scenes). The straitjacket, "Oh shit!" and Hudson Hornet (I had one) panels are the closest to serious answers, other than the non-illustrated final one.

Interview with Denis Kitchen

In the following interview judy Jacobi asked Denis Kitchen a few questions. He chose, characteristically, to answer in cartoon form.

Q. Now that you're rich and famous, why do you still do Bugle work?

Q: In the early months of the *Bugle's* existence you used to drive the paste-up from the Madison office to the Milwaukee printer at dawn, after working all night. Several times you fell asleep at the wheel and had "near misses." What went through your mind as you saw disaster staring you in the face?

Q: In retrospect, do you think the original Bugle founders were naive??

Q. If you had to choose between reliving that first year on the Bugle and receiving a 1951 Hudson Hornet in mint condition, which would you do?

Q: Describe your sex life in detail during the *Bugle's* second year.

Q: Did you ever rely on drugs to help you meet deadlines, or use them for inspiration?

Q: Do you feel you've grown as an artist from the first issue of the *Bugle* five years ago? Give us an example of a 1970 Kitchen drawing and a contemporary one.

Q. Is the Bugle really a staff-run cooperative?

Q: The *Bugle* for the first year or two had the unique feature of a regular comix page drawn by several local cartoonists. What happened to all those artists, and what are you doing these days?

A: I guess I'll have to deviate from pictures for this one. Don Glassford, who did the "Studley" strip is still in Milwaukee doing nice T-shirt designs that are distributed nationally. Bruce Walthers, who did "Oscar Kabibbler," now lives near Boston, freelances, and daydreams a lot. Wendel Pugh ("Fenster Sitzen") left for Colorado three years ago. The last I heard he was living on a mountaintop. Jim Mitchell ("Smile") is a tragic case. He was busted in Mexico almost two years ago on a drug charge (with circumstantial evidence). He has been languishing in a Mexico City prison cell ever since, and has yet to be tried or sentenced. The level of corruption there is incredible. As for myself, I'm living in the country and still publishing and drawing underground comix, although I am told they died two summers ago.

BELOW: **Dave Schreiner, Denis Kitchen, and Terry Shaw in Milwaukee | 1975**
Dave (1946-2003) and I met in journalism school in 1965 and five years later were
among the five co-founders of the *Bugle American*, the always struggling alternative
weekly. I "escaped" after splitting my time the first year or so between the *Bugle*
and my separate comix company, and I only made guest appearances thereafter. But
Dave toiled there through all seven of the paper's sometimes-brutal years. He was
the editor (and still was when this photo was taken) and heart of the paper, but was
in a deep political struggle with the two other remaining founders, Mike Jacobi and
his then-wife Judy. Mike controlled the checkbook and effectively ran the paper in
an icy and detached manner. Terry was my roommate and contributed ideas when I
created *Mom's* no. 1 in the late '60s. He died of AIDS in 1990.

OPPOSITE (AND PAGES 144-145): **"Life in the Ice & Salt Works" | 1975-1976**
The full three-page story ran in *Snarf* no. 6 (February 1976), but the splash was
a stand-alone in the *Bugle* fifth-anniversary issue (September 1975). The O'Jays'
"Backstabbers" on Steve Krupp's desk was an actual record album (1972) but had
a double meaning here, particularly when juxtaposed with impaled staffers. The
bearded iceman chipping meager coins for employees was intended to resemble
Mike Jacobi. These clues and the oppressive setting don't seem that subtle to me in
retrospect, but the page ran without objection or any apparent realization of intent
from the targeted parties. Dave and I later expanded the single page for *Snarf*.
Some of the new visual elements reflect shared joys, like the Carl Barks ducks and Krazy
and Ignatz. The ballplayer in the snow is Dave, wearing the uniform of his beloved
Phillies. He loved the game but wasn't able to play because of chronic illness.

By Dave Schreiner and Denis Kitchen

Life here is not for the meek. You'd better have a strong back and some woolen underwear.

Paydays are far and few between, but most of the inmates don't need money anyway. After all, what would they spend it on?

Occasionally, something happens that breaks the rugged tedium...

But most of the time, it's business as usual in this place of phantom whirlwinds, icy standoffs, chilblains and cramps...

WOW. ICE CREAM.

September 17, 1975

NO PRIMA DONNA PICK WIELDERS NEED APPLY

PRODUCTION FELL...

RAZZER FAZZER!

HMPH.

BEFORE SUN AFTER SUN

VANDALISM OCCURRED...

NN HNN

THE MINE RETALIATED AND PUT OUT THE SUN. IT WAS DONE WITH BLACK PAINT AND MIRRORS.

?

THE INMATES PANICKED. SOME SHOT GUNS AT THE SKY, TO SEE IF THAT WOULD HELP.

BANG! BLAM! POW!

IT DIDN'T.

KRUNK!

OTHERS DONNED HAIR-SHIRTS AND WAILED. A FEW TOOK UP MOUNTAIN CLIMBING. STILL MORE ORGANIZED RELIGIONS. ALL THAT DIDN'T WORK, EITHER.

THEY FINALLY FIGURED OUT, FROM ALL THE EMPTY PAINT CANS, THAT THE MINE HAD DONE IT. THEY FORCED THE SHADOWS THAT DIMMED THE SUN TO FIX THINGS, AND WITHOUT SUNBURN PAY. THINGS BEGAN GETTIN' A LITTLE BETTER AFTER THAT.

PAINT REMOVER

...AND AIN'T THAT JUST THE WAY...

© 1976 Kitchen

BELOW: **"Can't Get Stoned"/"A Maze"** | 1976

These conjoined half-pages appeared in full color in *Head* magazine (a short-lived competitor of *High Times*) and two years later were recycled as the back cover of *Dope Comix* no. 1.

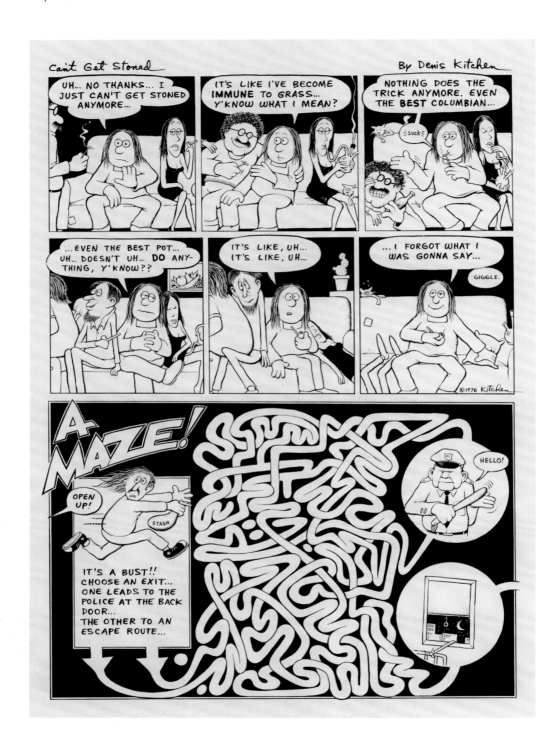

OPPOSITE: ***Fox River Patriot* no. 1 cover art** | 1976

I moved to rural Princeton, Wisconsin, in early 1973, where I ran Kitchen Sink Press and Krupp Distribution and continued to contribute to the Milwaukee-based *Bugle*. Two fellow *Bugle* co-founders, Mike and Judy Jacobi, had also moved to Princeton and purchased an old farmhouse. Mike and I decided to start a statewide alternative biweekly paper, similar in many respects to the weekly *Bugle*, but with a rural emphasis: the back-to-the-land movement, gardening, recycling, and local history. We knew country hippies would "get it," but this debut cover tried to stress that senior citizens, kids, regular people (a house painter), and even cows (who then outnumbered humans in Wisconsin) would appreciate the *Patriot*.

No. 1

Nov. 17-Dec. 7, 1976

FOX RIVER

PATRIOT

FREE
TAKE ONE

BELOW: *A Comic Book Convention* | 1976

I was on "assignment" for *Insight* magazine at the 1976 Chicago Comicon, where
Kitchen Sink Press exhibited annually, sometimes in a lavish wooden "gazebo."
Insight's reporter, Mark Sabljak, described the novel concept of comic book conventions
to Milwaukeeans ninety miles north. My illustration, which ran in full color, spoofs
an eager fan paying $200 (in '76 dollars) for *Obscure* no. 1. I was able to sneak in
plugs for *Snarf* and my personal favorite characters and artists (Sheena, Betty Boop,
Harvey Kurtzman, Basil Wolverton, Will Eisner, and Ernie Bushmiller). But the shopping
bag plug for my favorite comics/nostalgia shop in Milwaukee, Dale Manesis's Good
Old Days, was considered too-blatant a free advertisement and was censored in the
printed version.

A COMIC BOOK CONVENTION

OPPOSITE: *Fox River Patriot* no. 5 cover art | 1977

I've always been fascinated by the various permutations of the culture of flying saucers
and aliens. Here I found a way to integrate that amusement with my new rural
newspaper audience. I also briefly raised chickens in my gentleman farmer stage for
the first couple of years I owned the farm in Princeton, so I knew firsthand what was
on a chicken's tiny mind.

FOX RIVER PATRIOT

FREE!
TAKE ME HOME

I've never exactly been a "pet person," even though cats seem to abound in the backgrounds of many of my strips. But I've always enjoyed drawing animals, and this literal depiction of "raining cats and dogs" gave me a chance to create a deluge. Among the cascading creatures are Fat Freddy's Cat, Snoopy, Krazy Kat, and my own Cosmic Dog.

ABOVE: Various custom ads | Circa 1970s

One of the disadvantages of co-owning small newspapers like the *Bugle* and the *Fox River Patriot* was that our sales reps, eager to close an advertising contract, would too often tell clients, ". . . and Denis, our staff cartoonist, will be happy to draw your ad for free!" On deadline night, I'd be handed meager text and be told, "We promised you'd design this eighth-of-a-page ad. Oh, and make it nice and cute if you can." I understood the fragility and importance of small businesses and always tried to make the ads distinctive, with local color when possible. This grouping represents a tiny fraction of such custom-drawn ads.

"Congratulations on Your Big Dope Deal!" greeting card | 1977
Following the success of the Christmas Kruppcards card line, the company ventured into a line of "all-purpose" hippie greeting cards. My own contribution here (inside the card was a checklist of desired drugs) was probably not exactly practical; who would actually mail such a card to their dealer? Or, better stated, who would send a card like this today and live to tell about it?

OUTLAWED CARTOONS
In 1899, owners of the Southern Pacific railroad were irritated by Homer Davenport's editorial cartoons attacking the railroad's efforts to avoid paying its debt to the federal government. The railroad company's friends in the California state legislature made it illegal to publish the offensive cartoons. The new law read "It shall ... be unlawful to publish ... any caricature of any person residing in this state, which caricature will in any manner reflect upon the honor, integrity, manhood, virtue, reputation, or business or political motives of the person so caricatured, or which tends to expose the individual so caricatured to public hatred, ridicule, or contempt." The penalty for drawing or publishing unfriendly cartoons was to be a fine of not less than $100 nor more than $500, or by one to six months in jail, or both. In 1915 the law was repealed.

ABOVE: **"Outlawed Cartoons" | 1977**
Corporate Crime Comics, edited by Leonard Rifas, was Kitchen Sink's white-collar version of lurid titles like *Crime Does Not Pay*, which had dominated the comics industry a quarter-century earlier. Most stories in *Corporate Crime* focused on contemporary scandals, but I jumped at the chance to illustrate this early historical example of cartoon censorship, nearly a decade before founding the non-profit Comic Book Legal Defense Fund. And here Steve Krupp gets to play a *real* capitalist.

BELOW: **Death of Underground Newspapers | 1977**

When *Insight* editor George Lockwood decided to do a story on the death of
underground newspapers, he turned to his "inside man." I had mixed feelings.
Nationally, underground papers were expiring. Locally, the *Bugle* was still kicking
(it lasted until mid-1978). I drew the obvious: internal political squabbling and a
shortage of capital were endemic. This illustration (with full color overlay) and
article never ran, but I got to draw one of my favorite objects: a long stretchable
telephone cord (they are lovingly rendered wherever they appear). Among
the in-jokes: the last five keys on the manual typewriter are "DK ♥ HB" for my
then-girlfriend Holly Brooks. The *really* obscure detail: the typewriter isn't just
old—it's a *Sholes*. (C. L. Sholes invented the typewriter and QWERTY keyboard
in Milwaukee in the mid-nineteenth century.)

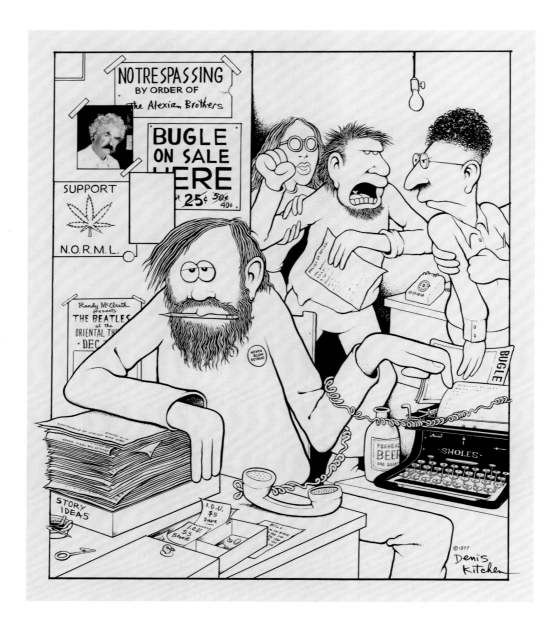

OPPOSITE: **"The Interview," jam with Will Eisner | 1977**

Comics legend Will Eisner retired his *Spirit* strip in 1952, but it was reintroduced to
a new generation in Kitchen Sink's "Underground" *Spirit* in 1972. These two issues,
featuring new covers and pages as well as reprints, were popular enough that larger
publisher James Warren lured Eisner away. Warren's *Spirit Magazine*, which was
distributed to newsstands, lasted sixteen issues before he and Eisner split. Kitchen Sink
picked up the series, continuing the numbering, and so in this jam in *Spirit Magazine*
no. 17, I welcome Will "back to the 'underground' press." Eisner good-naturedly makes
fun of his growing resemblance to Police Commissioner Eustace Dolan.

The Interview "

WORKING IN GEEKTOWN

BY DENIS KITCHEN ©1978

"Working in Geektown" | 1977

This was originally created at the request of *High Times* in 1977, but since it was rejected, it became the color back cover of *Mondo Snarfo* in 1978. It was intended to convey what many have realized in the workplace: that even a seemingly creative job can be a dehumanizing experience. Aside from the self-caricature, the clue that this has an autobiographical side is the company name on the door: MCG = Marvel Comics Group. In 1974, as Marvel was canceling my *Comix Book* experiment, Stan Lee still wanted me to work for him. He asked me to join his bullpen and edit *Crazy* (Marvel's watered-down version of *MAD*). The offer was financially tempting, but I declined. Thinking about that "What if" career eventually inspired "Working in Geektown."

ABOVE: *Fox River Patriot* **no. 23 cover art | 1977**

Because its statewide audience was concentrated in small towns and rural areas, the *Patriot* covers had to be designed with some restraint in comparison with the anything-goes *Bugle* covers. My cautious partner Mike Jacobi was always urging me to make the *Patriot* covers "cuter," and sometimes I caved in to his pressure, with occasionally embarrassing results. The clear exceptions were the Halloween covers, for which, like a minister's child, I could don a devil's mask and run amuck. Three of the four *Patriot* Halloween covers are depicted in this book.

And She Gives Good Head, Fred

By Denis Kitchen ©1981

MAUREEN IS A BIG FAN OF THE BAND "GRATEFUL DEAD."

SHE'S A DEADHEAD.

IN FACT, SHE'S PRESIDENT OF THEIR FAN CLUB.

SO SHE'S THE HEAD DEADHEAD.

AND SHE SMOKES POT.

SHE'S A HEAD HEAD DEADHEAD.

BLONDE ISN'T HER NATURAL HAIR COLOR.

SHE'S A REDHEAD HEAD HEAD DEADHEAD.

SHE'S A COMMUNIST SYMPATHIZER.

SHE'S A RED REDHEAD HEAD HEAD DEADHEAD.

SHE CAN ALWAYS BE FOUND WITH A GOOD BOOK.

SHE'S A WELLREAD RED REDHEAD HEAD HEAD DEADHEAD.

SHE ATTENDED RADCLIFFE.

SHE'S A WELLBRED WELLREAD RED REDHEAD HEAD HEAD DEADHEAD.

SHE'S NEVER BEEN SICK A DAY IN HER LIFE.

SHE'S A WELL WELL-BRED WELLREAD RED REDHEAD HEAD HEAD DEADHEAD.

THAT IS ... UNTIL TODAY.

SHE'S A NOT SO WELL WELLBRED WELLREAD RED REDHEAD HEAD HEAD DEADHEAD. AND DEAD.

OPPOSITE: **"And She Gives Good Head, Fred" | 1978**

OPPOSITE: **"And She Gives Good Head, Fred" | 1978**

When I was invited to do pages for *High Times*, I decided to create wordplay that would presumably be funnier when the reader was in an altered state. The editor, Bob Singer, accepted the page but asked me to change the title, which I did (to "High on the Hog," which I now prefer). But after many months of *High Times* neither running it nor paying for it, I demanded the art back. It finally appeared as the back cover of *Snarf* no. 9 in 1981 (hence the later copyright date) and then, recolored and retitled once again (as "Head Deadhead"), it ran in *Grateful Dead Comix* no. 5.

ABOVE: *Fox River Patriot* no. 30 cover art | 1978

While I wince at some of the cloyingly cute covers I drew for the *Patriot*, I like the notion and the grace of this lovestruck pig ice-skating under a starlit sky to impress his girlfriend. This is an example of the subject matter and sense of humor I could employ for a rural audience as opposed to the largely urban readership of the *Bugle*. The important thing to me was that for both publications, I had the freedom of subject matter and approach.

Vootie no. 12 cover art | 1978

Another regional fanzine to which I sometimes contributed was the Minneapolis-based _Vootie_, America's only publication devoted solely to anthropomorphic vegetables and funny animals. Here I explored the notion of a working "funny animal" character with a drinking problem and/or performance anxiety.

OPPOSITE: **_Weird Trips_ no. 3 unpublished cover jam | 1978**

The blue pencils and tormented upside-down head are by Peter Poplaski. Jay Lynch's characters are popping out of a nostril and having sex with two fingers. Dutch underground cartoonist Evert Geradts contributed the devil with a pitchfork and the bandit with jackhammer. The remaining tormentors, the creature with a pickax and the fish swimming in the hair, are mine. I regret that this cover was never finished, but when Leonard Rifas, who was coediting this third issue, left the Princeton complex, the short-lived title fizzled out.

WEIRD
TRIPS

$1.00

NO. 3

My friends Hank and Lesleigh Luttrell produced the comics and science-fiction
fanzine *Starling*, and I happily created a guest cover. I always liked playing with logos
and integrating them into the cover concepts, so the girl's balloon conveniently
forms an "S." I couldn't help it that the deviant clown's balloon had a mind of its own.

OPPOSITE: ***Bugle* no. 316 cover art | 1978**
The *Bugle* lasted nearly eight years and accomplished a lot, which was not bad
for a chronically under-capitalized alternative paper in a small market. When this
battered reporter representing the aggregate *Bugle* staff finally blew retreat,
with a mob of real and perceived enemies in pursuit, a chapter of my professional
life ended. Between the first and final issues that bookended the long run, I drew
nearly thirty *Bugle* covers plus scores of strips and illustrations, but was never paid
for a single one. People who have not been part of a dedicated collective effort
like this '70s-era weekly paper may have difficulty understanding.

THIS SPREAD: ***Nancy* parody for *Playboy* | 1978**

For a while America's leading men's magazine featured a section called "Playboy Funnies," with risqué strip-style comics by various artists, including underground cartoonists Art Spiegelman, Skip Williamson, and Gary Hallgren. My first submission, a parody of—what else?—Nancy and her Aunt Fritzi, was accepted, and the full-color version ran in the November 1978 issue of *Playboy*. I never made another submission, thus retiring with an unlikely 100% batting average in the tough gag-cartoon market.

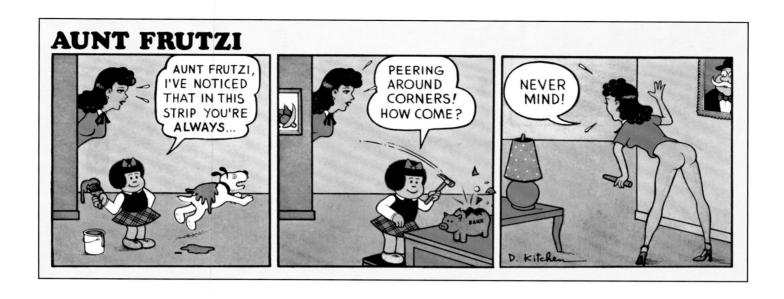

BELOW: ***Mondo Snarfo* cover | 1978**

From my earliest years both surrealism and comics held strong fascination; I conceived of *Mondo Snarfo* as a means of exploring the juncture between the two. I drew the front and back covers and a three-page story, inviting Bill Griffith, Art Spiegelman, Mark Beyer, Mike Newhall, R. Crumb, Kim Deitch, and others to mine the same vein. Wearing the publishing hat as well, I didn't care if the noncommercial title sold or not (it eventually did). The cover image is a variant of the musical ensemble on page 2 of the interior story, "Major Arcana." I've never played an instrument, but certain types of background music are important components of the creative process for me, particularly with nonrational drawings like the examples in *Mondo Snarfo*. When the original of this cover sold at Sotheby's, the buyer was, fittingly, a musician: Graham Nash.

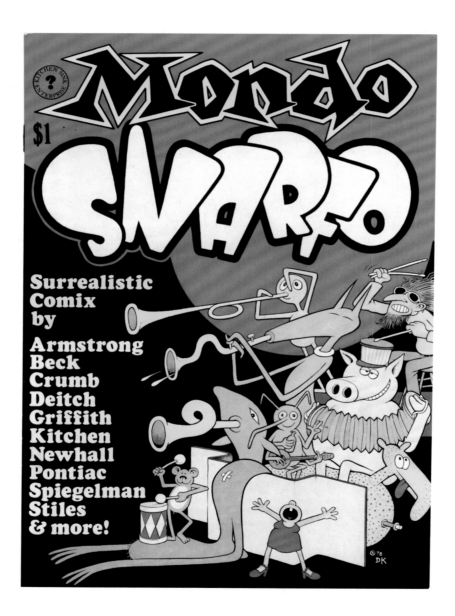

OPPOSITE (AND PAGES 168-169): **"Major Arcana" | 1978**

This three-page story appeared in *Mondo Snarfo*, a deliberately surrealist and mutant spin-off of *Snarf*, Kitchen Sink's humor anthology. The splash panel was originally drawn as an album cover in 1975. Recycling it, I decided, required some connective tissue to the pages that followed, even in an intentionally nonlinear comic. The Major (with the military medal) in the first and last pages provides loose bookends. Appearing in the final panel as a human in a Napoleonic hat, sitting dazed at a bar, he suggests that what came before was a hallucination. These pages, still mysterious to me today, were drawn without premeditation or hallucinogens. Had I not had to work for a living, I would have drawn many more pages of this nature.

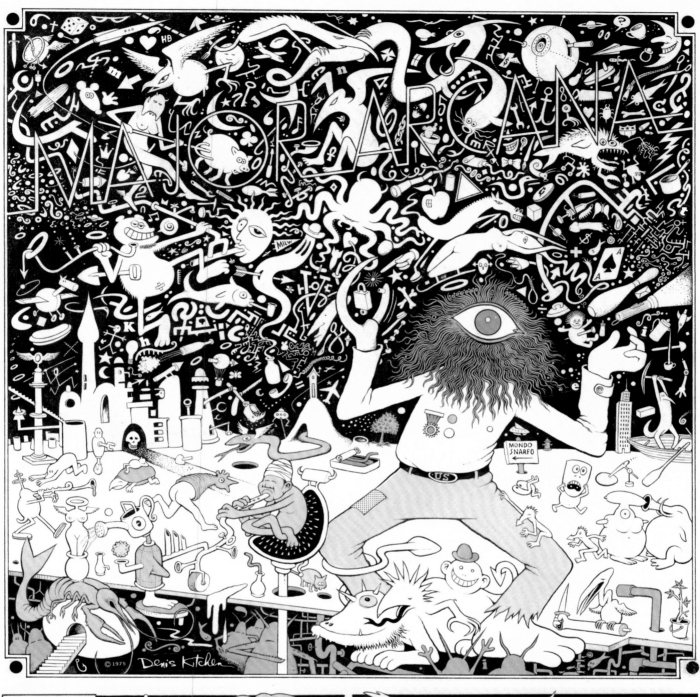

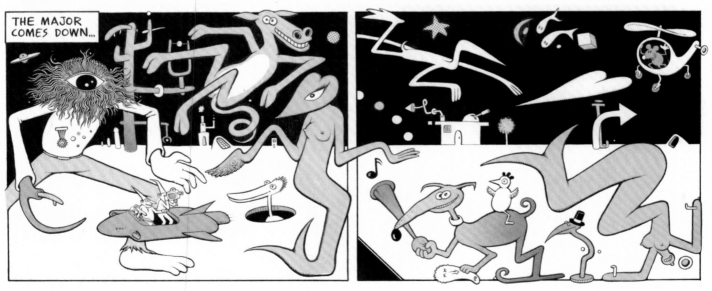

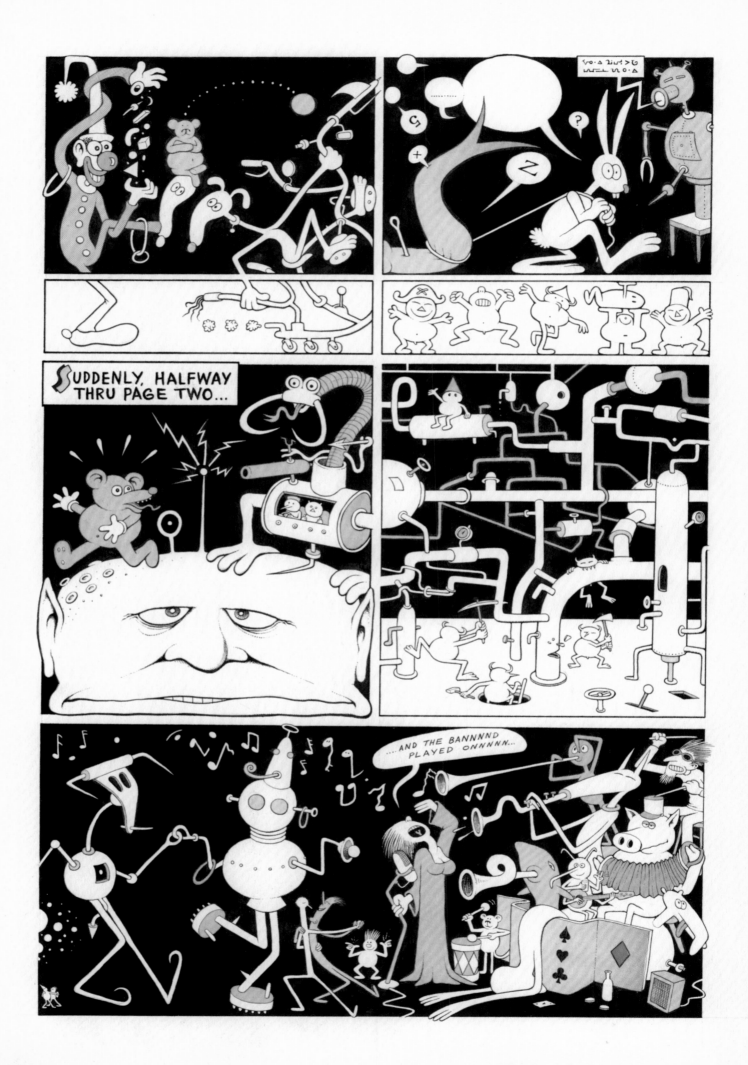

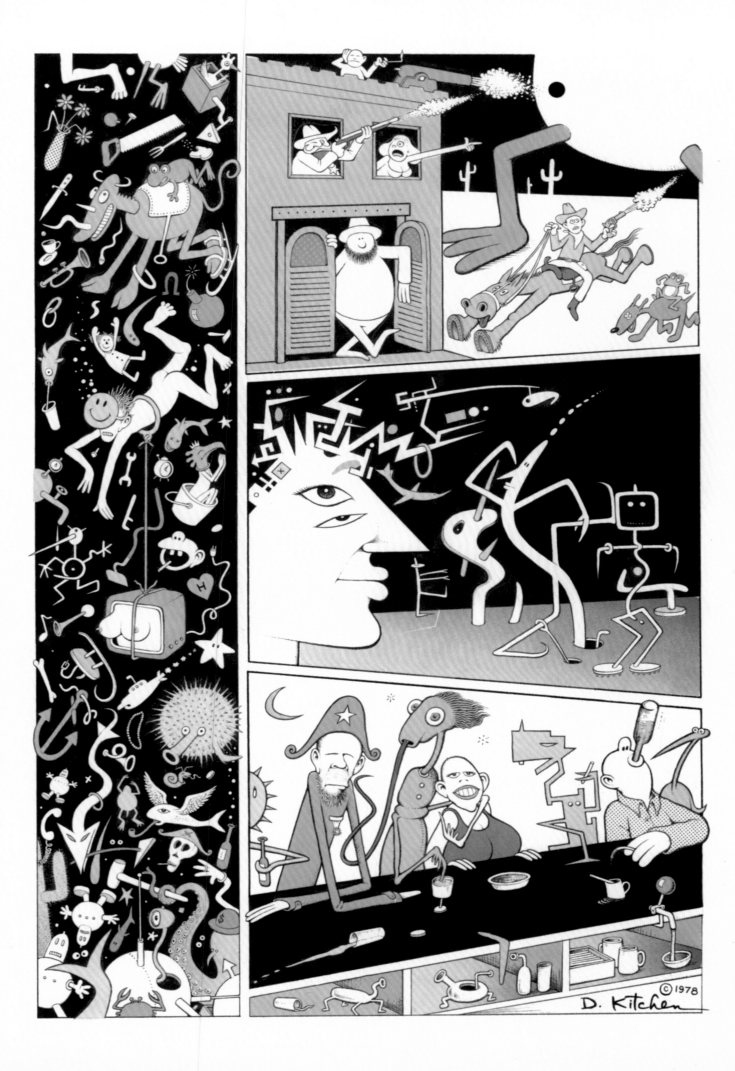

Although I have not been the most prolific of artists in terms of finished works, I am a compulsive doodler and will draw on anything if ordinary paper or notepads are not within reach. I especially love drawing with Sharpie markers on cardboard and chipboard unimpeded by filament tape, as this carton attests.

OPPOSITE: **"Eisner Vault" | 1979**
When Will Eisner and I jammed on "The Interview" in 1977, we thought we'd be doing jam features semiregularly for *The Spirit Magazine*. But our only other collaborative effort (aside from the fifty-creator "Spirit Jam" in 1981) was this page in no. 22. We used the notion of sloppily maintained archives in a subterranean vault to "explain" a time-line error in the previous issue.

Publisher's Note: Sharp readers instantly noticed that we ran Chapter Three of the "Outer Space" serial in the last issue and called it Chapter Two. For that mistake, we apologize. The real Chapter Two follows this page. To show readers how an editorial mistake like this could happen, Will and I invite you to follow us deep underground into the legendary...

EISNER VAULT

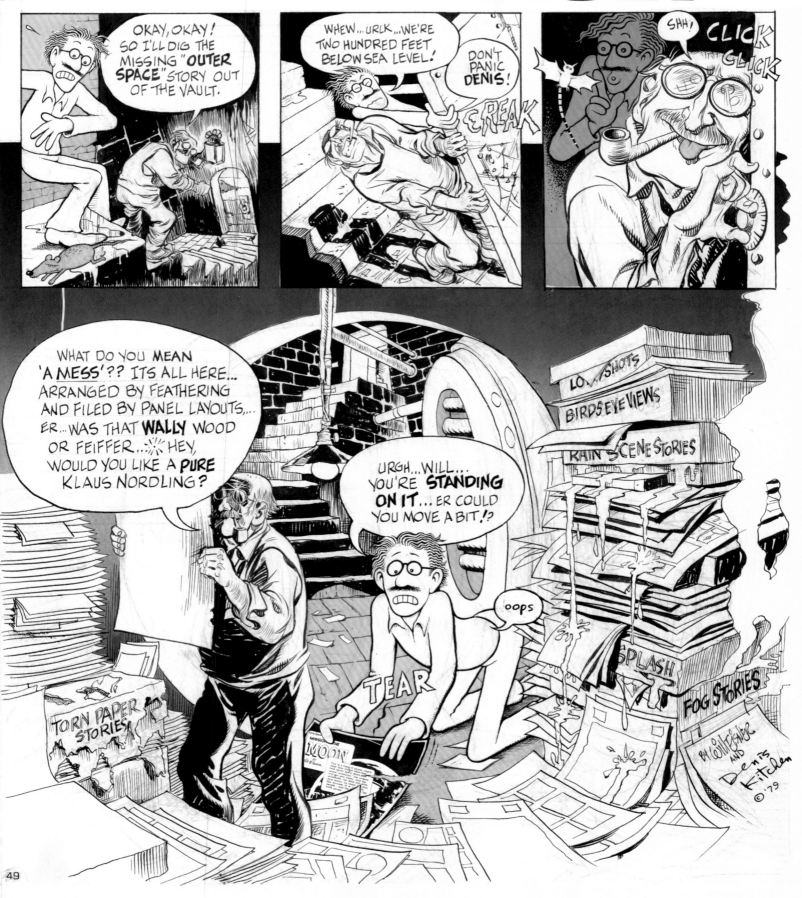

My contribution to *Corporate Crime Comics* no. 2 didn't tackle Exxon oil spills or insurance company schemes, but instead a topic that deeply affected baseball card collectors everywhere. Including me. I recycled altered versions of both of these images in the first of three team card sets we created for the Sinkers, Kitchen Sink's softball team.

Topps Stays on Top of Gumcard Biz

by Denis Kitchen

Bubblegum baseball cards, collected by millions of kids (and adults), is a big business. $6-7 million is spent annually on these cards.

And all of the baseball cards sold are made by the Topps Chewing Gum Company of Brooklyn.

Why is there no competition?

According to the Fleer Corporation of Philadelphia, another bubblegum company, Topps has illegally restrained potential competitors. When Fleer complained to the Federal Trade Commission in 1962, the F.T.C. determined that the baseball card industry was not a "commercially meaningful market" subject to antitrust supervision.

But Fleer filed an antitrust suit against Topps in 1975. In 1978 the U.S. Supreme Court brushed aside the F.T.C. ruling and declared that Topps must face trial on the antitrust suit.

The suit charges that Topps monopolizes the industry by signing exclusive bubblegum card contracts with virtually all major league baseball players. Fleer claims that the contract dates are "staggered" so that the players remain under contract with Topps five years in advance. Fleer President Donald Peck says this practice makes it impossible for his firm or any other to bid for the rights to the players' pictures, deprives players of an opportunity to maximize their income, and cheats collectors of the chance to acquire other series and designs.

Also named in the suit was the Major League Baseball Players Association for engaging "in a combination and conspiracy in restraint of interstate trade." The association (players' union) grants Topps the right to make exclusive five year picture contracts with the players. Topps calls all the charges "baseless."

I collect a lot of things (see "My 5 Minutes with God" on page 189), but for many years one of my primary passions was vintage jukeboxes from the 1930s and '40s. This self-portrait shows me dancing with a somewhat anthropomorphized 78 rpm Rock-Ola juke.

71 FOX RIVER 25¢

PATRIOT

OPPOSITE: *Fox River Patriot* no. 71 cover art | 1979

The *Patriot* was published in the most Republican county in Wisconsin, but the annual Halloween covers gave me an opportunity to get particularly weird and crazy. The inspiration for the tall ghoul standing in the doorway was a character in a 1950s E.C. horror comic drawn by Al Feldstein. To make sure any comic book fans who were paying attention knew this was an homage and not theft, I signed my name in Feldstein's trademark style.

ABOVE: *Fox River Patriot* no. 94 cover | 1980

The trick-or-treating kids from the 1979 *Patriot* Halloween cover are back, but this time the scares come from a snake-tongued ghost, a flying jack-o'-lantern, and the kind of pitchfork-toting devils that routinely ride cows in the Midwest countryside in late October.

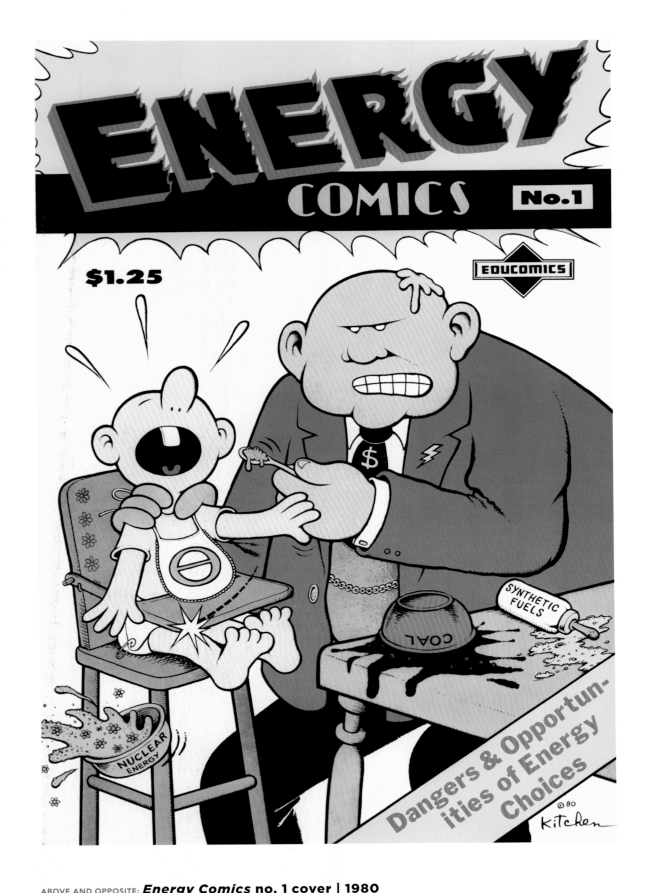

ABOVE AND OPPOSITE: *Energy Comics* **no. 1 cover | 1980**

Done for Leonard Rifas's EduComics imprint, this cover stars Steve Krupp as the powerful energy industry forcing coal, nuclear energy, and synthetic fuels on a resistant eco-baby. Leonard worked for me from 1978 to 1981 at Kitchen Sink's office in Princeton (population 1,400), but during his own time he continued to publish his educational comic book line. Leonard is about an inch taller than me (6'5"), so whenever anyone in the industry called me tall, my response was, "Me? Tall? I'm not even the tallest comic book publisher in Princeton, Wisconsin!"